# Baseball
In Columbus

# Baseball In Columbus

James R. Tootle

Copyright © 2003 by James R. Tootle
ISBN 978-1-5316-1449-2

Published by Arcadia Publishing
Charleston, South Carolina

Library of Congress Catalog Card Number: 2002094831

For all general information contact Arcadia Publishing at:
Telephone 843-853-2070
Fax 843-853-0044
E-mail sales@arcadiapublishing.com
For customer service and orders:
Toll-Free 1-888-313-2665

Visit us on the Internet at www.arcadiapublishing.com

# Contents

| | | |
|---|---|---|
| Introduction | | 7 |
| 1. | Columbus Discovers Baseball | 9 |
| 2. | Professionals Take Over | 21 |
| 3. | The Capital Welcomes the Senators | 39 |
| 4. | The Red Birds Build a Ballpark | 55 |
| 5. | The Jets Take Off | 75 |
| 6. | Columbus Wins with the Clippers | 91 |

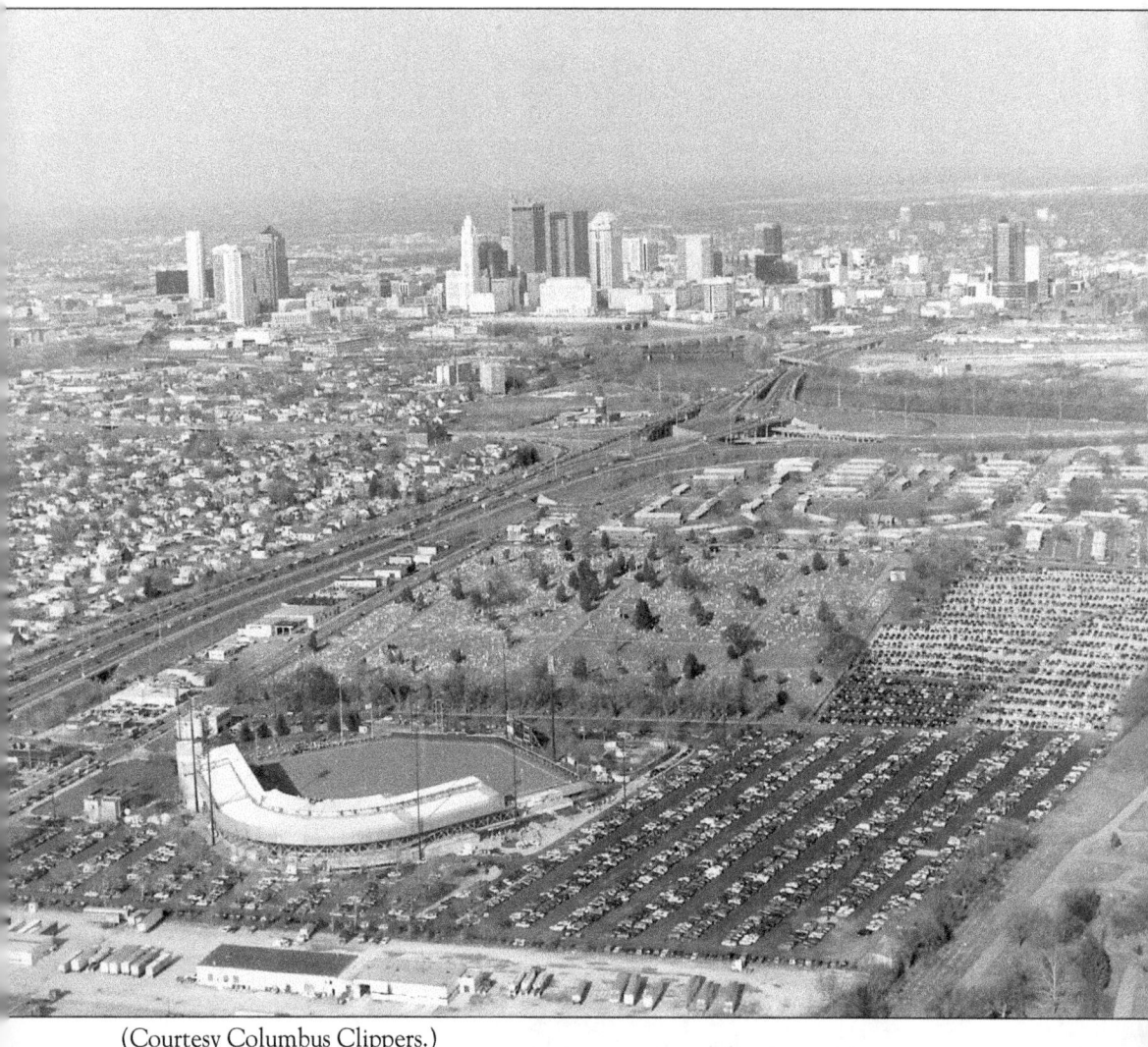
(Courtesy Columbus Clippers.)

# INTRODUCTION

With the founding of three baseball clubs in 1866, Columbus was typical of many cities in the Midwest. Young men returning from the Civil War formed teams in order to play the game they learned while serving in the army. These amateur clubs attracted crowds of supporters and helped baseball take root in its early days as The National Pastime.

Columbus became a major league city for five seasons in the late 19th century. This should be of particular interest to those who may have assumed that the city's acquisition of the NHL Blue Jackets is the first time Columbus has had a team in the "big leagues." Known as the Buckeyes (1883-84) and the Solons (1889-91), the teams played in Recreation Park and its successor, Recreation Park II, both on the south edge of downtown.

The colorful minor league history of Columbus includes the Senators (1902-1930), who won three straight American Association championships in the first decade of the 20th century. Veteran fans may remember the Senators' home field, Neil Park, on Cleveland Avenue near Fort Hayes.

When they became the minor league affiliate of Branch Rickey's St. Louis Cardinals in 1931, the team changed its name from Senators to Red Birds (1931-1954). In 1932, they moved into the new Red Bird Stadium on West Mound Street. This site has remained Columbus' home ballpark into the 21st century.

The Columbus Jets (1955-1970) were briefly affiliated with the Kansas City Athletics and then with the Pittsburgh Pirates. Many Pirate greats came through Columbus, including Willie Stargell, who polished his skills here on his way to Cooperstown.

Columbus was without baseball from 1971 to 1976. The stadium that Commissioner Landis once described as "the finest in all of baseball," fell into disrepair. Fortunately for Columbus fans, baseball returned to the renovated Franklin County Stadium in 1977. The Columbus Clippers were affiliated with the Pirates for two seasons and then began a long and successful association with the New York Yankee organization.

This book is not an encyclopedia of Columbus baseball. Rather, it is a collection of vignettes, anecdotes, and memories that portray a long and interesting history. It presents photos of the greats, near-greats, and journeymen who wore the uniforms of the Columbus professional teams through the decades. College baseball has been part of the Columbus sports landscape since the 1880s and is included in this visual history.

We are indebted to James Thurber's powers of recollection and description for some wonderful old stories of players from the local sandlots who went on to national renown. Perhaps these photos will evoke similar memories for the reader.

The following sources were very helpful to me in preparing this book: David Nemec, *The Beer and Whisky League* (New York: Lyons & Burford, 1994) and *The Great Encyclopedia of 19th Century Major League Baseball* (New York: Donald I. Fine Books, 1997); Marshall D. Wright, *The National Association of Base Ball Players 1857-1870* (Jefferson, NC: McFarland, 2000), *19th Century Baseball: Year-by-Year Statistics for the Major League Teams, 1871 through 1900* (Jefferson, NC: McFarland, 1996), and *The American Association: Year-by-Year Statistics for the Baseball Minor League, 1902-1952* (Jefferson, NC: McFarland, 1997); Lloyd Johnson and Miles Wolff, eds., *The Encyclopedia of Minor League Baseball* (Durham, N.C.: Baseball America, 1997); Alvin K. Peterjohn, *Baseball in Columbus the Years 1866-1907: A Narrative History* (Unpublished manuscript, the Columbus Metropolitan Library, 1971); David L. Porter, ed., *Biographical Dictionary of American Sports: Baseball, Revised and Expanded Edition* (Westport, CN: Greenwood Press, 2000); John Thorn et al., eds., *Total Baseball*, 6th edition (New York: Total Sports, 1999); Bill James et al., eds., *STATS All-Time Baseball Sourcebook* (Skokie, IL: STATS, 1998); www.baseball-reference.com; www.BaseballLibrary.com; Rex Hamann, ed., *The American Association Almanac*; James Pollard, *Ohio State Athletics 1879-1959* (Columbus: Athletic Department, 1959); Michael Gershman, *Diamonds: The Evolution of the Ballpark* (Boston: Houghton Mifflin, 1993); Alfred E. Lee, *The History of the City of Columbus* (New York: Munsell & Co., 1892); *The Story of Columbus: Past, Present and Future of Metropolis of Central Ohio* (Columbus: Johnston Publishing, 1898); *International League of Professional Baseball Clubs 2002 Record Book*; John Swierz, ed., *2002 Columbus Clippers Media Guide*. Contemporary newspaper accounts from the *Base Ball Players' Chronicle* and the *Ohio State Journal* are available on microfilm.

The author is grateful to the following for the use of photographs and other images from their collections: Wendy Greenwood of the Grandview Heights Public Library and Photohio.org; Sam Roshon of the Columbus Metropolitan Library; Raimund Goerler and Julie Petersen of The Ohio State University Archives; Bill Burdick of the National Baseball Hall of Fame and Museum; Larry Romanoff and Greg Aylsworth of The Ohio State University Department of Athletics; Paul Krebs and Kris Kamann of Bowling Green State University; Eric Welch of Columbus State Community College; Jeff Blair of Ohio Dominican University; and Ed Syguda of Otterbein College.

Additional images came from: Library of Congress, Toledo-Lucas County Public Library, Ohio Historical Society, and Thurber House.

The following photographers allowed me to use their excellent images: Dan Trittschuh, Suburban News Publications, and Kevin Fitzsimons, The Ohio State University.

The author appreciates the generosity of the following individuals who shared photos and other materials from their personal collections: Tracy Martin, Mike Nightwine, Richard Barrett, John Husman, Rex Hamann, Greg Rhodes of Road West Publishing, Fred Michalski, Jack Timmons, and Mark Carrow. David Nemec, John Husman, and Joe Santry were helpful in identifying players in old photographs. Any errors are the author's.

Thanks to Joe Santry, Columbus Clippers Director of Communications and Club Historian, for the use of items from his personal collection as well as access to the team archive. He was generous with his time, resources, and knowledge.

My editor at Arcadia, Jeff Ruetsche, has been both patient and helpful. He guided me through this endeavor with good humor and steady encouragement.

This book would not have been possible without the assistance of John Wells of Quality Design Xpress. His expertise, enthusiasm, and dedication to the project were invaluable, and I am indebted to him for his generous contributions and friendship.

I would like to thank my wife, Barbie, for her professional editing, organizational assistance, and encouragement of my interest in baseball history. For her many contributions to this project, this book is dedicated to her.

James R. Tootle

# One

# COLUMBUS DISCOVERS BASEBALL

The game of baseball arrived in Columbus in the early spring of 1866, with the nearly simultaneous formation of three amateur clubs: the Buckeyes, Capitals, and Excelsiors. This sudden interest in baseball, increasingly known as the "national game," was part of an explosion of interest in baseball that swept the country in the first year of peace after the close of the Civil War.

While various bat and ball games had been played since ancient times, historians of the game agree that baseball originated in New York City. In 1845, Alexander Cartwright, a member of the Knickerbocker Club, drew up a set of rules for a new game that included the concept of foul territory and a diamond-shaped field. When building began to encroach on their playing field in Manhattan at 27th Street and 4th (now Park) Avenue, the Knickerbockers began taking the short ferry ride across the Hudson to Hoboken, New Jersey. They rented space at the Elysian Fields, a popular recreation area often used for cricket matches. Meanwhile, other clubs in New York and Brooklyn were beginning to take up the game as played by the Knickerbocker rules. The first baseball game between two clubs is usually traced to June 19, 1846, when the Knickerbockers played the New York Club at the Elysian Fields.

The popularity of baseball spread through the greater New York area with more teams forming in Manhattan and Brooklyn. Although in a state of healthy growth, on the eve of the Civil War baseball was still confined to the East Coast. The war itself proved to be a catalyst for the spread of baseball. As troops were deployed around the country, soldiers from the East taught the game to their comrades from other parts of the country. When these young men returned to their homes after the war, they were eager to form their own baseball clubs. The three clubs that formed in Columbus in the spring of 1866 were representative of this post-war boom in baseball's popularity.

James M. Comly, editor and publisher of the *Ohio State Journal* and an ardent proponent of establishing baseball in Columbus, started publishing baseball news in the "City Matters" page of his newspaper. The March 12, 1866 edition of the *Journal* noted the formation of the Buckeye Base Ball Club with James A. Williams as president. On April 5, the *Journal* announced the organizational meeting of a second group, to be held that evening at the office

of H.T. Chittenden at 5 West State Street. This group was named the Capital Base Ball Club, with Comly as president and J.A. Scarritt as vice president.

On April 6, the Buckeyes took the field for their first game (to be played by two teams of club members) at "the field near the Lunatic Asylum" (where I-71 now intersects East Broad Street). The spacious lawn in front of the asylum would have made an excellent playing field.

On the afternoon of Saturday, April 14, the members of the Capitals played their first game at the corner of Cleveland Avenue and Long Street, where the campuses of Columbus State Community College and the Columbus College of Art and Design meet today. That evening, a third group, the Excelsior Club, had its organizational meeting at the office of J.A. Neil.

Clubs such as the Crescent, Olentangy, Athletic, Railway Union, Lenape (of Delaware), and others formed in 1866 and 1867. In addition to playing games among the members, the clubs began having matches with each other and traveling to play clubs in nearby towns.

In July 1867, the Washington Nationals, one of the leading baseball clubs in the country, visited Columbus for a game with the Capital Club. Columbus was their first stop on a ten-game tour of six western cities. The game was played at City Park (now Schiller Park). Because of the Nationals' prominence, the event received considerable attention. As expected, the Nationals scored a lopsided victory, 90-10, but it was an exciting day for the city, and the traveling party of the Nationals praised Columbus for its good sportsmanship, hospitality, and the skill of its players.

In August 1868, another well-known club, the Cincinnati Red Stockings, visited Columbus and played the Capitals and Railroad Club at the Capitals' new home grounds at Olentangy Park on North High Street (now the Olentangy Village apartment complex). The Red Stockings won both games easily, defeating the Railroaders 34-15 and, with more regulars in the line-up the next day, swamping the Capitals 43-5. It was becoming apparent that it would be difficult for amateur clubs like the Capitals to compete with clubs such as the Nationals and Red Stockings that were recruiting highly skilled players and paying them for their services. The growing issue of amateurism versus professionalism loomed for future resolution, but The National Pastime had definitely been established in Columbus.

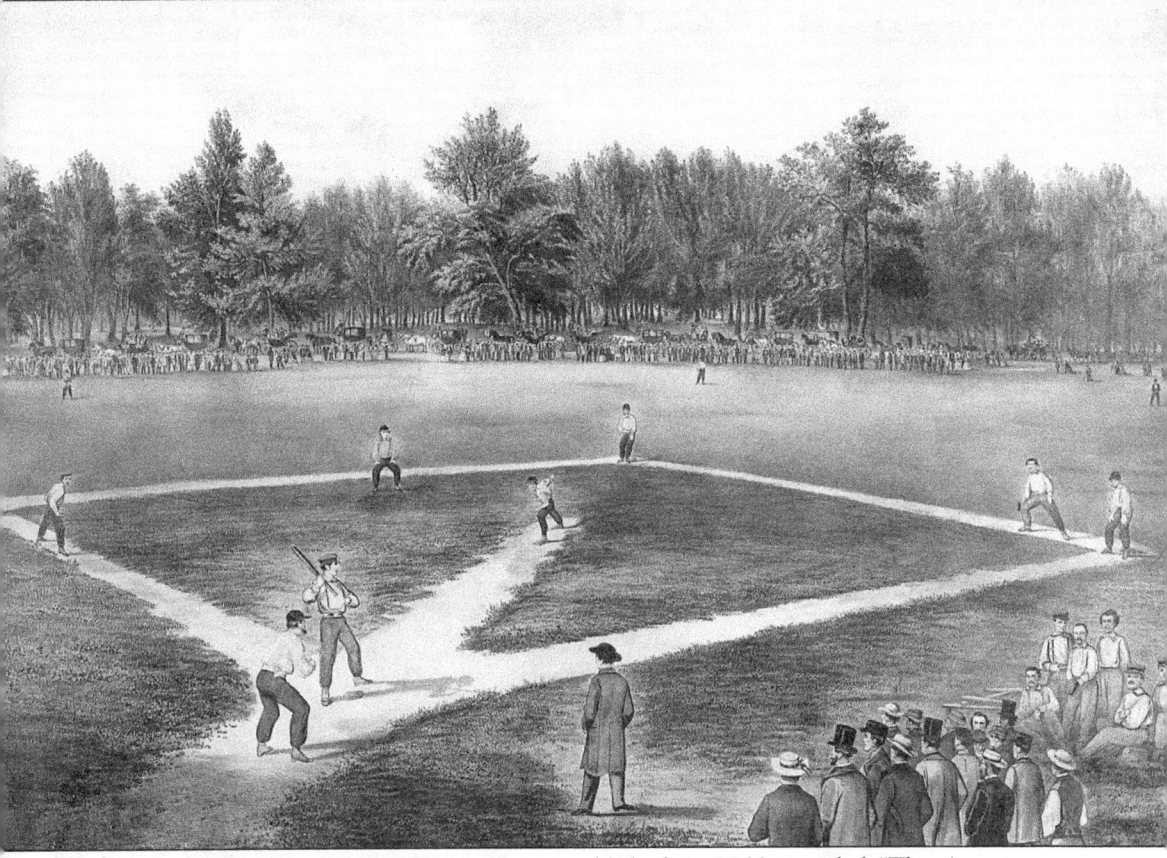

**BASE BALL 1866.** This Currier & Ives print, published in 1866, is titled "The American National Game of Base Ball: Grand Match for the Championship at the Elysian Fields, Hoboken, N.J." Baseball clubs had been playing the game in the New York City area for about 20 years before the first clubs were formed in Columbus the year after the Civil War ended.

Studying this picture reveals a lot about how baseball was played at that time. The pitching was done with an underhand delivery. The basemen played on their bases. The catcher stood a few steps behind a round home plate and received the pitch on the first bound, while the umpire stood off to the right of the plate.

The two teams are in matching uniforms. The base paths are well worn. A "championship" game has been organized, a crowd is on hand (note the ring of carriages around the perimeter of the playing field), and an artist has painted this entire scene. These factors indicate that the game was well established in New York by 1866, the year that amateur clubs first took the field in Columbus. (Author's collection.)

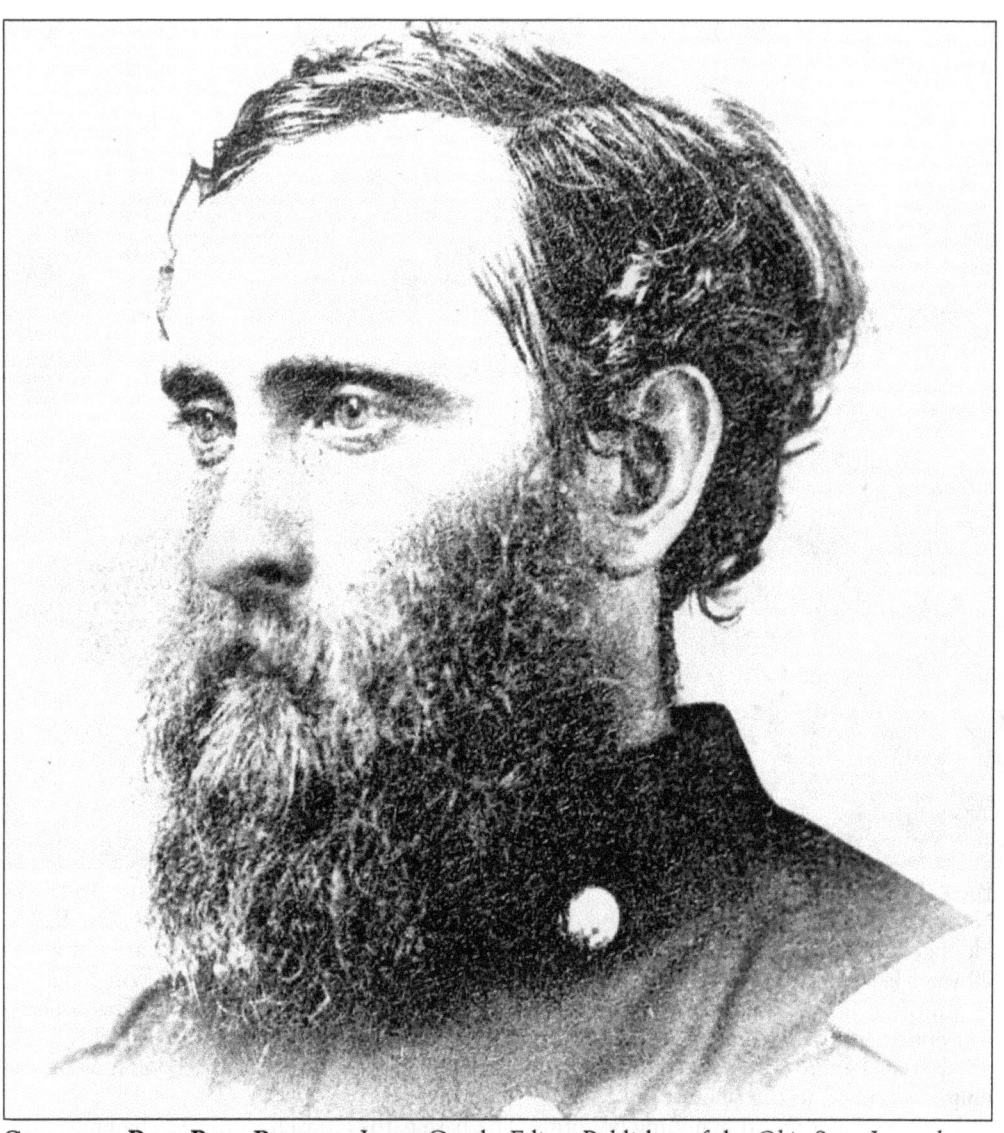

**COLUMBUS BASE BALL PIONEER.** James Comly, Editor-Publisher of the *Ohio State Journal*, was a key figure in the founding of baseball in Columbus after the Civil War. He was elected the first President of the Capital Base Ball Club in April 1866, and used his newspaper to promote all the Columbus clubs by publishing news of their meetings and games.

On April 12, 1866, under the heading "Out Door Sports," his paper reported: "We have now in this city two Base Ball Clubs, fully organized for the Summer Campaign." After the Capitals' April 14 game, the *Journal* commented, "Quite an interest was manifested in the first game played by the Capital Base Ball Club on Saturday afternoon, and in spite of the threatening state of the weather, quite a number of ladies and gentlemen were present as spectators. The scorer reports not a very good game but a 'jolly good time.'"

Comly, a leading citizen of Columbus, served with future Ohio Governor and U.S. President Rutherford B. Hayes in the Civil War as fellow officers in the 23rd Ohio. Comly and Hayes remained close personal friends and political allies after the war. President Hayes appointed Comly Minister to the Hawaiian Islands where he served with distinction from 1877 to 1881. (Library of Congress, 4192-C)

COMLY AT ANTIETAM. In early September 1862, Rutherford B. Hayes, commander of the 23rd Ohio, was seriously wounded at the battle of South Mountain. In Hayes' absence, Colonel James Comly assumed command and led the regiment at the critical battle of Antietam September 16-17, 1862. This monument on the Antietam Battlefield commemorates the contributions made by future baseball pioneer Comly and the men of the 23rd Ohio. (Author's collection.)

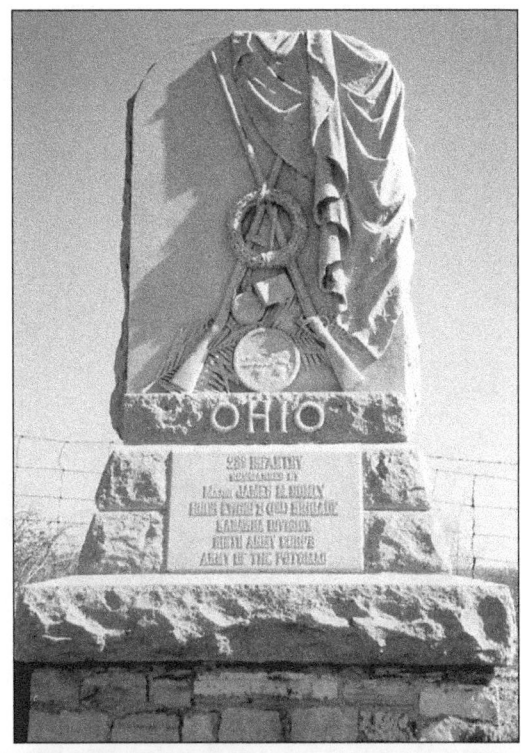

COMLY REMEMBERED. When Columbus baseball pioneer James M. Comly died in 1887, former President Hayes delivered a eulogy recalling his friend's accomplishments as a journalist, soldier, and diplomat. Comly was "a gentleman of the old school…able, honest, gallant, generous, and true." Despite his "prominent position" in public affairs, Comly was modest and reserved, qualities represented by his unpretentious stone (center foreground) in Columbus' Greenlawn Cemetery, marked simply "J.M.C." (Author's collection.)

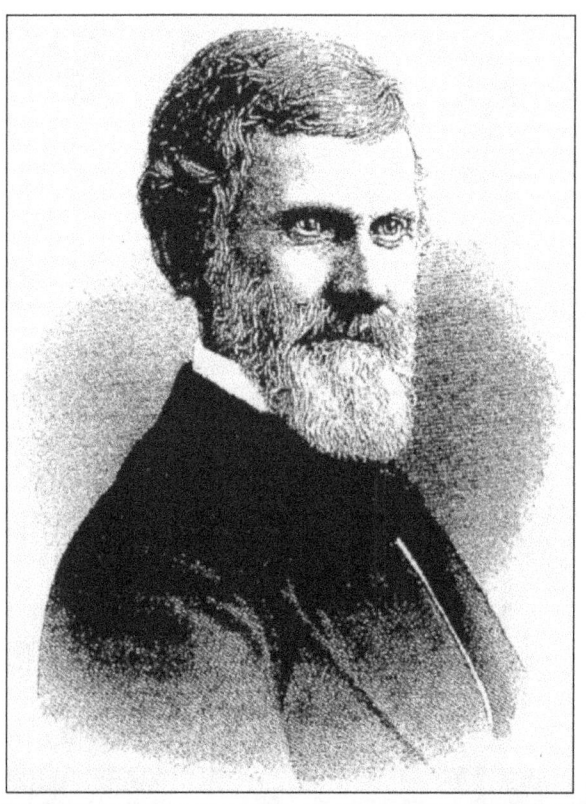

**WILLIAM PLATT.** The Capital Base Ball Club played its first game April 14, 1866, at Cleveland Avenue and Long Street, on grounds owned by William Platt, president of the gas company. The playing field was behind Platt's stately home at the northeast corner of Broad and Cleveland. Platt was the brother-in-law of future U.S. President Rutherford B. Hayes and a friend of the Capitals' first president, James Comly. (Lee, *History of Columbus*.)

**EARLY GAME SITE.** Pictured above is the corner of Cleveland and Long, site of the Capitals' first game, as it looks today. In promoting the game on Saturday, April 14, the *Journal* commented, "Quite an interesting time is anticipated." A score of 115–78 was published for the Buckeye Club's game of April 13 along with the comment, "The count shows not very good playing, but very fair for new beginners." (Author's collection.)

ALLEN G. THURMAN. In the spring of 1866, W.G. Deshler, Daniel Deshler, and Allen Thurman purchased Stewart's Grove south of the city. Thurman's son Allen W. played on the Excelsiors and young W.K. Deshler played on the Capitals. Used for baseball for several years, the land was divided into Thurman and Deshler Avenues and City Park (now Schiller Park). Thurman was later a U.S. senator and the Democratic nominee for vice president in 1888. (Lee, *History of Columbus*.)

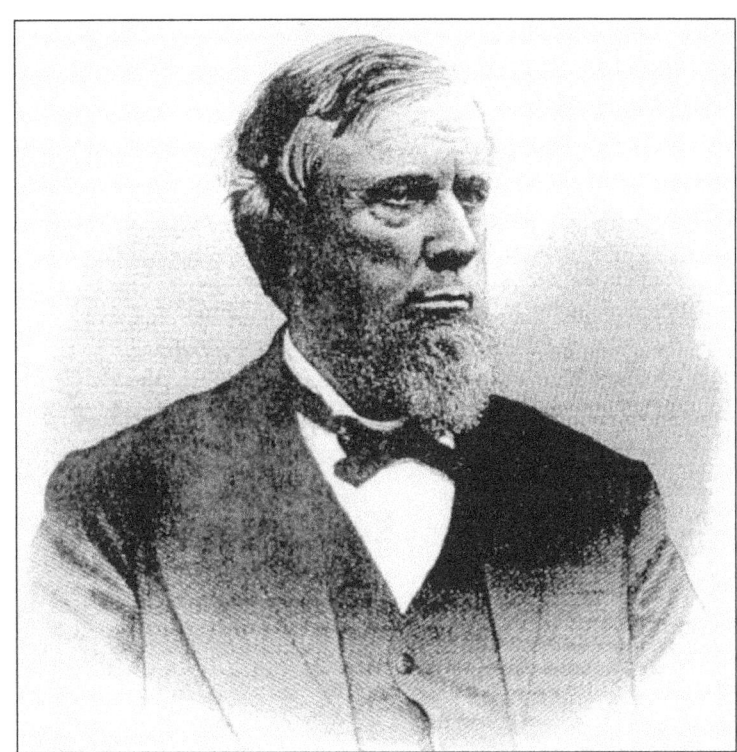

FIRST BOX SCORE. The April 25, 1866 edition of the *Ohio State Journal* carried an account of the previous day's Capital Base Ball Club game accompanied by the first published box score of a baseball game in Columbus. As was the custom of the day, only outs and runs were recorded. Both teams batted in order by position and all members participated, each side having three extra fielders. (*Ohio State Journal*.)

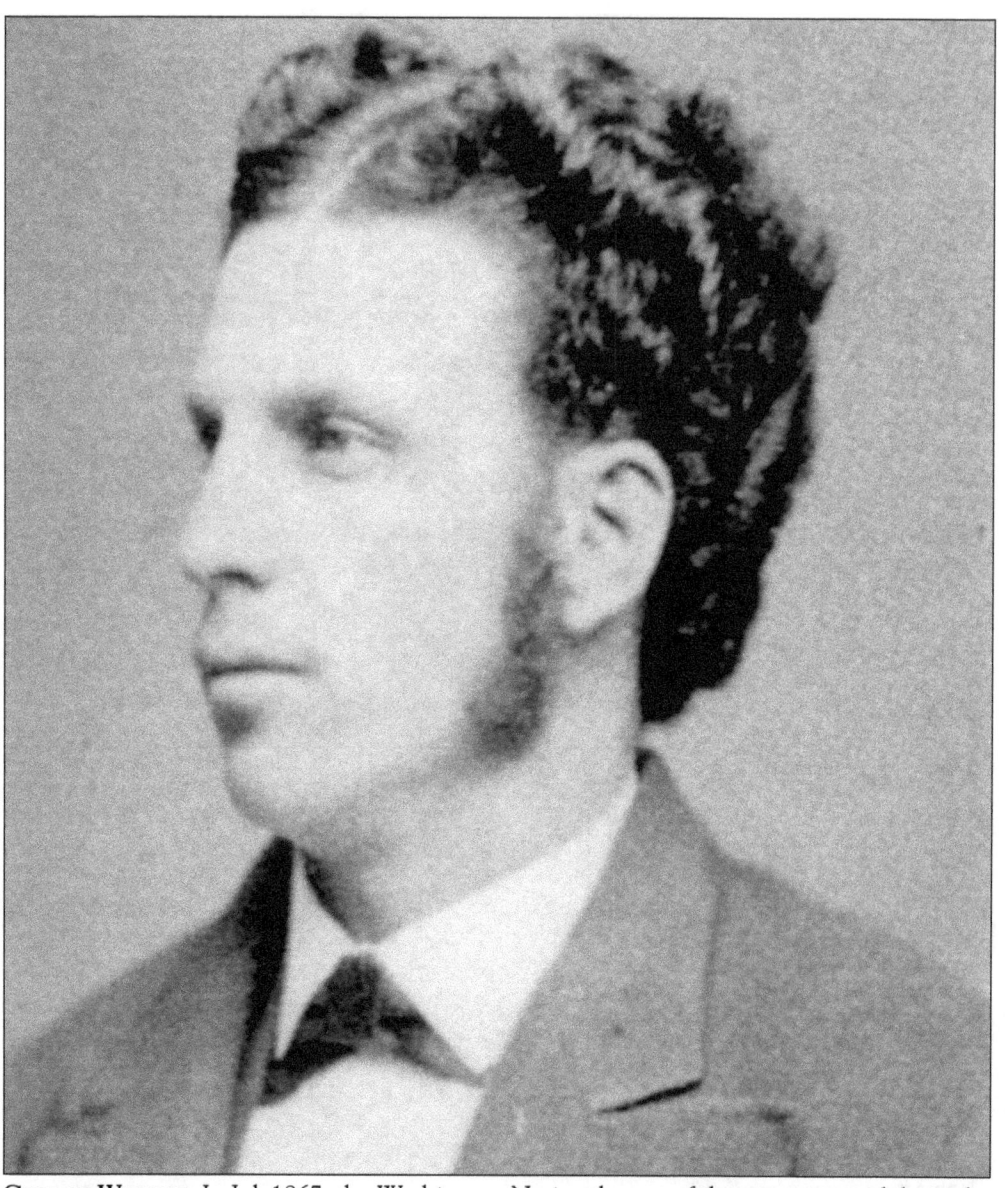

GEORGE WRIGHT. In July1867, the Washington Nationals, one of the preeminent clubs in the country, embarked by train on a ten-game "western" tour. Columbus was the first stop, followed by Cincinnati, Louisville, Indianapolis, St. Louis, Rockford, and Chicago.

When the Nationals played the Columbus Capitals at City Park, three future members of the Hall of Fame were present. George Wright, generally regarded as the finest player of his era, was in the line-up for the Nationals. George's brother, Harry Wright, captain of the Cincinnati Reds Stockings, came up from the Queen City to umpire the game and escort the Nationals to their next stop. Henry Chadwick, the first baseball sportswriter and inventor of the box score, known during his lifetime as "The Father of Baseball," accompanied the Nationals as official scorer. In recognition of their contributions to the game, all three are enshrined at Cooperstown.

Chadwick awarded the Capital players and the Columbus crowd "the palm of superiority for their deportment on the ground. We have never seen more creditable conduct at a ball match than was shown on this occasion." (Road West Publishing.)

## BATTING SCORE.

| CAPITAL. | O. | R. | NATIONAL. | O. | R. |
|---|---|---|---|---|---|
| E. Williams, 1st b. | 3 | 1 | Parker, 2d b. | 2 | 11 |
| Baker, r. f. | 3 | 1 | Robinson, l. f. | 1 | 11 |
| King, 2d b. | 3 | 1 | Wright, c. | 2 | 9 |
| Dolson, c. | 3 | 1 | Fox, 3d b. | 2 | 10 |
| Elliott, c. f. | 1 | 2 | Studley, r. f. | 2 | 11 |
| F. Williams, 3d b. | 3 | 1 | Fletcher, 1st b. | 1 | 12 |
| Douty, l. f. | 0 | 3 | Smith, s. s. | 2 | 10 |
| J. Williams, p. | 3 | 0 | Berthrong, c. f. | 3 | 9 |
| Dawson, s. s. | 1 | 0 | Williams, p. | 6 | 7 |

| INNINGS. | 1st. | 2d. | 3d. | 4th. | 5th. | 6th. | 7th. |
|---|---|---|---|---|---|---|---|
| Capital | 2 | 2 | 0 | 3 | 0 | 3 | 0—10 |
| National | 7 | 14 | 7 | 21 | 18 | 5 | 18—90 |

Bases on hits—E. Williams 1, Baker 0, King 0, Dolson 1, Elliott 2, F. Williams 0, Douty 3, J. Williams 1, Dawson 2—total by Capital, 10. Parker 10, Robinson 7, Wright 10, Fox 5, Studley 7, Fletcher 11, Smith 9, Berthrong 8, Williams 6—total by National, 73.

## FIELDING SCORE

Fly catches—Elliott 3, Baker 1, E. Williams 1, King 1—total by Capital, 6. Fox 2, Wright 2, Robinson 1, Parker 1—total by National, 6.

Foul bound catches—By Dolson 2. By Wright 3.

Base play—Put out—By E. Williams 6, King 2, Dolson 2—total by Capital, 12. Assisted by King 5 times, J. Williams 2, Dawson 2, Dolson 1, F. Williams 1. Put out—By Fletcher 5, Fox 1, Wright 1, Parker 1—total by National, 8. Assisted by Fox 2, Williams 2, Parker 1, Smith 1, Fletcher 1, Wright 1.

Run out—Williams, by F. Williams.

Double plays—By Fletcher and Wright, and by Fox and Fletcher.

Out on strikes—Put out—By Wright 2, by Fletcher 2.

Clean home runs—Wright 2, Fletcher 2, Studley 1.

**WASHINGTON 90, COLUMBUS 10.** While the score of the 1867 game between the Nationals and the Capitals was a lopsided victory for the touring club, it was not the devastating defeat that a modern score of that nature would represent. In other games on the western tour, the Nationals won by comparable scores of 88–12 at Cincinnati, 88–21 at Louisville, 106–26 at Indianapolis, and 113–26 at St. Louis. Also, high scores were common in that day. Later that summer, the Capitals beat the Excelsiors 45–27, and then topped the Railroad Club 74–42 at the Franklin County Fair.

It should also be remembered that the Capitals and the other Columbus clubs were true amateurs, while the elite clubs in the East had taken steps toward professionalism. The best players in the country were attracted to clubs like the Nationals by salaries or by "jobs" for which no work was required other than playing on the baseball team. Despite the score, it was a great day for baseball in Columbus. Local citizens were honored to host the renowned National Club, and, as Henry Chadwick observed in his published account of the game, scoring 10 runs against the Nationals was a considerable accomplishment for the Columbus club. (*The Ball Players' Chronicle*.)

FIRST BASEBALL HERO. In July 1867, Jimmy Williams was the starting pitcher for the Capitals against the mighty National Club of Washington. Columbus historian Alvin K. Peterjohn has observed that because of his excellent play in 1866 and 1867, "the town had its first baseball hero in Jimmy Williams, the Capitals' fine pitcher." The energetic and innovative Williams enjoyed a long career as a field manager, league organizer, and executive in the majors and minors. (Courtesy Joe Santry.)

UNION STATION. Built in 1850, the station stood on North High Street in the area of the present Convention Center. Henry Chadwick wrote that when the Washington Nationals arrived by train on July 12, 1867, "a large crowd of the [baseball] fraternity were there to welcome them, including President Scarrett [Scarritt], of the Capital Club. At once the visitors entered stages and were escorted to the principal hotel of the city, the O'Neil [Neil] House." (*The Story of Columbus.*)

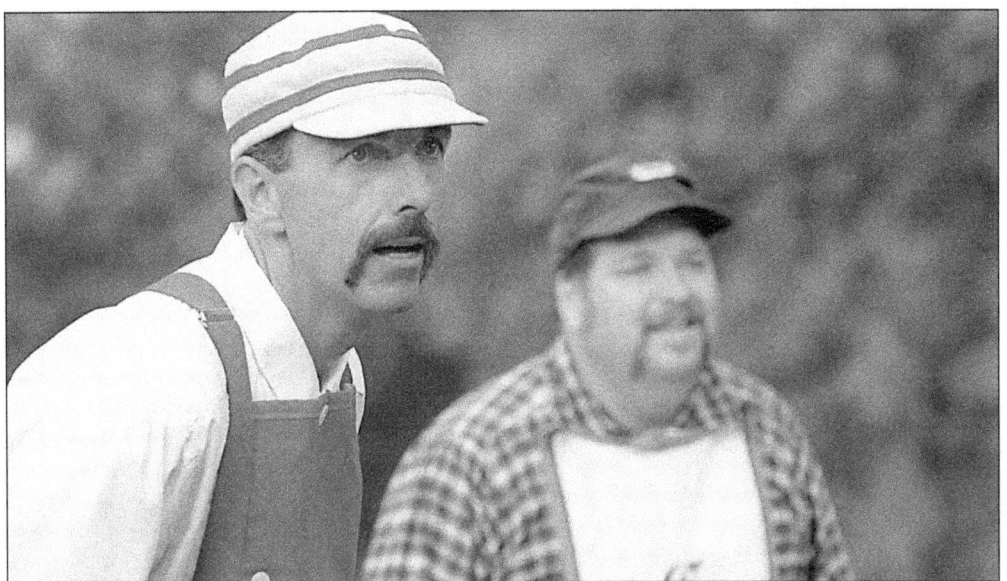

THE NATIONALS RETURN. The visit of the Washington Nationals to Columbus in July 1867 was re-created in July 2002 on the grounds where the original game with the Capitals took place. The Nationals (in white) were portrayed by the Ohio Historical Society's vintage team, the Ohio Village Muffins. The Capitals of old (in plaid) were portrayed by new Capitals, a team organized in 1997 on the model of the original club. (Dan Trittschuh, Suburban News Publications.)

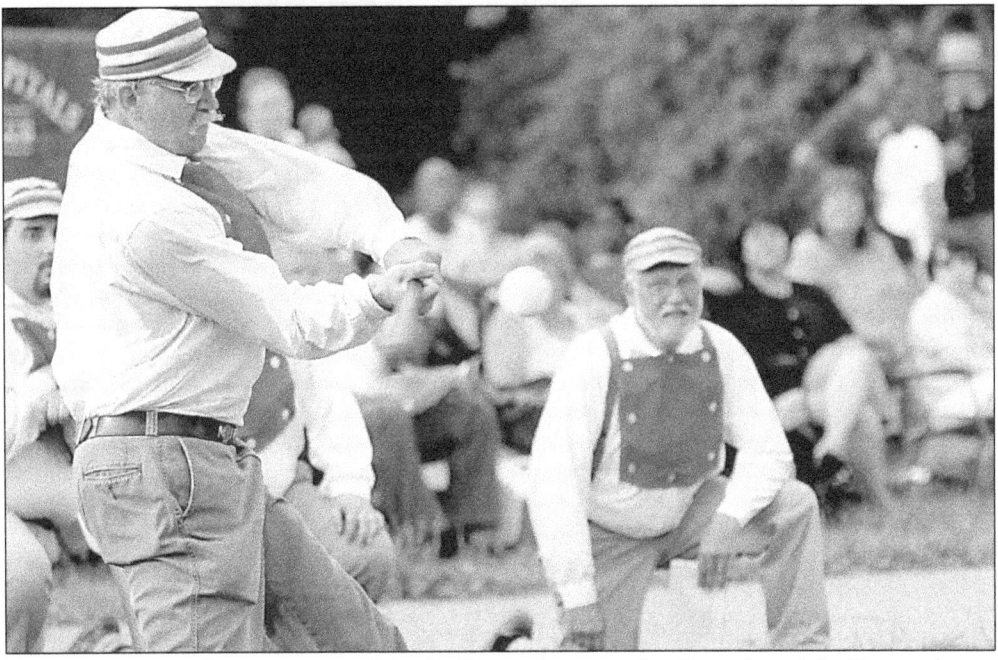

STEPPING BACK. The re-creation of the 1867 game between the Capitals and the Nationals, co-sponsored by the two participating vintage teams and the German Village Society, encouraged the large and enthusiastic crowd to step back in time 135 years. The event enabled spectators to learn about the early game and consider life in Columbus when baseball was emerging as the national pastime. (Dan Trittschuh, Suburban News Publications.)

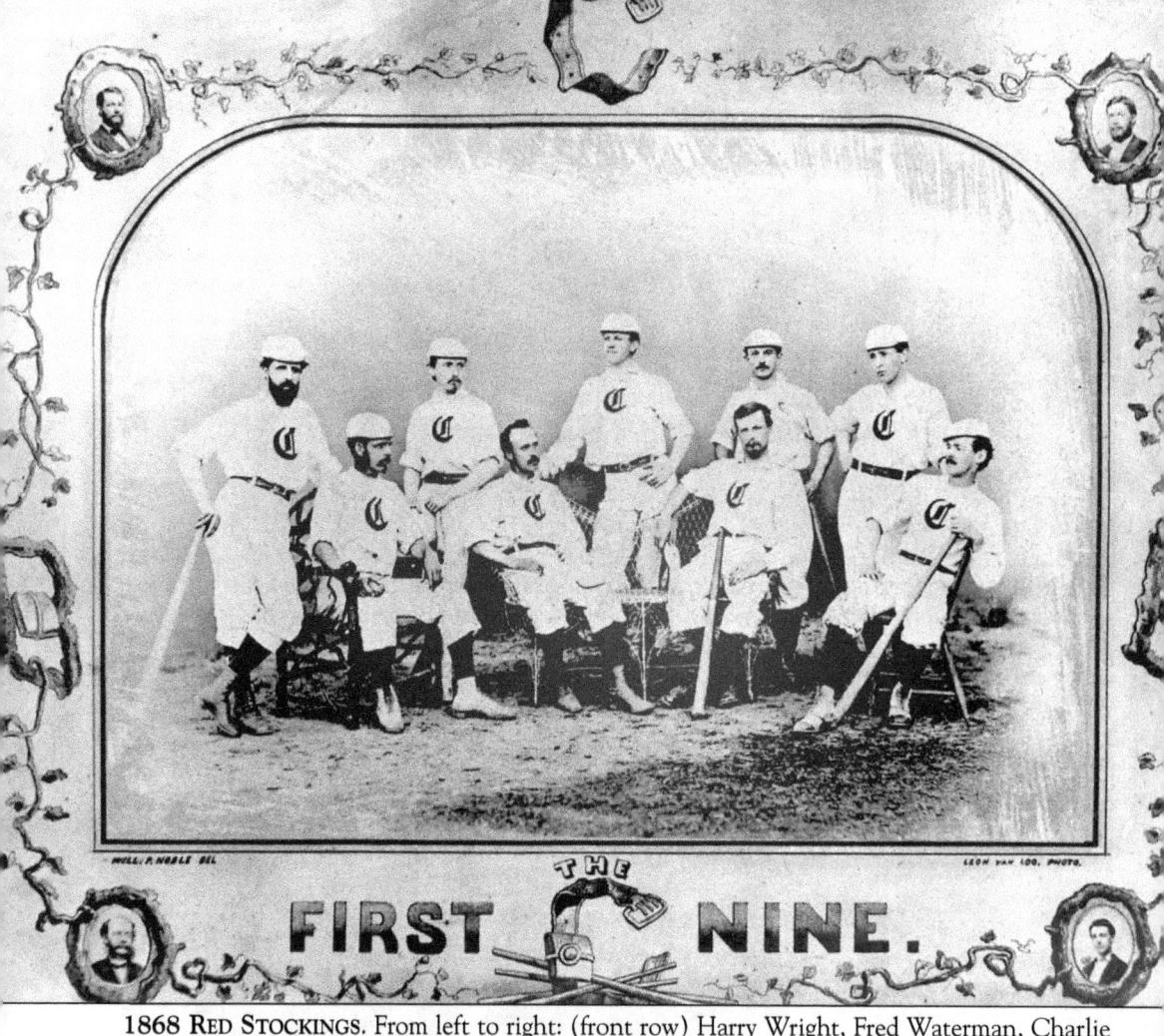

**1868 RED STOCKINGS.** From left to right: (front row) Harry Wright, Fred Waterman, Charlie Gould, and Moses Grant; (second row) Asa Brainard, J. William Johnson, John Hatfield, Rufus King, and John How.

When the Washington Nationals defeated the Cincinnati Red Stockings 53–10 in 1867, the officers of the club authorized captain and center fielder Harry Wright to begin hiring experienced players who could beat the established eastern clubs. In August 1868, the powerful Red Stockings came to Columbus to play the Railroad Club and the Capitals. The *Journal* provided this description of the new home grounds of the Capitals at Olentangy Park: "The circling rows of carriages with the inner rows of spectators seated or standing; the members of the clubs in their uniforms; the stars and stripes and the colors of the two clubs flying from the staff—all these made a pretty picture, call it a base ball scene or what you will."

Cincinnati beat the Capitals 43–5. The next year, Harry Wright retained the nucleus of the 1868 club while adding brother George Wright and several other experienced professionals. The product of his efforts was the one of the legendary baseball teams of all time, the undefeated (57–0) national champion Cincinnati Red Stockings of 1869, the country's first openly all-professional team. (Road West Publishing.)

# Two

# PROFESSIONALS TAKE OVER

By the early 1870s, local enthusiasm for baseball had begun to wane. When clubs from other cities adopted the practice of hiring professional players, it was clear that the still-amateur Columbus clubs could not compete with them. In addition, a cholera epidemic in the summer of 1873 caused local citizens to avoid crowds, resulting in a decline in baseball attendance and interest.

According to historian Alvin K. Peterjohn, Jimmy Williams, who pitched for the Columbus team when the Washington Nationals came to town in 1867, stepped forward to lead a revival of baseball enthusiasm. In 1874, he reorganized the Buckeye Club. The Buckeyes had a fairly successful year in 1875 playing games around the state, and late in the season added their first two paid professional players. In 1876, the year the country celebrated its centennial and the National League was founded, Williams and the leadership of the Buckeyes decided to field a completely professional club. Captained by New Yorker Billy Barnie, the all-professional Buckeyes, dressed in white uniforms with brown trim, played on the grounds near the Union Station on North High Street.

In 1877, Jimmy Williams organized the seven-city International Association, which is generally recognized as the first minor league. Over time, Williams became known as the "Father of Minor League Baseball." He strengthened his Columbus team by adding pitcher Jim McCormick and young Mike Kelly, both of whom went on to considerable success in the majors. McCormick won 265 games during his career and catcher-outfielder "King" Kelly is enshrined in Cooperstown.

A new major league was formed in 1881: the American Association. With franchises in Cincinnati, Louisville, Philadelphia, Pittsburgh, St. Louis, and Baltimore, it began play in 1882. After its inaugural season, the new league expanded from six to eight clubs, with Jimmy Williams securing a franchise for the Columbus Buckeyes. The New York Metropolitans were the other new team. With Henry T. Chittenden as club president, Columbus had joined the major leagues.

In 1883, Columbus' first major league team finished sixth (32-65) in the eight-team Association, as the Philadelphia Athletics won the pennant. Columbus' best pitcher, Frank

Mountain, had 57 complete games and won 26, but also lost 33. The 1884 Columbus team, managed by Columbus native Gus Schmelz, showed remarkable improvement. For most of the season, they led the league, but injuries to key players caused them to fall to second late in the year.

The Columbus team's home field was Recreation Park, a wooden structure that seated 1,550, located near Parsons and Mound. Today the site of Columbus' first major league ballpark has been paved over by the major highway interchange known locally as the I-70/I-71 split. Thousands of vehicles whir by that spot every day, their occupants unaware that they are driving over a former major league baseball field.

Although the Buckeyes almost won the pennant, Columbus lost its major league franchise after the 1884 season, in part because the city's blue laws prohibited baseball games on Sunday, the day most teams drew their biggest crowds. Columbus fielded minor league teams in 1887 and 1888. Using the wood from the old Recreation Park, a new Recreation Park was constructed in the area bounded by Kossuth, Ebner, Schiller (now Whittier) and Jaeger in what is now German Village.

When Cleveland dropped out of the American Association after the 1888 season to join the National League, Columbus club president Conrad Born and vice president Ralph Lazarus, with the support of Jimmy Williams, secured the open franchise spot—and major league baseball returned to Columbus in 1889. Recreation Park's seating capacity was increased to 5,000 and Al Buckenberger was hired as manager of the new Columbus team called the Solons. Despite excellent hitting by first baseman Dave Orr and extraordinary pitching by Mark Baldwin, the team finished sixth.

Labor problems between players and management resulted in the formation of the Players' League in 1890. Many established major league stars jumped from the American Association and the National League to this new third major league. Columbus lost its two best players—Orr and Baldwin—but the surprising Solons, with Gus Schmelz returning as manager, improved significantly and finished second to Louisville in 1890.

The Players' League folded after the 1890 season. The American Association was also experiencing financial and organizational problems. Allen W. Thurman of Columbus, an infielder on the Excelsiors in 1866 and the son of Senator Allen G. Thurman, was elected president of the Association. Billy Barnie, catcher and captain of Columbus' first professional team in 1876, was the Association's vice president. Thurman's term was brief, however, as serious policy differences with club owners led to his departure in February 1891.

The 1891 season was the last one for the American Association. The Columbus Solons, weakened when several key players jumped to the National League, slipped to sixth in the final standings. When the American Association ceased operations at the end of season, the major league era ended in Columbus.

Over the next few years, Columbus teams played in the Western League and Interstate League. This era of instability would end with the creation of a new top-level minor league, the American Association (not to be confused with the former major league of the same name), which began play in 1902 with Columbus as a charter member.

BILLY BARNIE. When Columbus fielded its first professional team in 1876, the catcher was 23-year-old New Yorker Billy Barnie. He made it to the majors in 1883 when he became the player-manager of the Baltimore club of the American Association and continued piloting the Orioles until the AA folded after the 1891 season. He managed five more seasons in Washington, Louisville, and Brooklyn. (Library of Congress, Prints and Photographs Division, 13163-05, no.327.)

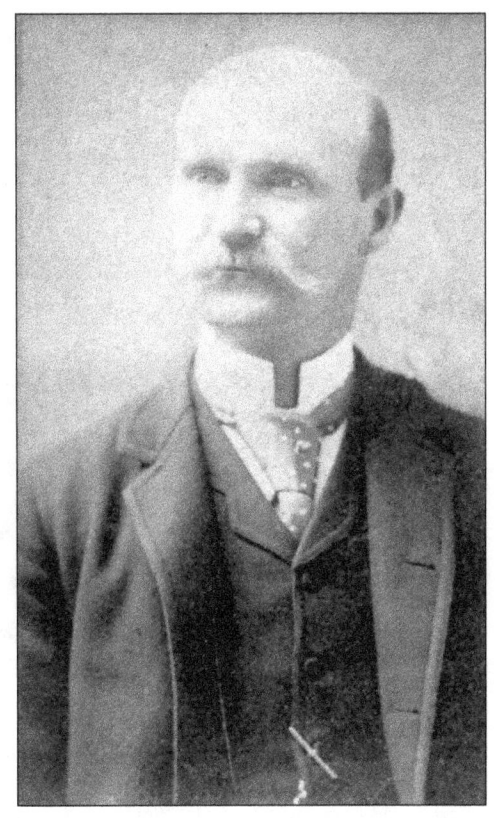

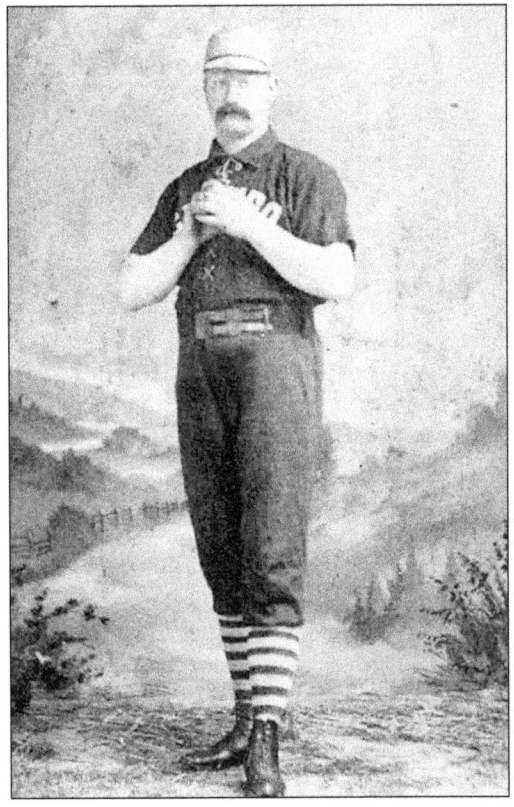

STARTING PITCHER. The pitcher in Columbus' first professional team game in 1876 was Ed "The Only" Nolan, who went on to pitch for five different teams in the majors. The leading pitcher for Columbus in 1877 was Jim McCormick (left), who became an eight-time 20-game winner in the majors. McCormick won 45 with 72 complete games for Cleveland in 1880. (Library of Congress, Prints and Photographs Division, 13163-05, no. 66.)

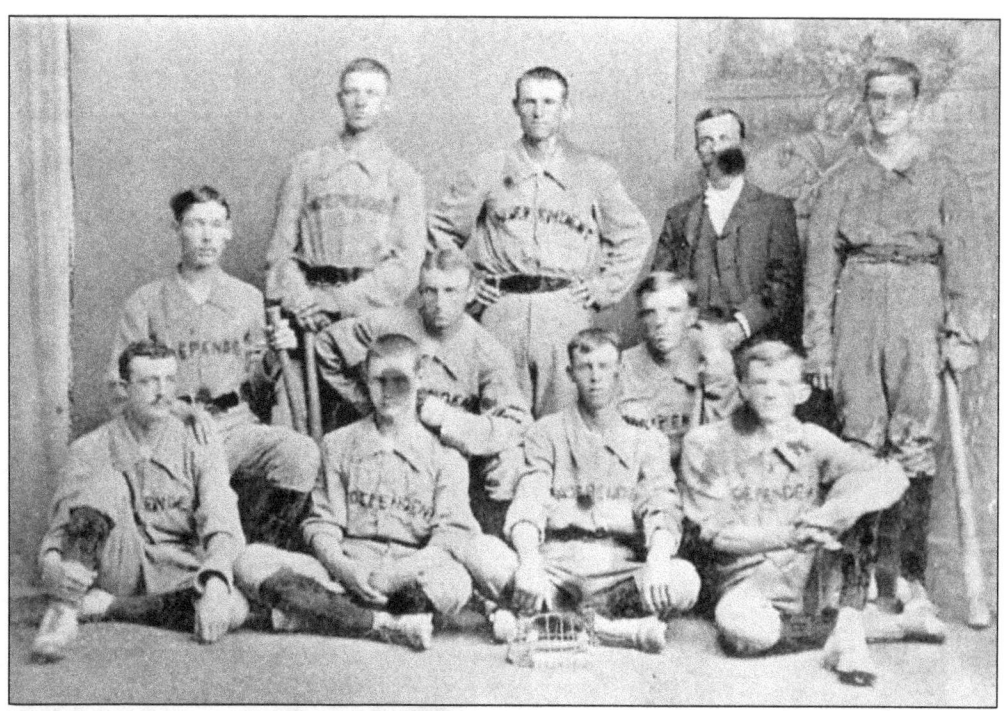

**DEAF SCHOOL NINE.** Pictured above is the Deaf School baseball team of 1879. Ed "Dummy" Dundon (front row, right) later pitched in the major leagues for the Columbus Buckeyes of the American Association in 1883 and 1884, going 6–4 for the strong 1884 team. Dundon also filled in at first base and the outfield. (Columbus Circulating Visuals Collection, Columbus Metropolitan Library.)

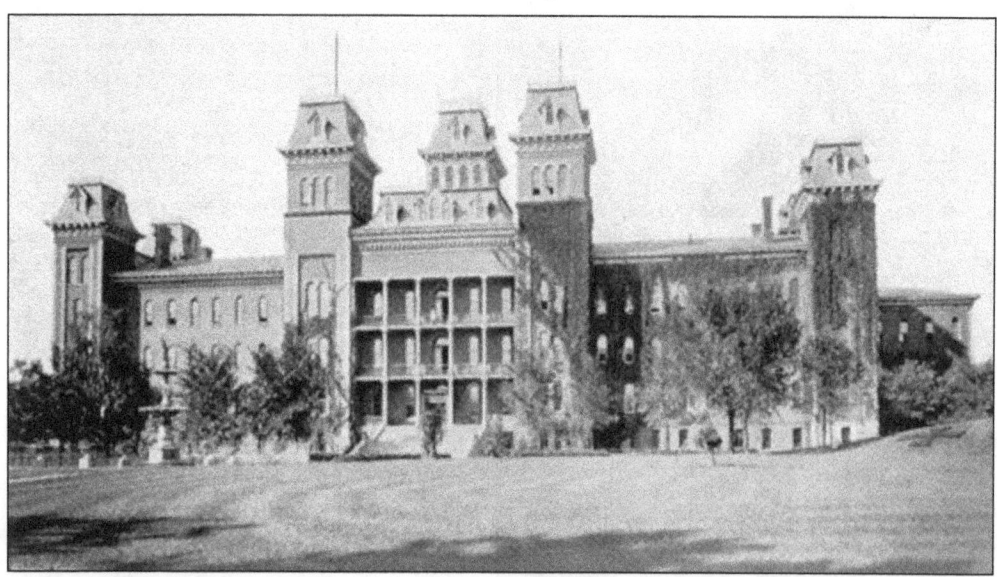

**THE OLD DEAF SCHOOL.** The "Deaf and Dumb Asylum," as it was called at the time, was located on East Town Street between Sixth (now Grant) and Washington, the present location of the topiary park. Ed Dundon, who pitched for the Columbus major league entry in 1883 and 1884, was employed at the school at the time he joined the team. (*The Story of Columbus.*)

**HORACE PHILLIPS.** When the Columbus Buckeyes joined the major leagues in 1883, Horace Phillips of Salem, Ohio, was selected as the non-playing manager. He had managed the Troy team in the National League in 1879. After one season in Columbus, Phillips went to Pittsburgh of the American Association where he managed six more years (1884-89). (Columbus Circulating Visuals Collection, Columbus Metropolitan Library.)

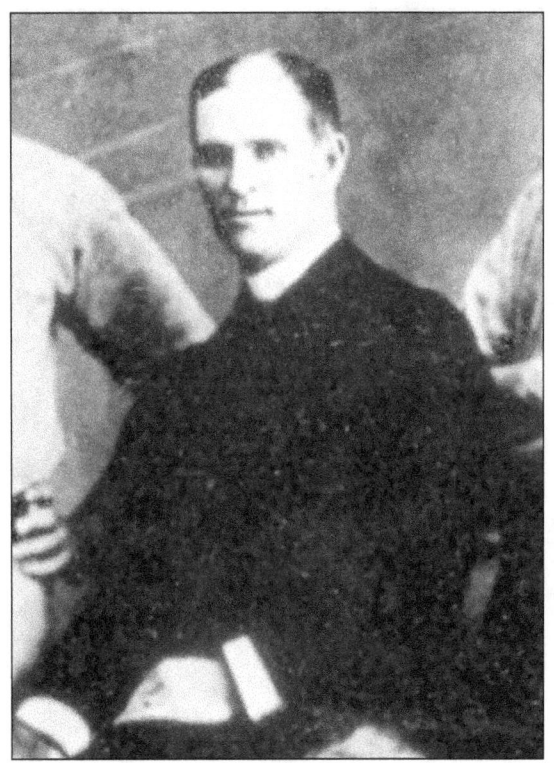

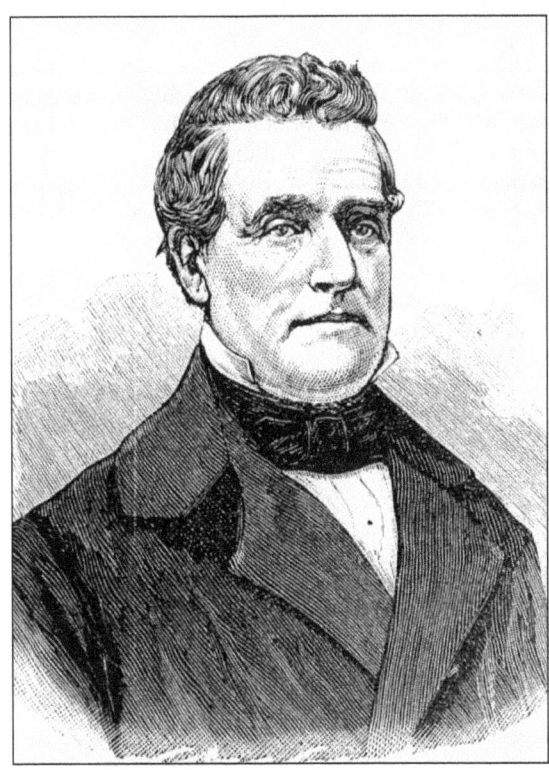

**CHARLES C. WALCUTT.** Franklin County Surveyor from 1859 to 1861, Walcutt rose to the rank of general during the Civil War. He helped organize Columbus' first professional team, the 1876 Buckeyes. He became Mayor of Columbus in 1883, the year that Columbus joined the major leagues as part of the American Association. (Columbus Circulating Visuals Collection, Columbus Metropolitan Library.)

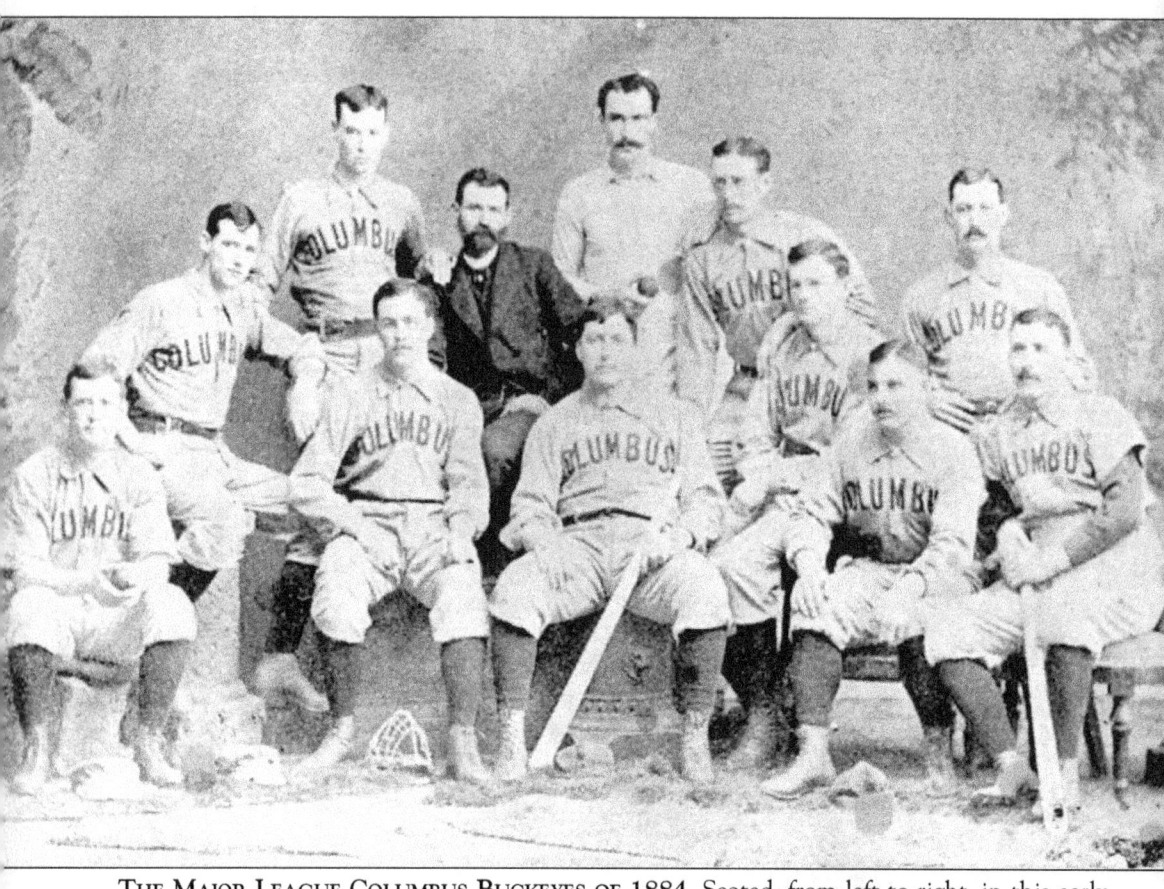

THE MAJOR LEAGUE COLUMBUS BUCKEYES OF 1884. Seated, from left to right, in this early season photograph are pitcher Ed "Cannonball" Morris, right fielder Tom Brown, catchers Fred Carroll and Rudy Kemmler, pitcher Ed Dundon, third baseman Willie Kuehne, and center fielder Fred Mann. In the back row, first baseman Jim Field leans on the shoulder of Manager Gus Schmelz (business suit), pitcher Frank Mountain (holding ball) leans on second baseman Charles "Pop" Smith, and shortstop and captain John Richmond stands at the right behind Kuehne and Mann.

Columbus fielded a strong team in the American Association in 1884, finishing with a record of 69–39. The Buckeyes led the 13-team league for much of the season before finishing second to the New York Metropolitans. Morris (34–13, 2.18 ERA) and Mountain (23–17, 2.45 ERA) were a formidable one-two punch—starting 93 of the team's 108 games—with Columbus native Dundon filling in capably (6–4, 3.78 ERA) when needed. (Columbus Circulating Visuals Collection, Columbus Metropolitan Library.)

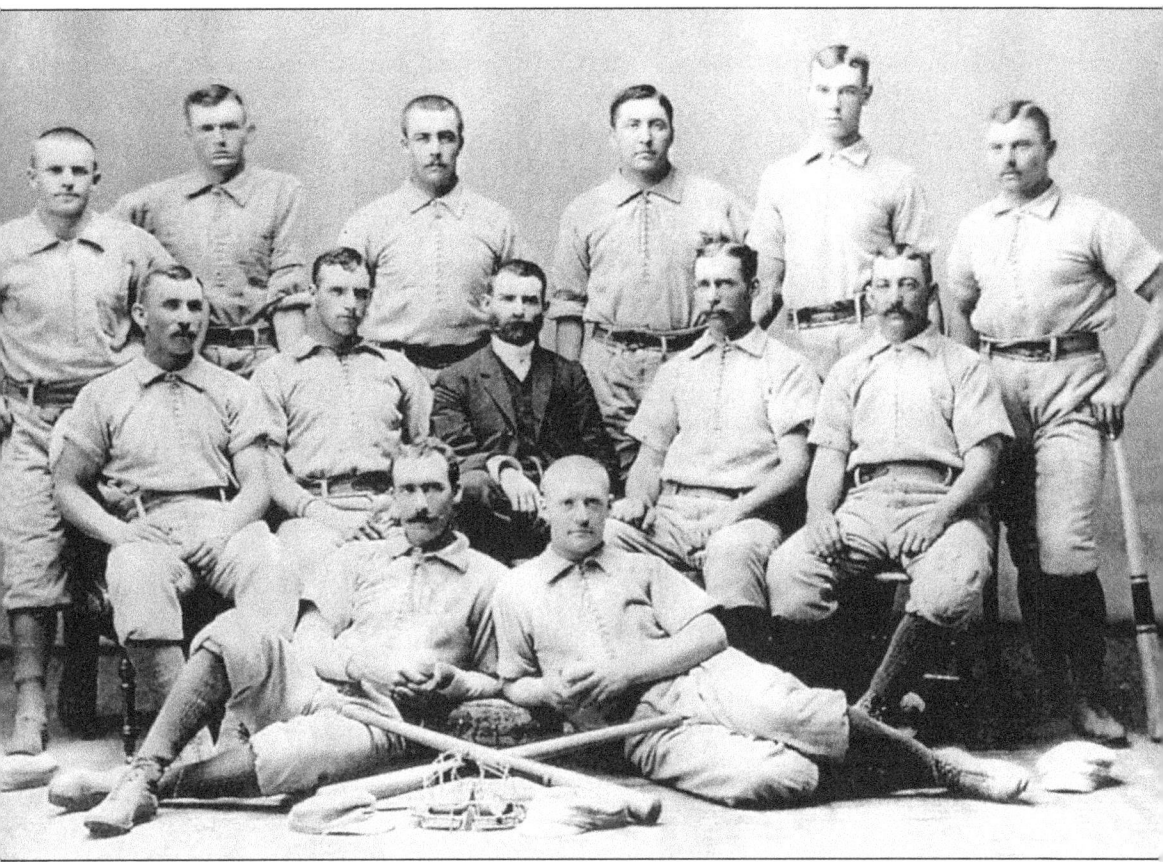

**THE 1884 COLUMBUS BUCKEYES.** From left to right: (front row) Frank Mountain and Ed Morris; (middle row) Fred Mann, Tom Brown, Gus Schmelz, Pop Smith, and John Richmond; (back row) Patsy Cahill, Ed Dundon, Fred Carroll, Rudy Kemmler, Jim Field, and Willie Kuehne.

The Buckeyes wore uniforms of pearl gray with blue trim in their second season in the majors. After finishing sixth in 1883, Columbus upgraded its roster over the winter, adding pitcher Ed "Cannonball" Morris and catcher Fred Carroll. The newly acquired Morris and 1883 holdover Mountain both pitched no-hitters in 1884, one of the few times in major league history that two pitchers from the same team have hurled no-hit games in the same season. Due to the Buckeyes' strong showing in 1884, games at Recreation Park on the city's south side drew good crowds.

Internal wrangling over finances had led to the departure of manager Horace Phillips after the 1883 season. Local favorite Jimmy Williams had already taken the job as manager in St. Louis, so ownership hired Gus Schmelz of Columbus to manage the Buckeyes in 1884. (Toledo-Lucas County Public Library, Ralph Lin Webster Collection.)

FRED MANN. When Columbus obtained a major league franchise for 1883, Mann was acquired and became the club's regular center fielder. A productive hitter during Columbus' first two years in the majors, Mann was among the league leaders in doubles and triples in 1883, home runs and slugging percentage in 1884. (Library of Congress, Prints and Photographs Division, 13163-05, no. 408.)

FRED CARROLL. A valuable addition to the Columbus club in 1884, Fred Carroll shared catching duties with Rudy Kemmler and also played in the outfield. Only 19 when he joined the Buckeyes, Carroll's .278 batting average led the '84 team. He continued to play in the majors in Pittsburgh from 1885 to 1891, compiling a career average of .284. (Library of Congress, Prints and Photographs Division, 13163-02, no. 32.)

**VISITING STARS.** When Columbus became a major league city in 1883, local fans had the opportunity to see the leading players of the day at Recreation Park. Tim Keefe of the New York Metropolitans won both games of a July 4 double header in Columbus in 1883, allowing a total of only 3 hits. Keefe won 342 games and was elected to the Hall of Fame in 1964. (Author's collection.)

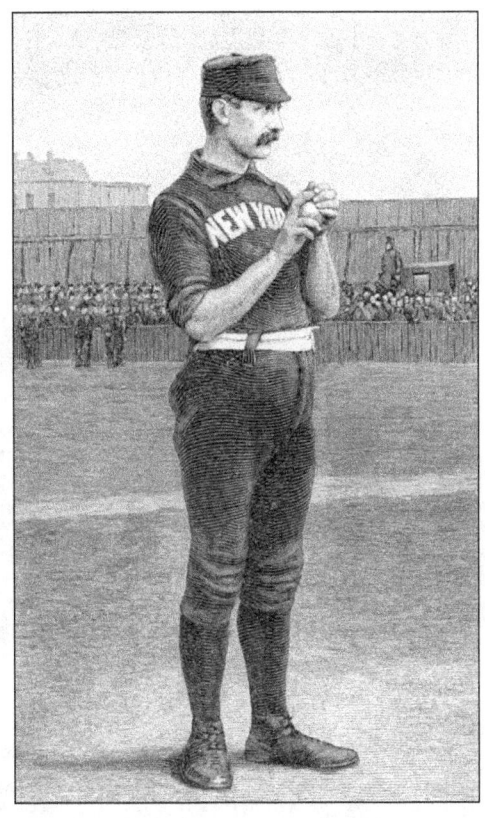

**WILLIE KUEHNE.** The regular third baseman for the Columbus Buckeyes during the city's first two years in the major leagues (1883 and 1884) was Willie Kuehne. When Columbus lost its franchise, Kuehne continued to play in the majors in Pittsburgh from 1885 to 1890. In 1891, he returned to play for the Columbus Solons and his old manager, Gus Schmelz. (Library of Congress, Prints and Photographs Division, 13163-05, no. 285.)

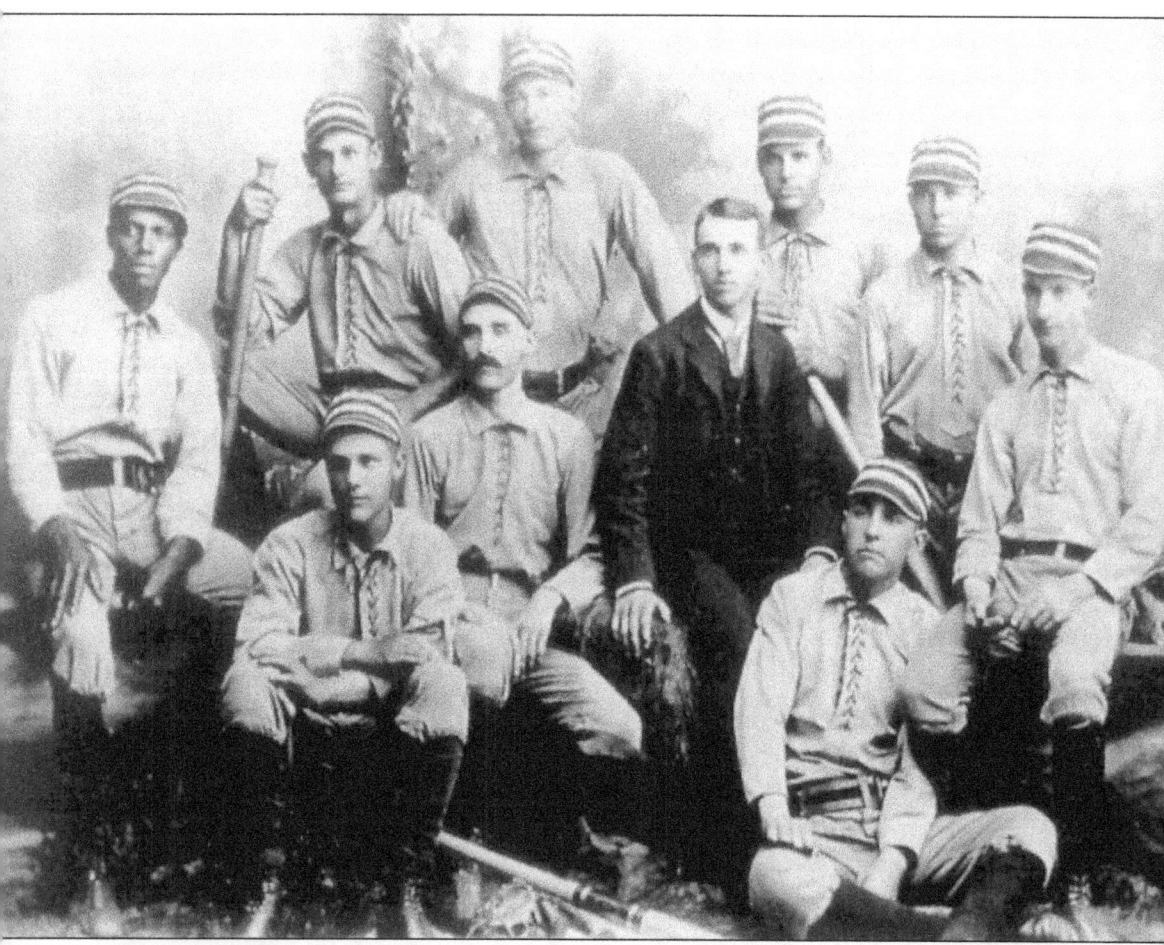

**1887 BUCKEYES.** After two years without professional baseball, in 1887 Columbus entered the Ohio State League, which included Akron, Canton, Mansfield, Sandusky, Steubenville, Zanesville, Kalamazoo and Wheeling. This is believed to be a photo of the 1887 Columbus team, whose roster included a player identified in box scores as J. Higgins, the first African-American to play for a professional team in Columbus. (Columbus Circulating Photo Collection, Columbus Metropolitan Library.)

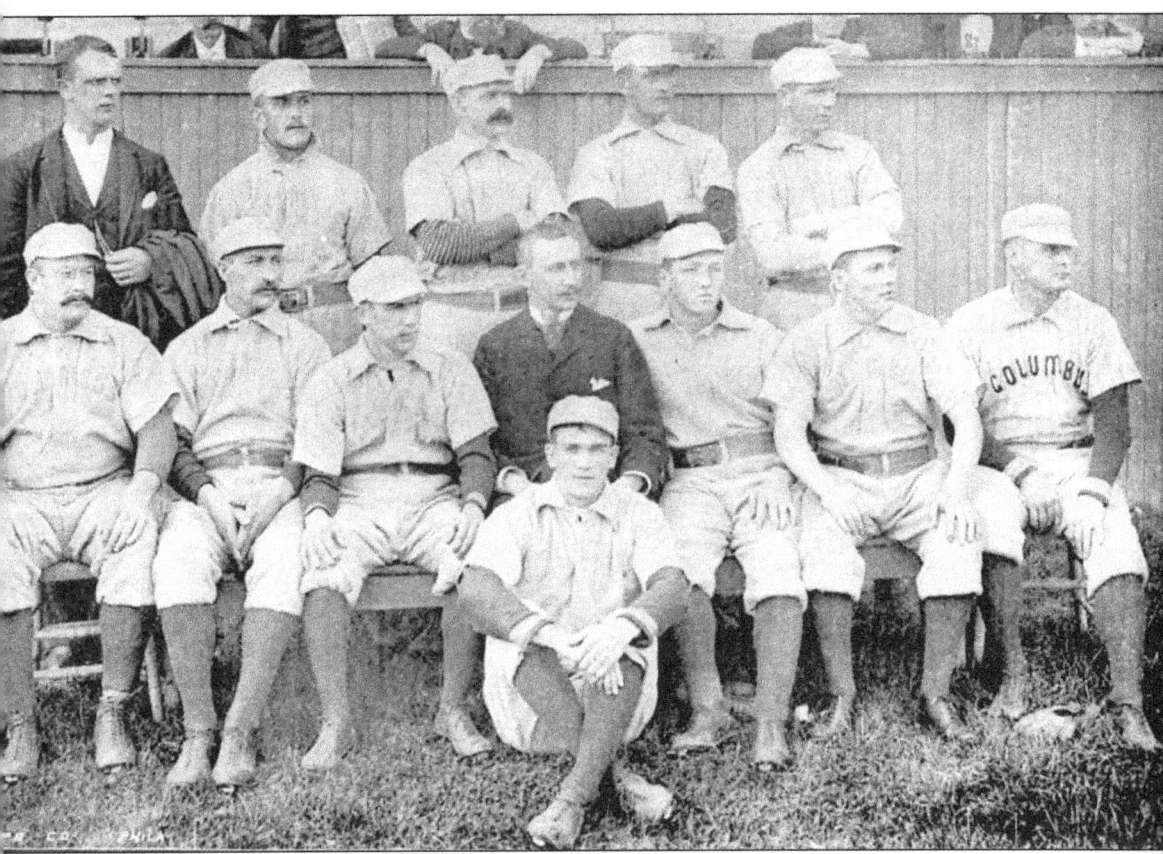

THE 1889 COLUMBUS SOLONS. From left to right: (up front) pitcher Al Mays (?); (middle row) first baseman Dave Orr, shortstop Henry Easterday(?), second baseman Bill Greenwood, Manager Al Buckenberger, utility player "Dirty" Jack Doyle, catcher Jack O'Connor, and outfielder Spud Johnson; (back row) pitcher Mark Baldwin (in street clothes), second baseman Jack Crooks, outfielder Jim McTamany, pitcher Hank Gastright, and outfielder Ed Daily(?). Team members not pictured are third baseman Lefty Marr, third baseman-shortstop Heinie Kappel, pitcher Bill Widner, and catchers Jim Peoples and Ned Bligh.

Columbus re-entered the major leagues in 1889 as a member of the American Association. The Solons compiled a winning record at home (36–33), but did not do well on the road. The club's overall mark of 60–78 resulted in a sixth place finish. Brooklyn won the 1889 pennant followed by St. Louis, Philadelphia, Cincinnati (piloted by former Columbus Manager Gus Schmelz), Baltimore, Columbus, Kansas City, and Louisville. The Solons played at Recreation Park II, located in the German Village area. (Author's collection.)

**WORKHORSE HURLER OF 1889.** Columbus pitching ace Mark "Fido" Baldwin was acquired prior to the season from Cap Anson's Chicago White Stockings. He won 27 games for the second-division Columbus team, leading the American Association with 368 strikeouts and a phenomenal 513.2 innings pitched. In his seven-year major league career he won 156 games, all before his 30th birthday. (Library of Congress, Prints and Photographs Division, 13163-05, no. 31.)

**DAVE ORR.** The top hitter for Columbus in 1889 was burly first baseman Dave Orr (pictured here as a New York Metropolitan in 1887). "Big Dave" was among the league leaders in 1889 in hits, doubles, triples, and RBI. Orr had compiled a career average of .342 when a stroke suddenly ended his great career at age 30 in 1890. (Library of Congress, Prints and Photographs Division, 13163-02, no. 42.)

**RECREATION PARK II.** The Columbus Solons of the major league American Association played their home games during the 1889, 1890, and 1891 seasons at Recreation Park II. Labeled "base ball park" on this 1890 map of Columbus, Recreation Park II was located on the site now occupied by the Big Bear super market that serves German Village. (Josiah Kinnear map, Ohio Historical Society.)

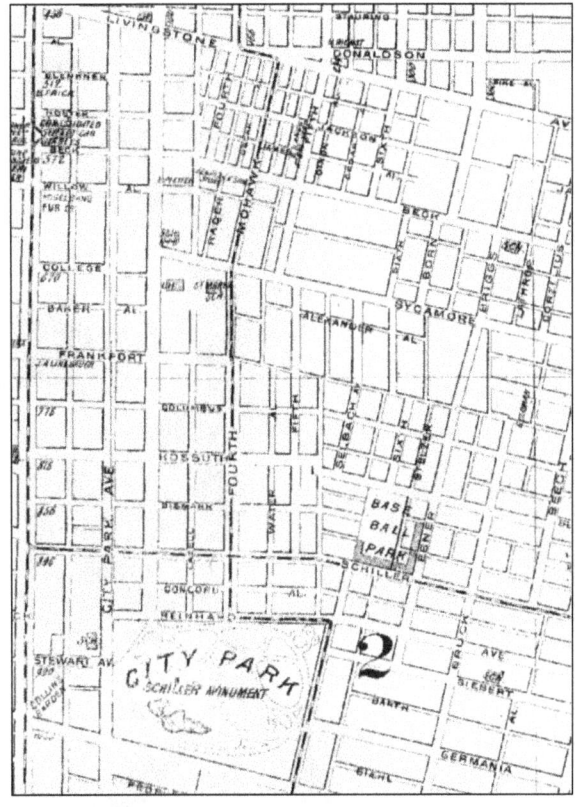

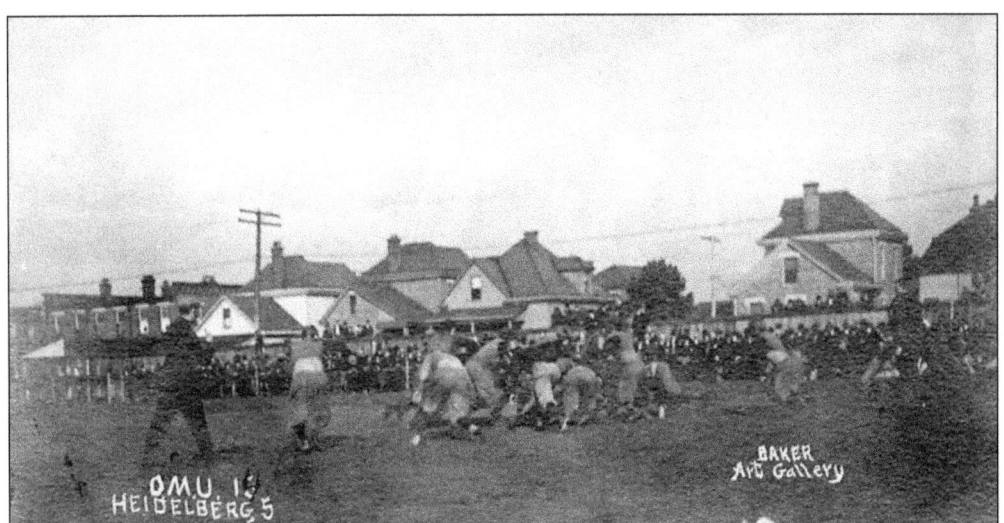

**RECREATION PARK.** This photo, taken during a college football game between the Ohio Medical University and Heidelberg, is one the few surviving pictures of Recreation Park II, the home field of Columbus' major league baseball team. From the perspective of the grandstand, the outfield fence can be seen behind the players and spectators. (Courtesy Richard E. Barrett.)

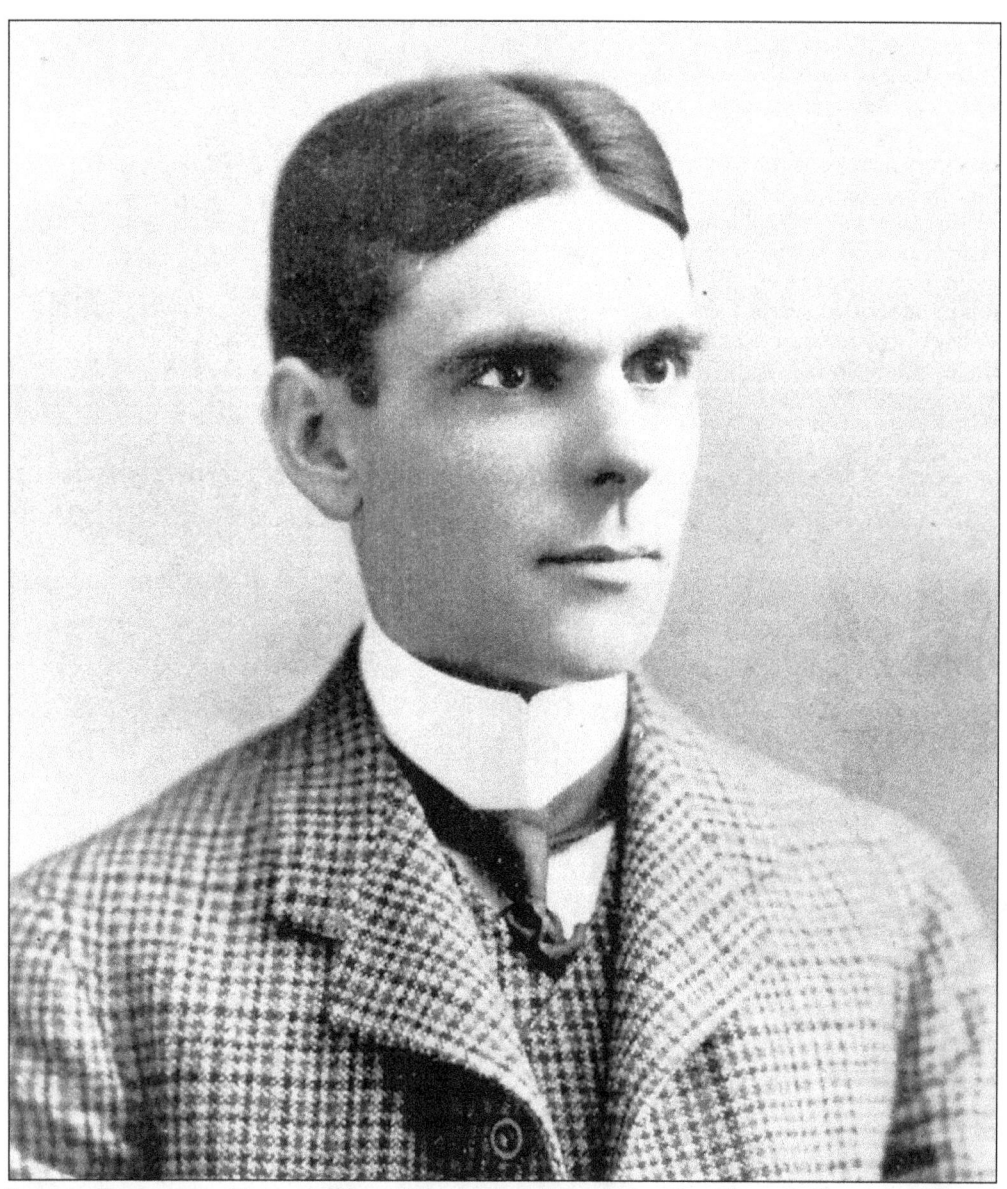

LEAGUE PRESIDENT. Ernest S. "Barny" Barnard graduated from Otterbein College in 1895, and then coached the football and baseball teams for three years. He is considered the "father" of Otterbein athletics. After his years at Otterbein, he coached the Ohio Medical College football team before becoming sports editor of the *Columbus Dispatch* in 1900. In 1903, he became traveling secretary for the Cleveland club of the American League and was promoted to the post of vice-president and general manager of the Indians in 1908. Barnard's Indians overcame the tragic death of shortstop Ray Chapman during the 1920 season and went on to win the American League pennant. Cleveland then beat Brooklyn 5 games to 2 in the World Series.

Barnard became president of the Indians in 1922. When the owners ousted American League founder Ban Johnson in 1927, Barnard was selected to succeed him as league president. Having done an excellent job for three years, his appointment as American League president was extended in 1930 for five more years. He was not able to serve out his term, however, passing away at the Mayo Clinic in 1931. (Otterbein College.)

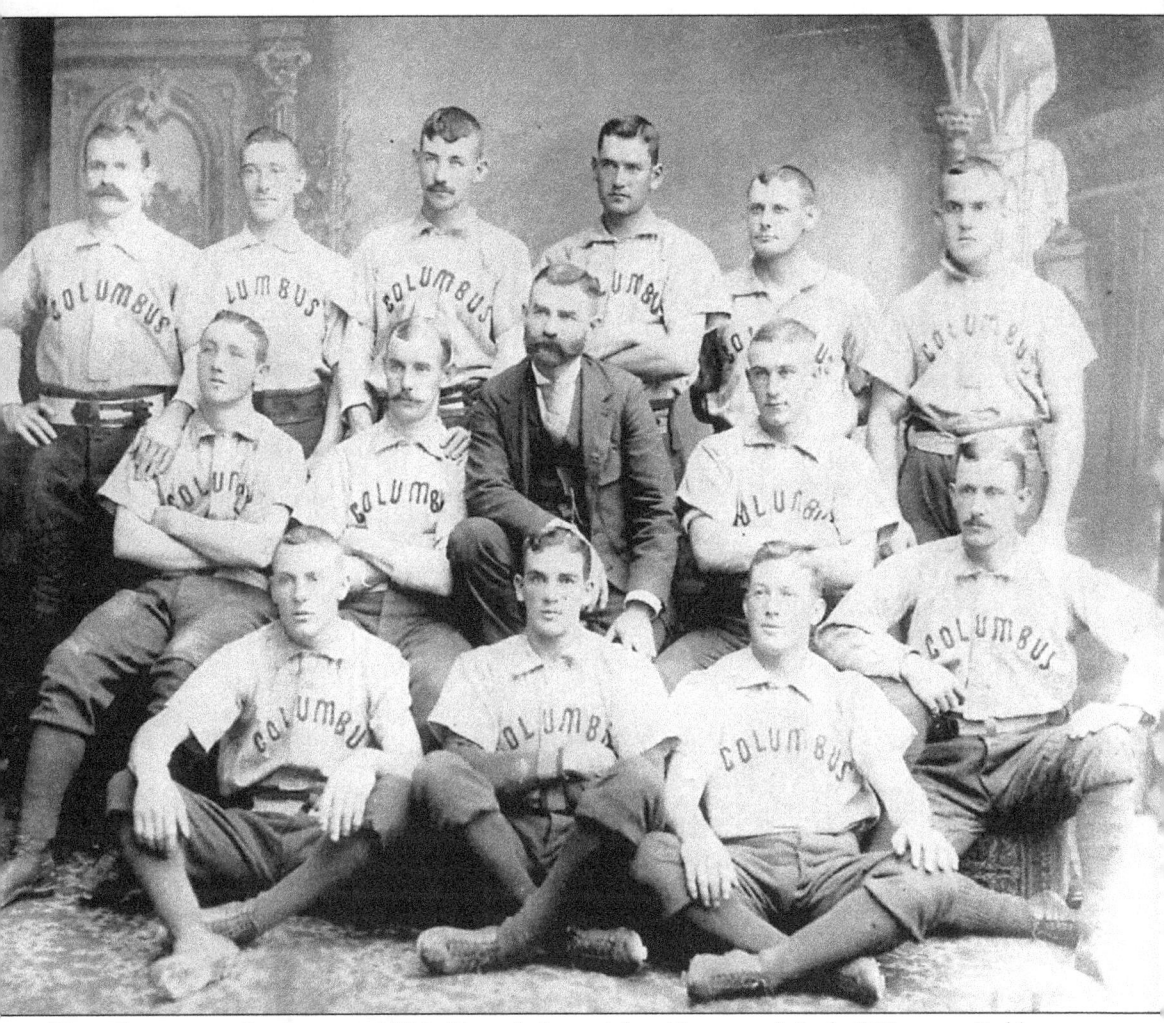

THE COLUMBUS SOLONS OF 1890. From left to right: (front row) Jack O'Connor, Bobby Wheelock, John Easton, and John Sneed; (middle row) Jack Doyle, Bill Widner, Gus Schmelz, and Icebox Chamberlain; (back row) Jim McTamany, Frank Knauss, Mike Lehane, Hank Gastright, Spud Johnson, and Jack Crooks.

Columbus' prospects for winning the American Association pennant in 1890 declined when their best pitcher, Mark Baldwin, and best hitter, Dave Orr, jumped to the new Players League. Despite this setback, the Solons improved from sixth to second, with a record of 79–55. When the Solons got off to a slow start, Manager Al Buckenberger was let go, and Gus Schmelz, who had led the Columbus team in 1884, returned to his hometown to manage the team. Columbus finished strong under Schmelz, but was unable to overtake pennant-winning Louisville.

Outfielder Spud Johnson hit .346 and was among the league leaders in hits and slugging percentage. Jim McTamany led the league with 140 runs scored. Catcher Jack O'Connor hit .324. Thirty-game winner Hank Gastright led the pitching staff, which included Frank Knauss (17 wins), John Easton (15 wins), and the ambidextrous Icebox Chamberlain (12 wins). In October, Gastright pitched an eight-inning no-hitter at Recreation Park in a game called because of darkness. (Columbus *Citizen*, Scripps-Howard Newspapers/Grandview Heights Public Library/Photohio.org.)

**WILD BILL.** Bill Widner, a native of Cincinnati, pitched for Columbus in 1889 and 1890. His statistics indicate how he came by his nickname, "Wild Bill." He won 12 games for the Solons in 1889, but over his five-year career in the majors he walked more batters than he struck out. (Columbus *Citizen*, Scripps-Howard Newspapers/Grandview Heights Public Library/Photohio.org.)

**NED BLIGH.** Catcher Ned Bligh came to the Columbus Solons from the Cincinnati Reds for the 1889 season and got into 28 games in a reserve role. In 1890 he played with both Columbus and the Louisville Cyclones, who won the American Association pennant. Bligh died of typhoid fever at age 26 in his hometown of Brooklyn, New York, in April 1892. (Library of Congress, Prints and Photographs Division, 13163-05, no. 349.)

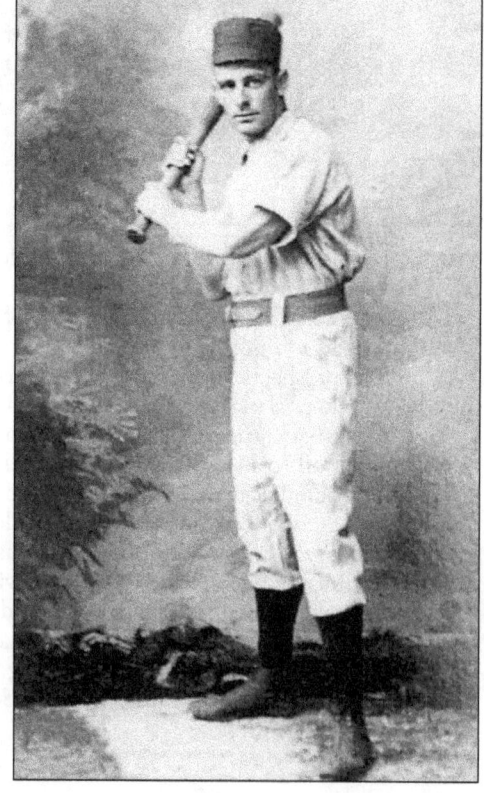

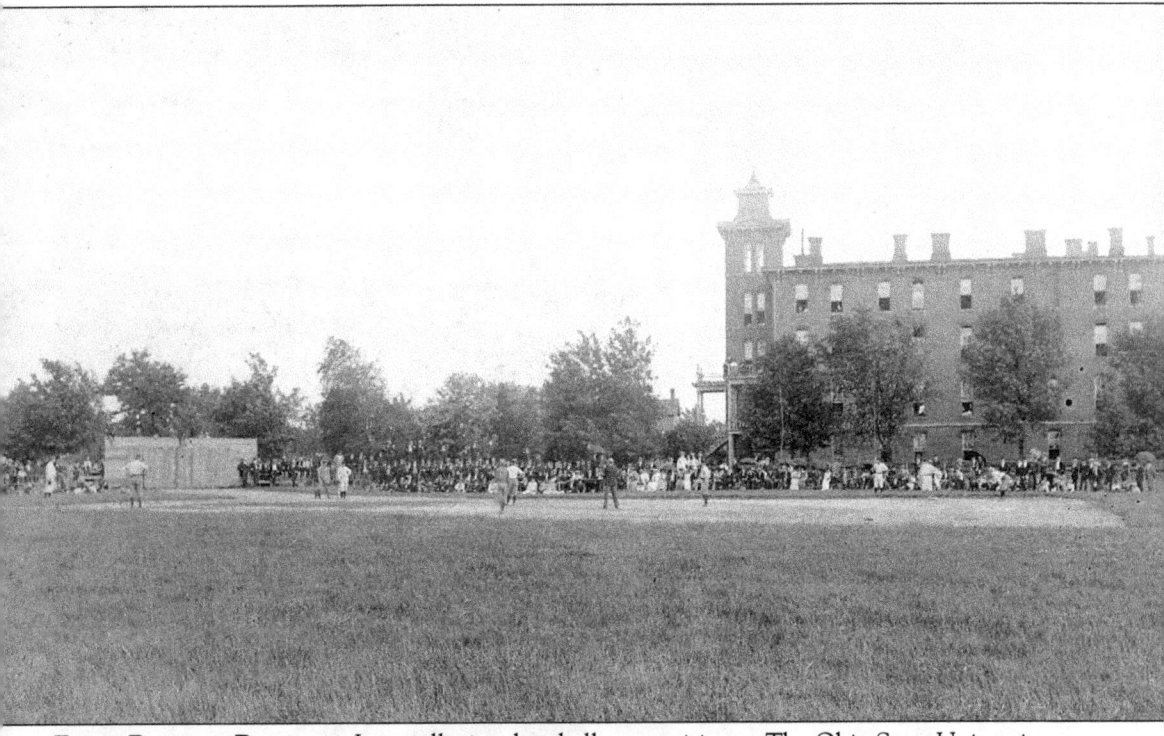

EARLY BUCKEYE BASEBALL. Intercollegiate baseball competition at The Ohio State University dates from 1881, when the Buckeye nine defeated Capital University 8–5 in its only game of the year. Eight years would pass before the university fielded its first football team. The baseball game in this photograph was played in either 1891 or 1892. It is taking place on the university's main athletic field on the west side of Neil Avenue at the corner of 11th Avenue, across from the present location of Oxley Hall.

The large building in the background was the North Dormitory. Note the solid wooden backstop near Neil Avenue. Wooden stands, seating about 200, stood on the south (third base) side of the field.

The first baseball "coach" was the recent Ohio State graduate Kip Selbach of Columbus. A player for the major league Washington team, Selbach was hired in 1896 for the month of March to get the team ready for the season. Subsequent practices and games were under the direction of the student captain. In the early years, baseball was played in both the spring and the fall. (The Ohio State University Archives, 144.)

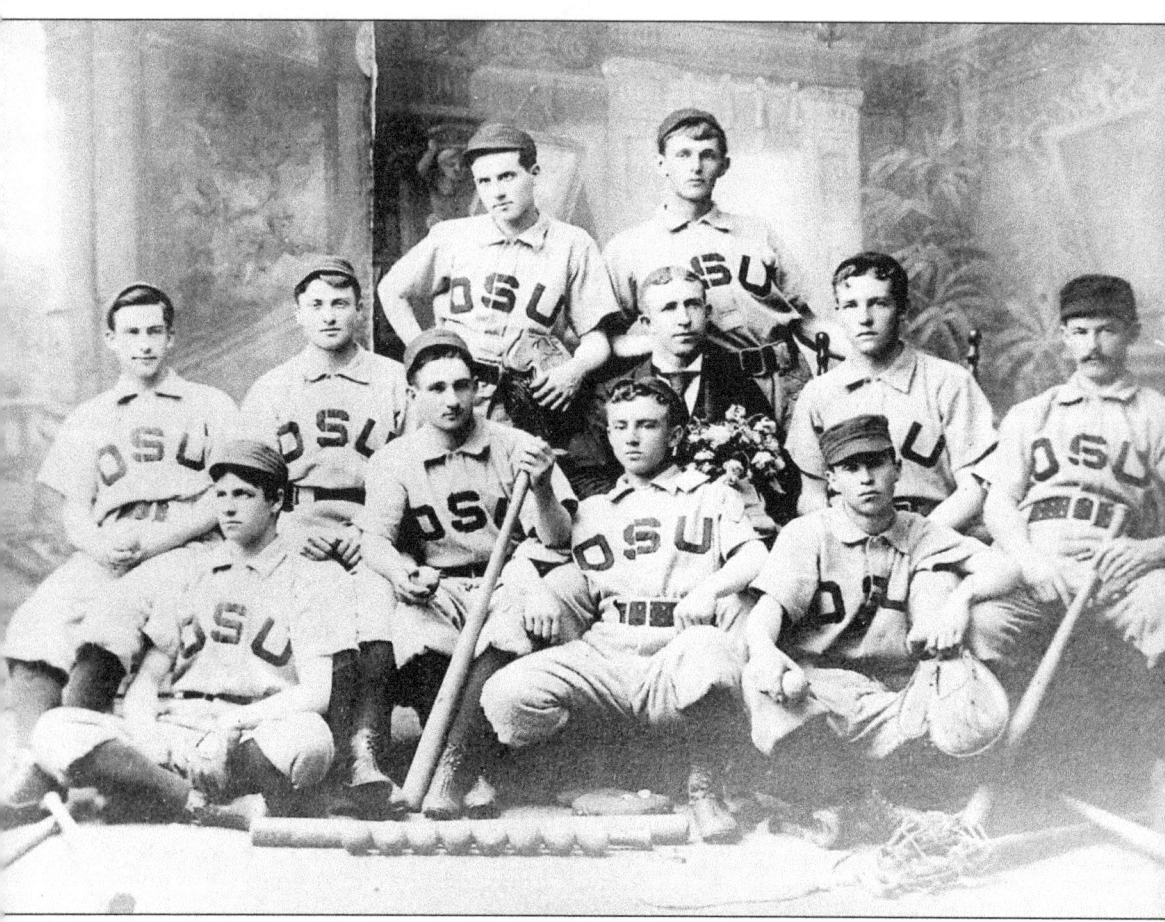

**THE 1892 OHIO STATE TEAM.** This Buckeye nine claimed the championship of an athletic group formed in 1890 consisting of Denison, Kenyon, Buchtel (Akron), Wooster, and Ohio State. The Buckeyes also played other Ohio colleges such as Wittenberg, Capital, and Ohio Wesleyan during these years. According to Athletic Department records, this 1892 team defeated Capital University 44–2, a total that still stands as the record for the most runs scored in a game by an Ohio State team.

In *Ohio State Athletics, 1879-1959*, university historian James Pollard reports that in 1895 enough students went out for baseball to form two teams. The first nine wore "the regulation scarlet and gray, while the second team have secured the uniforms of the old Columbus professional team." Pollard points out that the star of the 1895 team, Elisha "Effie" Norton, pitched in the major leagues the following year for the Washington Senators. On the Senators, Norton would have been a teammate of fellow former Buckeye Kip Selbach. Coincidentally, the Washington manager was Gus Schmelz, the manager of Columbus' major league teams of 1884 and 1890-91. (The Ohio State University Archives, 144.)

*Three*

# THE CAPITAL WELCOMES THE SENATORS

Baseball experienced a period of uncertainty in the 1890s, with teams and leagues coming and going every year. The new century brought stability to the larger cities of the Midwest, including Columbus. Historian Marshall Wright gives credit for this development to the formation of a new league that proved to be a model of consistency and longevity. "Eight cities (Columbus, Indianapolis, Kansas City, Louisville, Milwaukee, Minneapolis, St. Paul, and Toledo) were to be the founding members of a new minor league in the Midwest that would begin play in 1902. This new league, borrowing a name from a major league of the past, would call itself the American Association." From the beginning, "the American Association was deliberately designed to be one of the top minor leagues in the land, and its teams saw the best baseball players the minors had to offer."

The American Association remained unchanged for the next half century. "The eight cities that comprised the circuit in 1902 were the same cities that started the 1952 season," Wright points out. "This 50-year run of stability for a minor league was unique and truly remarkable." Milwaukee gained a major league franchise with the relocation of the Boston Braves for the 1953 season, the first change in the composition of the league.

The Columbus entry in the America Association was known as the Senators. Business Manager Bobby Quinn began making a series of player transactions from 1902 to 1904 to build a winning team. In the early years of membership in the Association, the Columbus team played at Neil's Field on Cleveland Avenue across from Ft. Hayes. In 1904, the club rose to second place and did well at the gate. After that season, the club purchased the playing field from the Neil family and announced plans to build a concrete and steel stadium on the site. Wood from the old stands was used for the bleachers. The new stadium, opened in 1905, had a seating capacity of over 10,000. The combination of Quinn's skillful work in strengthening the roster and the opening of the new Neil Park had immediate results. Under player-manager Billy Clymer, the Senators won the 1905 pennant. Wright comments, "The revamped Neil Park was a huge success. The Senators saw more than 280,000 fans go through their turnstiles during the 1905 season, almost 100,000 more than second place Minneapolis."

The success continued. Under Clymer, the Senators won three straight American

Association championships and became the stuff of local legend. The great American humorist James Thurber was a boy growing up on Columbus' east side at that time. Thurber, his father, and two brothers were ardent and knowledgeable fans of the home team. When older brother William visited the writer in New York in 1960, James wrote his family, "We had a memory game about the Columbus of 55 years ago and longer. Turned out we could both name all the players on the Columbus Senators in 1904 and 1905."

Thurber's boyhood interest in baseball is evident in "A Tree on the Diamond," a tale from *The Thurber Album*, his 1952 book of Columbus recollections. The story involves the quirky configuration of the ball field behind the Blind School on Parsons Avenue. Thurber recalls how the building's huge wings encroached upon the playing field, causing balls to ricochet unpredictably past the outfielders and how a large tree between first and second base stopped extra-base hits headed for right field. The story serves as a vehicle for Thurber to pass along valuable information about the early years of local players, such as Hank Gowdy and Billy Southworth, who went on to successful careers in the majors.

Memorable as they were to Thurber and his contemporaries, the three consecutive championships in the early years of the American Association were the only ones the Senators would win at Neil Park. However, the Senators did have several contending teams under player-managers Bill Friel and Bill Hinchman in the years that followed. Hinchman was one of the great players in Columbus history and had a solid major league career before and after his years with the Senators. His sons Bill and Lew played baseball at Ohio State in the late 1920s and early 1930s, with Lew attaining All-American honors in football.

A new wave of baseball excitement energized the city when the great Chicago Cub shortstop Joe Tinker came to Columbus in 1917 as player-manager and club president. As *New York Times* columnist Dave Anderson has written, "the phrase 'Tinker to Evers to Chance' has endured in baseball lore and in poetry as an instant definition of the double play," and Tinker was a Columbus celebrity during his years with the Senators. After his departure, however, the club's fortunes declined in the 1920s and a series of second division finishes, including three straight years in the cellar, led to lean years at the gate. The 1926 club represents the nadir of this era, drawing only 93,205 for the entire year and finishing 64 1/2 games out of first place with a record of 39-125—the poorest in club history.

Better days were just ahead. Branch Rickey was revolutionizing baseball by building the St. Louis Cardinals' farm system. Therefore, according to Wright, there was a proverbial silver lining for Columbus in this dark cloud of failure: "On the field, the team had suffered through a miserable decade of the 1920s, and thus were ripe for the picking" by St. Louis. The Cardinals acquired the Columbus franchise in 1931 and the club began to improve as "the Cardinals stocked their new farm team with many top players who would lead the team to pennant glory in the decades to come." Neil Park's days as the home of Columbus baseball came to an end in 1931, as the Cardinals not only purchased the club, but decided to build a new stadium.

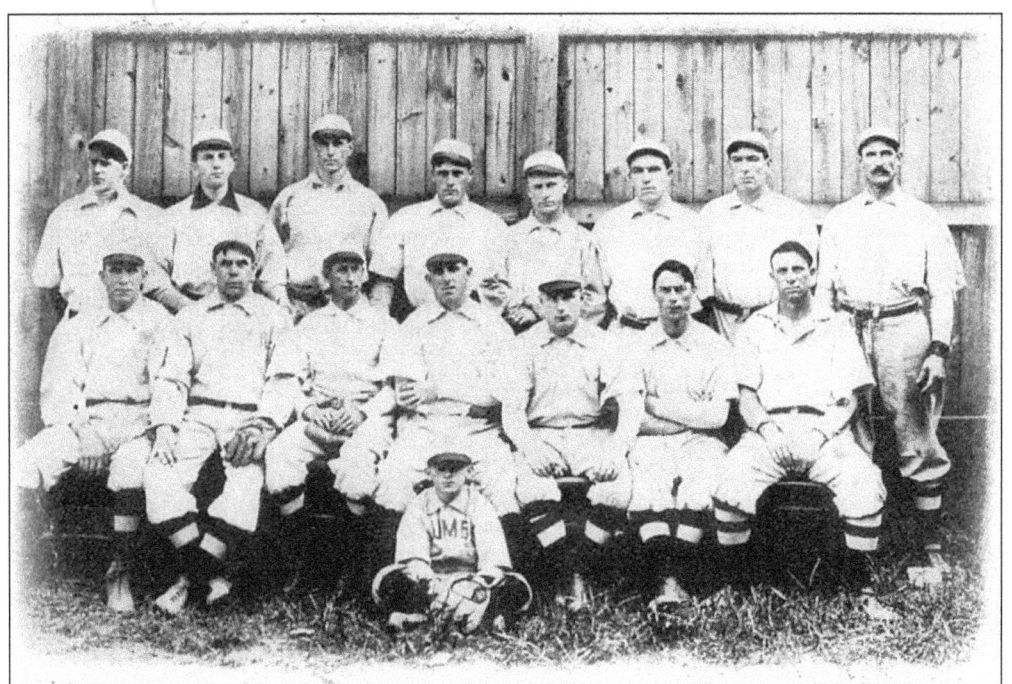

THE SUCCESSFUL SENATORS OF 1906. The Columbus Senators won three straight American Association pennants from 1905 to 1907. "The first dynasty in the American Association was built in central Ohio," writes historian Marshall Wright. "To win a championship three times in row was a difficult feat—a feat that only would be accomplished by two other teams during the first fifty years of the Association's existence." (Courtesy Tracy Martin.)

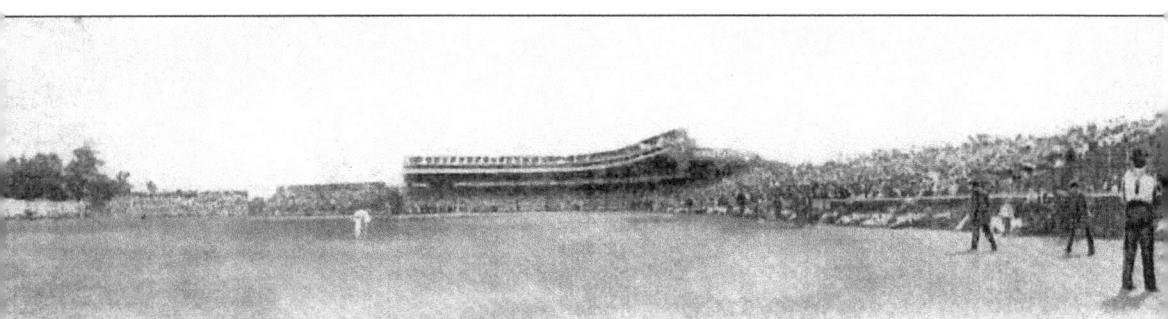

OHIO RIVALS. A great rivalry between Columbus and Toledo developed during the early years of the American Association, as evidenced by this huge crowd of over 16,000 at Neil Park. When the Columbus Senators, under Manager Bill Clymer, won their third consecutive pennant in 1907, they edged the Mud Hens by a game and a half. (Courtesy Rex Hamann.)

**THIRD BASEMAN AND MANAGER.** Bill Friel had three years' experience as a major league player before joining the Senators in 1906. Friel was the regular Columbus third baseman for the next four years and was a key player on the AA championship teams of 1906-07. He became the manager of the Senators in 1909 through 1912. (Columbus *Citizen*, Scripps-Howard Newspapers/Grandview Heights Public Library/Photohio.org.)

**BATTER UPP.** George "Jerry" Upp, an Ohioan from Sandusky, was the pitching ace of the 1907 Senators as they won their third straight American Association pennant. With a record of 27–10, he led the league in wins and winning percentage (.730). Upp pitched briefly in the majors, going 2–1 in seven games with the Cleveland Naps in 1909. (Columbus *Citizen*, Scripps-Howard Newspapers/Grandview Heights Public Library/Photohio.org.)

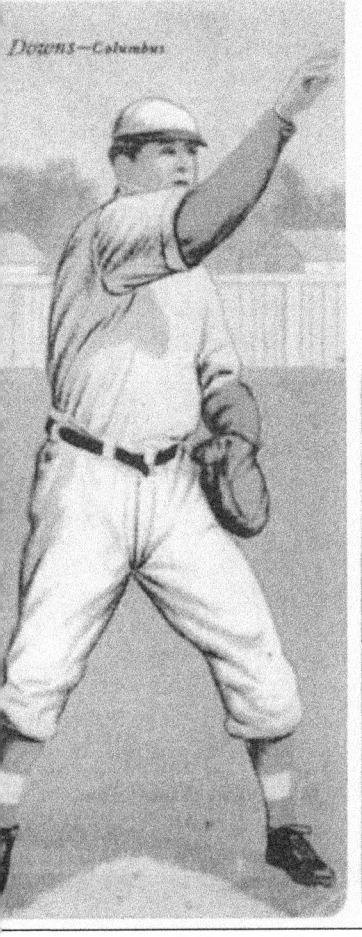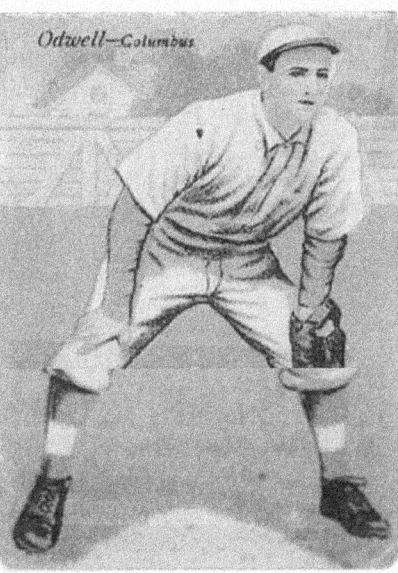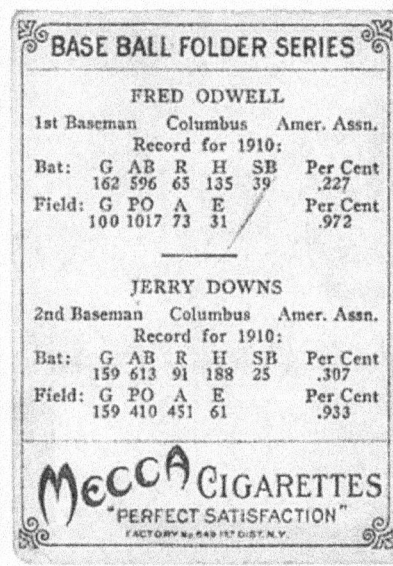

**Jerry "Red" Downs/Fred "Fritz" Odwell.** This Mecca Double Folder baseball card, issued by the American Tobacco Company in 1911, features two prominent players of the Columbus Senators. The picture of Odwell (center) shows how the card looked when it was folded. This 50-card set was the first to print player statistics.

Second baseman Downs had played in the majors with Detroit in 1907 and 1908, appearing in two games for the Tigers in the 1908 World Series against the Cubs. With Columbus in 1911, he hit .301 and led the team in stolen bases, and then returned to the majors in 1912 with Brooklyn and Chicago of the National League.

Odwell played for Cincinnati for four seasons (1904-07). As the Reds' regular right fielder in 1905, he led the National League in home runs with nine. He joined Columbus in 1908 and was a regular in the outfield and at first base for four years. Although he was 35 when he came to the Senators, he led the club twice in stolen bases, with 38 in 1909 and 39 in 1910. (Library of Congress, Prints and Photographs Division, 13163-27, no. 40.)

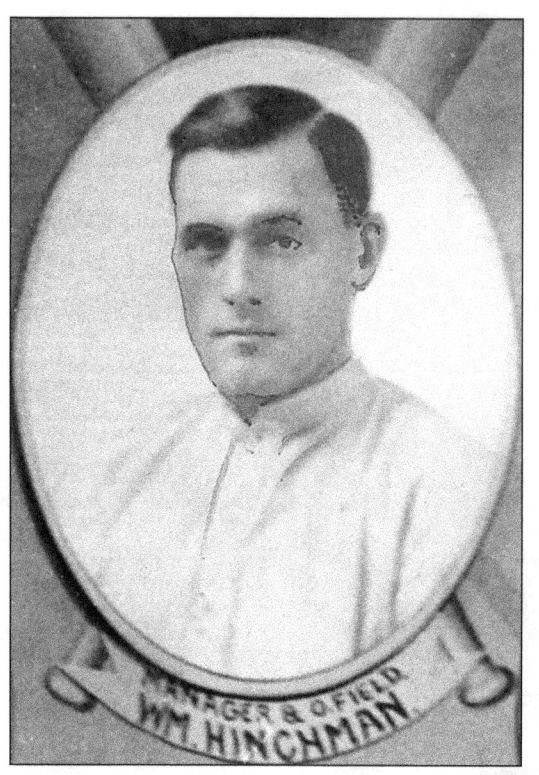

**PLAYER-MANAGER.** Bill Hinchman played five years in the majors (1905-1909), served as player-manager of the Columbus Senators in 1913 and 1914, and then returned to the majors at age 32 with the Pirates for five more seasons, hitting over .300 twice. His .366 average for Columbus in 1914 led the league. He returned to live in Columbus after a broken leg ended his playing days. (Columbus *Citizen*, Scripps-Howard Newspapers/Grandview Heights Public Library/Photohio.org.)

**FLYCHASER.** Andrew "Skeeter" Shelton was a regular outfielder for the Columbus Senators from 1912 to 1915. The speedy Shelton led the team in stolen bases all four years he played in Columbus (averaging 36 per season) and scored over 100 runs three times. In August 1915, he joined the New York Yankees and played in ten games. (Columbus *Citizen*, Scripps-Howard Newspapers/Grandview Heights Public Library/Photohio.org.)

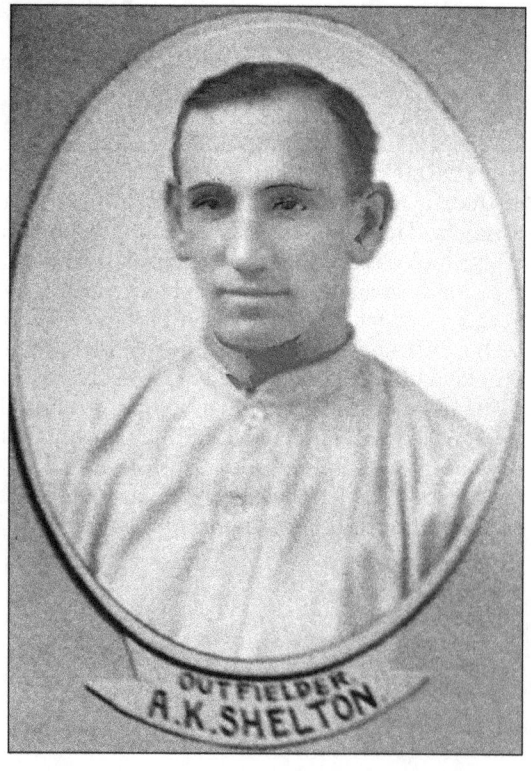

**CONSISTENT CONTRIBUTOR.** Fred Cook was a solid and dependable member of the Senators' pitching staff from 1911 to 1914. Cook posted double-digit victory totals every season he was in Columbus. He averaged 40 mound appearances and 260 innings pitched per year under Managers Bill Friel (1911-12) and Bill Hinchman (1913-14). (Columbus *Citizen*, Scripps-Howard Newspapers/Grandview Heights Public Library/Photohio.org.)

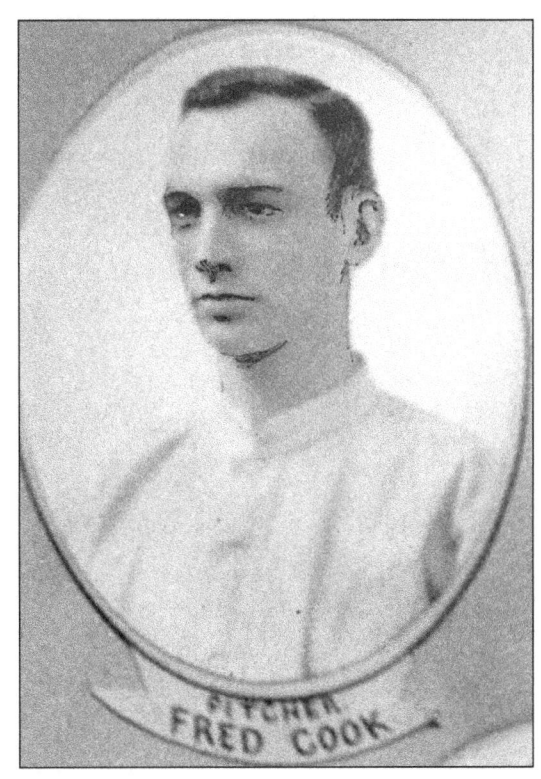

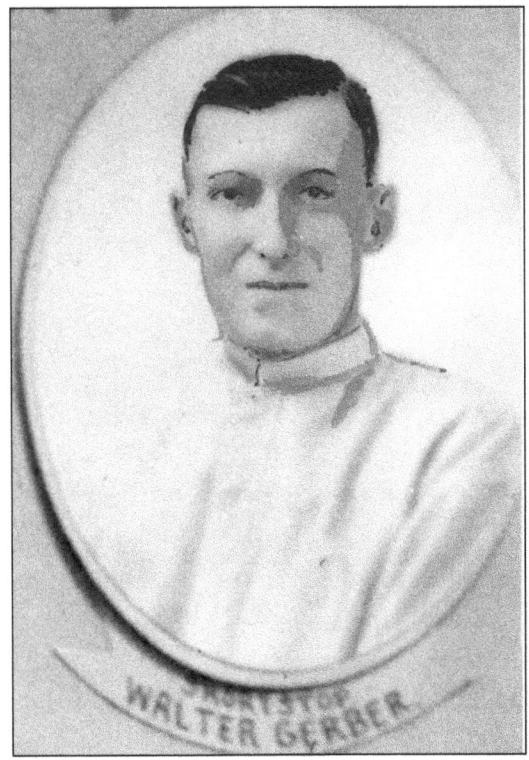

**EVERYDAY SHORTSTOP.** Wally Gerber, a native of Columbus, was the durable shortstop for the Senators for three seasons (1912-14), averaging more than 160 games and 600 at bats. Gerber then had a successful 15-year career in the majors, 11 as the shortstop of the St. Louis Browns, where he was a teammate of the legendary George Sisler, father of future Clippers GM George Sisler, Jr. (Columbus *Citizen*, Scripps-Howard Newspapers/Grandview Heights Public Library/Photohio.org.)

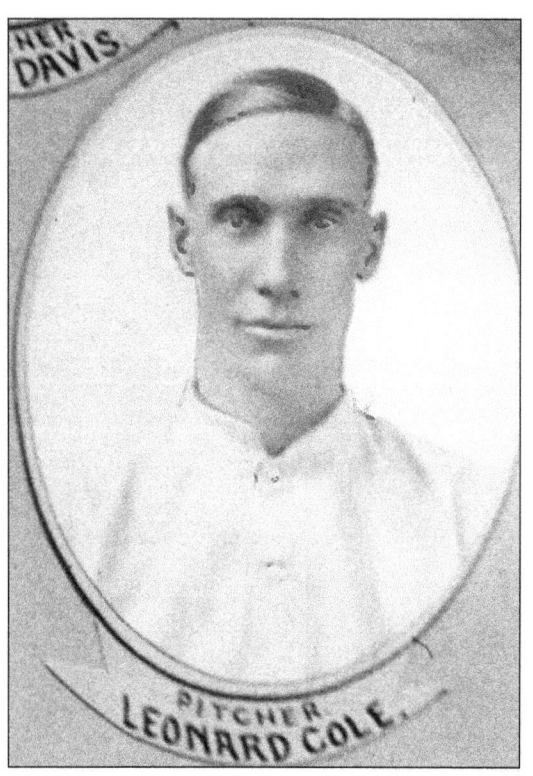

**KING OF COLUMBUS.** Leonard "King" Cole won 20 games for the Chicago Cubs in 1910 and 18 in 1911. After slipping to 3–4 in 1912, he came to Columbus and regained his form, pitching an astonishing 342 innings and compiling a record of 23–11 for the Senators, who won 93 games but finished fourth. He returned to the majors with the Yankees in 1914. (Columbus *Citizen*, Scripps-Howard Newspapers/Grandview Heights Public Library/Photohio.org.)

**SYD SMITH.** After playing in the majors for three seasons, catcher Syd Smith came to Columbus in 1912 and was the Senators' regular catcher for three years. He was a model of consistency and durability, hitting .282 in 155 games his first year, and then .284 in 133 games in 1913 and .286 in 148 games in 1914. (Columbus *Citizen*, Scripps-Howard Newspapers/Grandview Heights Public Library/Photohio.org.)

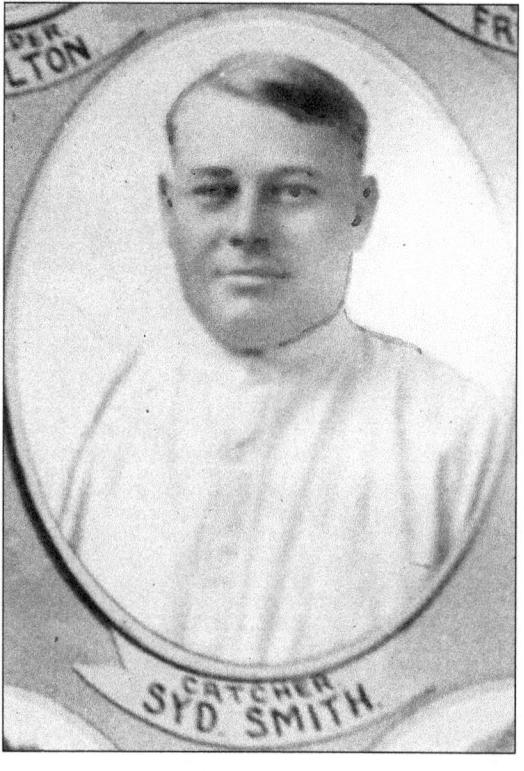

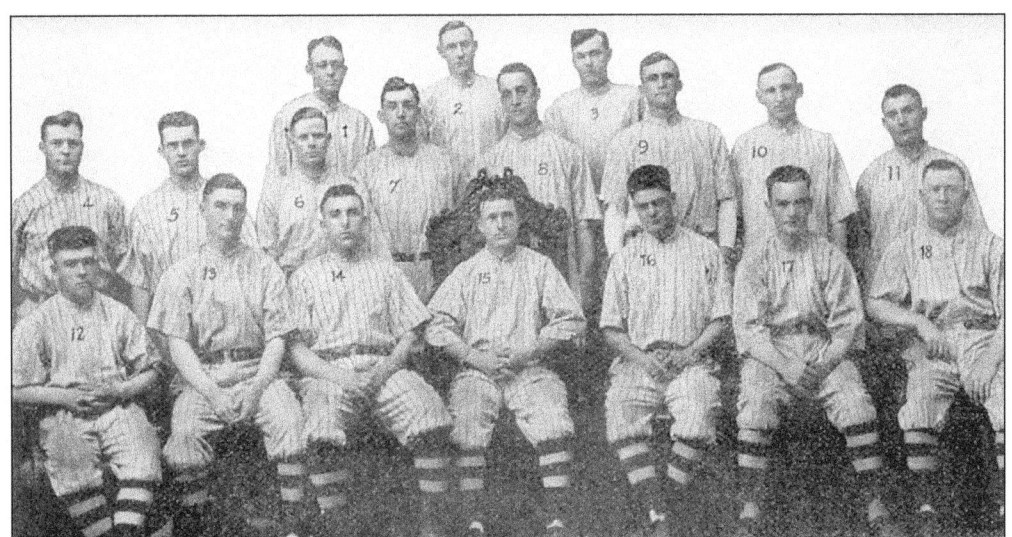

**1915 Senators.** From left to right: (front row) Steil, O'Toole, Lowery, Hulswitt, Bennett, Shevlin, and Demmit; (second row) Wright, Bacon, Burch, Coleman, Scheneberg, Curtis, Shelton, and Mueller; (back row) Benson, Ferry, and Bratchi. Manager Rudy Hulswitt (seated in the ornate chair) had played seven seasons at shortstop in the National League through 1910. The Senators finished in the cellar in 1915 and Hulswitt was replaced during the 1916 season. (Courtesy Tracy Martin.)

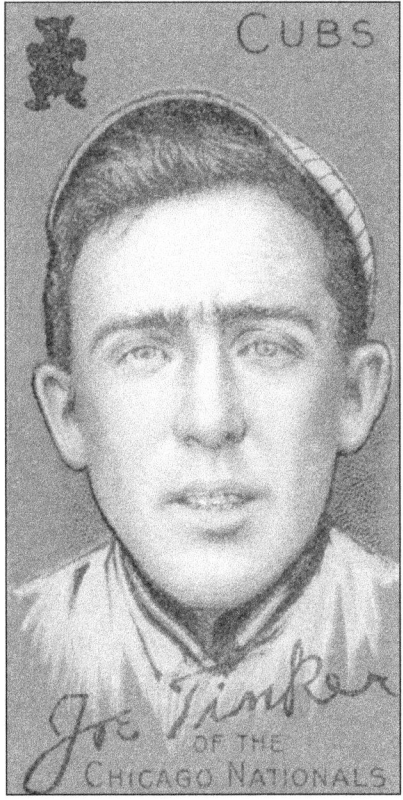

**An All-Around Joe.** Joe Tinker came to Columbus in 1917 as player-manager and club president. From 1902 to 1912, he was part of the Chicago Cubs' celebrated Tinker to Evers to Chance double-play combination. Tinker's Senators finished fourth in 1917 and were just two games off the lead in 1918 when the league suspended operations on July 21 due to World War I. (Library of Congress Prints and Photographs Division, 13163-25, no. 41.)

47

**HALL OF FAME MANAGERS.** Toledo manager Roger Bresnahan, the former major league catcher who is often credited with inventing shin guards, is pictured here on a visit to Columbus to play the Senators. With Joe Tinker at the helm of the Senators, Columbus fans had an opportunity to see these two future Hall of Fame members square off at Neil Park as rival managers. (Courtesy John Husman.)

**1920 SCORE BOOK.** Club President Joe Tinker is featured on the cover of this program. Tinker's presence and leadership were so much a part of baseball in Columbus at this time that sportswriters often referred to the Senators as the "Tinks." Already a baseball legend when he came to Columbus, Tinker, along with double-play partners Johnny Evers and Frank Chance, was elected to the Hall of Fame in 1946. (Courtesy Mike Nightwine.)

**THE NEGRO LEAGUES.** In 1920, the Negro National League was founded in Kansas City. Columbus became a member of the league in 1921. The team was known as the Columbus Buckeyes and featured the great John Henry "Pop" Lloyd, whose line-drive hitting and extraordinary fielding at shortstop generated comparisons to Pittsburgh's Hall of Fame-bound shortstop, Honus Wagner. Lloyd was elected to the Hall of Fame in 1977. (National Baseball Hall of Fame Library, Cooperstown, NY.)

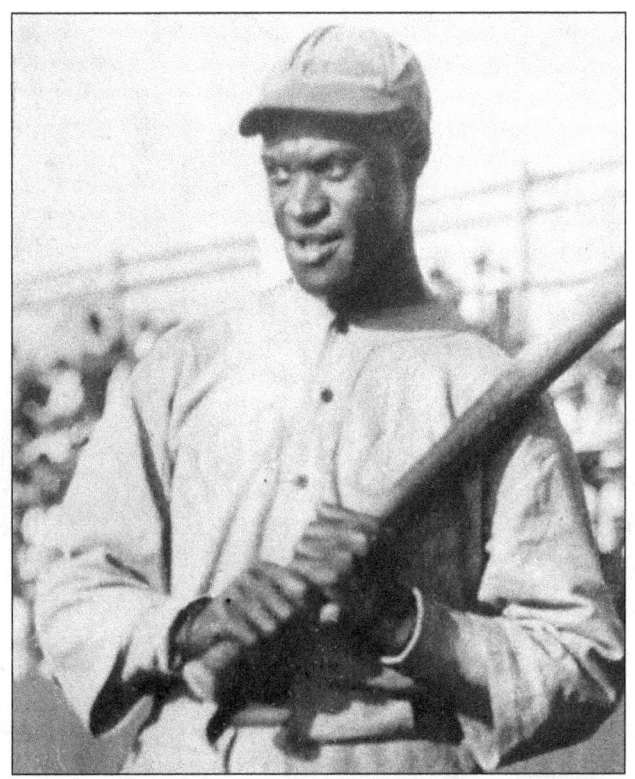

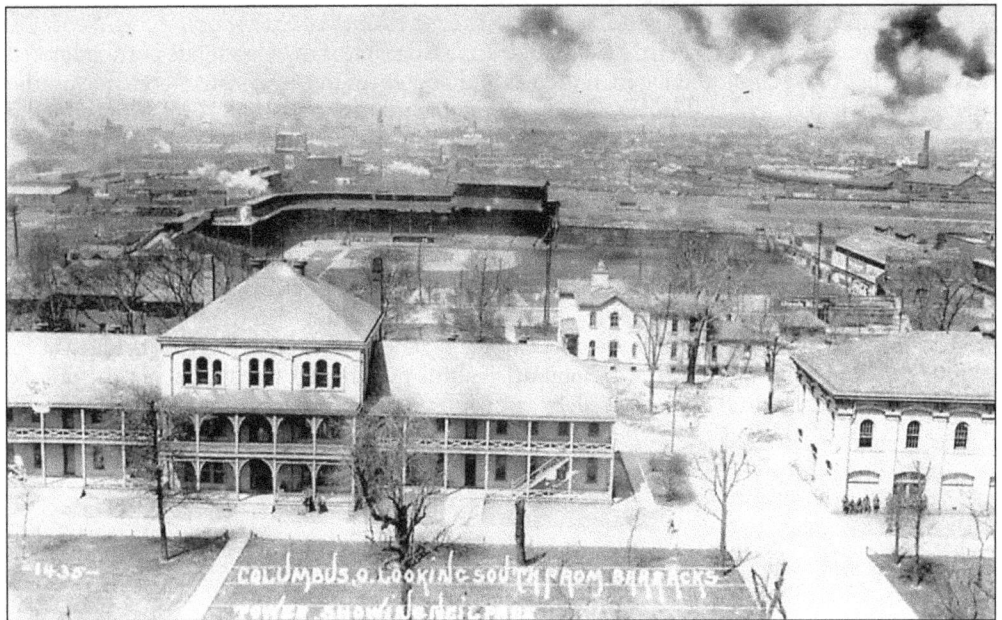

**NEIL PARK.** This view of Neil Park was taken from Ft. Hayes, looking west across Cleveland Avenue. After the 1904 season, the wooden park was replaced with this concrete and steel structure. "The revamped Neil Park was a huge success," writes historian Marshall Wright, who cites Columbus' Neil Park as the inspiration for the building of concrete and steel parks in the majors over the next few years. (Courtesy Richard E. Barrett.)

AN UNUSUAL BALL FIELD. An ardent and knowledgeable fan, Columbus-born humorist James Thurber often employed baseball themes and references in his writing. "The Tree on the Diamond," a chapter in *The Thurber Album* (1952), describes the baseball field behind the old State School for the Blind at 240 Parsons Avenue, which served for many years as the home grounds for a team composed of the institution's employees.

The field's main feature was a "gigantic tree between first and second" that "was a hazard out of Lewis Carroll." According to Thurber, "It had the patriarchal spread of Longfellow's chestnut, and it could drop leaves on the shortstop and, with its large and sinewy roots, trip up runners rounding first." Because of the tree's large size and odd placement, "Many a hard-hit ball that should have been good for extra bases would cling and linger in the thick foliage," then drop harmlessly into the waiting glove of the home team's first baseman or right fielder.

Today, the old building (now the Columbus Health Department) still stands, but the unique baseball diamond behind it is covered by a concrete parking ramp. (Courtesy Richard E. Barrett.)

BIG LEAGUER FROM COLUMBUS. To Thurber's "crazy field" behind the old Blind School "The Avondale Avenue team came from the West Side, bringing with it, around 1908, a youngster of destiny, its captain and center fielder, Billy Southworth." After a long playing career, Southworth managed the Cardinals to three pennants and two World Series victories, and then piloted the 1948 Braves ("Spahn, Sain, and pray for rain") to the NL pennant. His managerial winning percentage of .597 is fifth best in baseball history. (Thurber House.)

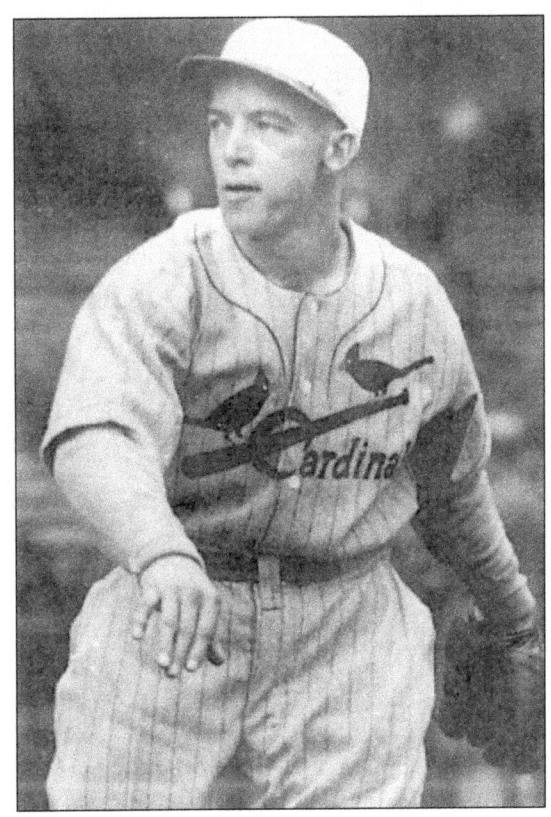

BILLY PURTELL. Recalling those who played on the old diamond behind the Blind School, James Thurber mentioned, "old-timers distinctly remember Billy Purtell, who went to Chicago fifty years ago to play third base for the White Sox." Purtell, who was born in Columbus in 1886, played 335 games between 1908 and 1914 in the American League as an infielder with the White Sox, Boston Red Sox, and Detroit Tigers. (Library of Congress, Prints and Photographs Division, 13163-18, no.232.)

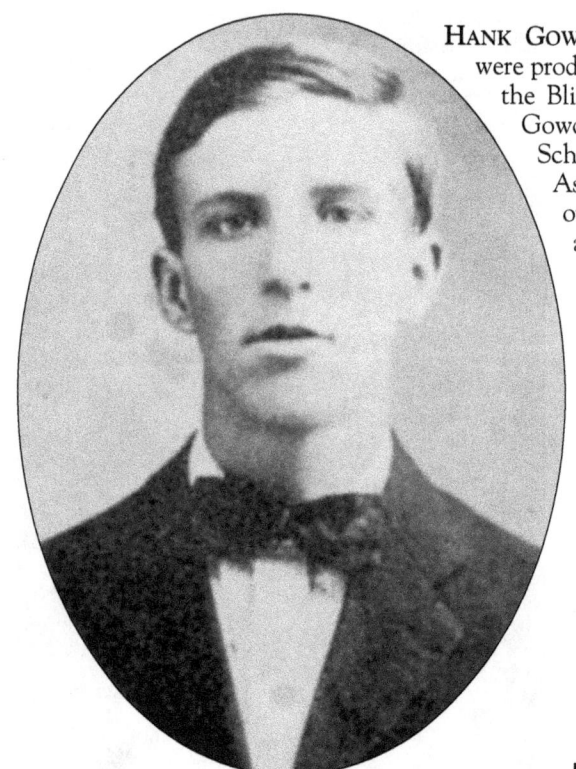

HANK GOWDY. Mentioning future luminaries who were products of the idiosyncratic ball field behind the Blind School, James Thurber names Hank Gowdy, a three-sport star at North High School and "hero of the 1914 World Series." As the catcher on the "Miracle Braves" of 1914, Gowdy hit .545 in the Series as Boston upset Connie Mack's favored Philadelphia A's. (Columbus Circulating Visuals Collection, Columbus Metropolitan Library.)

GOWDY'S CAREER. In addition to his heroics on the diamond, Columbus' Hank Gowdy was hailed for his patriotism when he became the first major league player to enlist in the army for World War I. He participated in the battles of Chateau-Thierry, St. Mihiel, and the Argonne Forest, but returned home safely to resume his long career in the majors. (Library of Congress, Prints and Photographs Division, 13163-30, no. 3.)

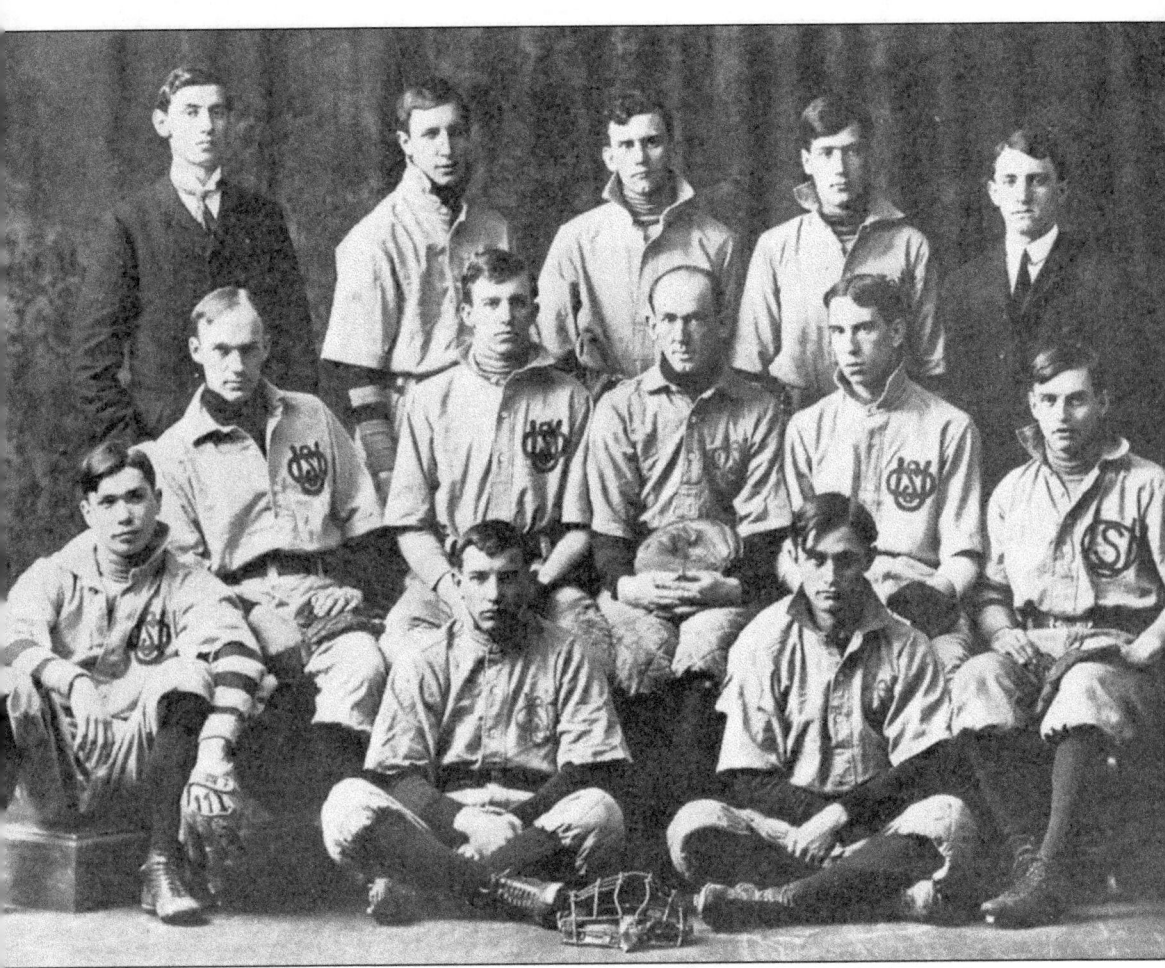

GEORGE BELLOWS. Another alumnus of Thurber's quirky Blind School diamond was a neighborhood boy named George Bellows, who "later became, among other things, one of the best shortstops Ohio State ever had." A member of Ohio State's 1904 team (back row, second from left), Bellows went to New York to study painting and became one of the foremost American artists of the 20th century. (The Ohio State University Archives, x29928.)

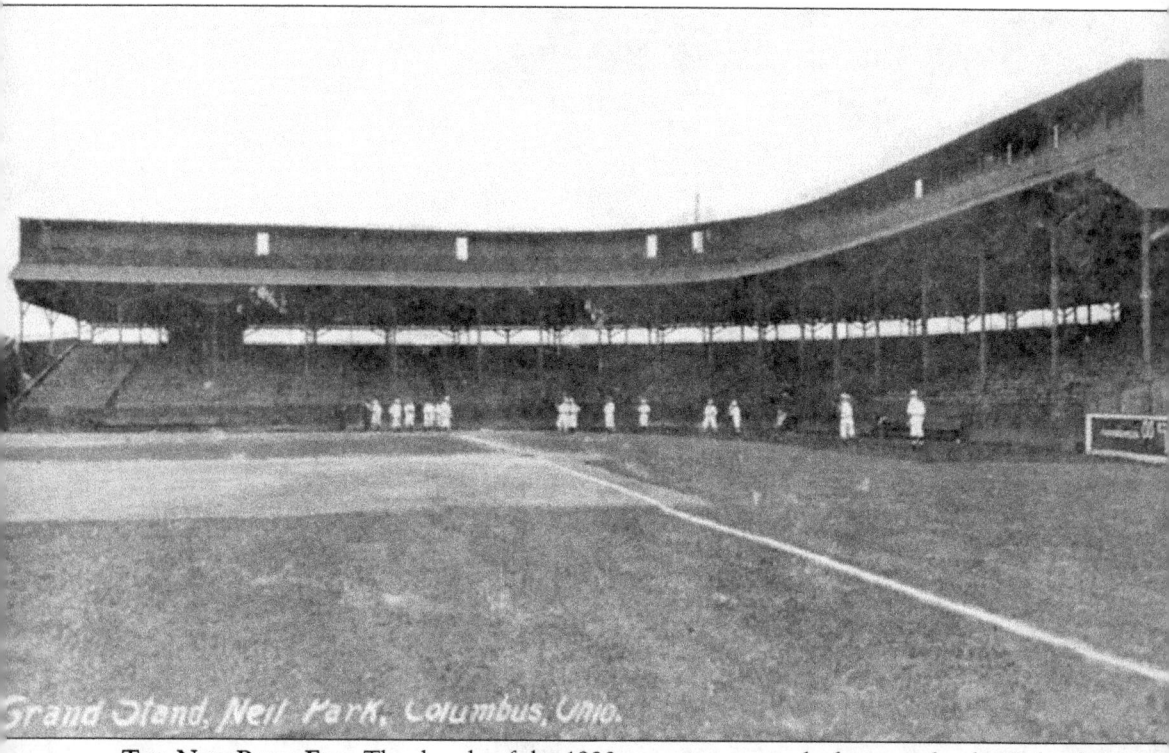

**THE NEIL PARK ERA.** The decade of the 1920s was not a period of success for the Columbus Senators, who finished 6th, 7th, or 8th every year except one. They continued to play at Neil Park through 1931, when they became part of Branch Rickey's St. Louis Cardinal farm system, were renamed the Red Birds, and began a climb back to the top of the standings. (Courtesy Richard E. Barrett.)

## Four

# THE RED BIRDS BUILD A BALLPARK

As a farm team of the St. Louis Cardinals, the Columbus club changed its name from Senators to Red Birds in 1931 while playing its last season in Neil Park. With an infusion of new players from the Cardinal system, Columbus climbed to a respectable fourth place finish. The following season was a landmark year as the new stadium on Mound Street opened on June 3, with Commissioner Kenesaw Mountain Landis on hand for the festivities. A crowd of 15,000 watched Columbus beat Louisville 11-2 at the first game in the new park, built at a cost of $450,000.

The team improved to second place and drew 309,869 fans. Leading the club's resurgence was new president Larry McPhail, who built the park and installed lights. On June 17, a crowd of 21,000 came to the first night game as the Red Birds edged St. Paul 5-4 in 11 innings. McPhail would go on to revitalize franchises in Cincinnati in 1935 and Brooklyn in 1938 by installing lights for night baseball and increasing radio broadcasts of games. After World War II, he was part owner of the Yankees with Dan Topping and Del Webb and brought night baseball to Yankee Stadium for the first time in 1946.

The Red Bird manager when the new ballpark opened was Billy Southworth, who grew up in Columbus and had played 13 years in the majors. He hit .320 in 1926, helping the Cardinals win the World Series. Evar Swanson was an especially exciting player for the Red Birds in 1931 and 1932. A track star in college who had played end in the NFL for three seasons, Swanson set a record as a Reds rookie in 1929 by circling the bases in 13.3 seconds; with Columbus in 1932, he was timed in at 13.2.

Under manager Ray Blades, the Red Birds won the American Association pennant in 1933 by a decisive margin of 20 games over Indianapolis. Dizzy Dean's younger brother Paul won the pitching Triple Crown by leading the league in wins, strikeouts, and ERA. This was Columbus' first pennant since the Senators took three straight from 1905 to 1907. In 1934, Paul Dean moved up to St. Louis and won 19 for the "Gas House Gang" World Series champs. But Columbus still had enough talent to win its second straight American Association title. In both 1933 and 1934, Columbus went on to win the Junior World Series against the International League champion.

Columbus had briefly been part of the Negro National League in 1921. In 1933, it was represented again in the circuit by the Columbus Blue Birds. Playing for Columbus that year was one of the all-time greats of the Negro Leagues, Ted "Double Duty" Radcliffe, who received his nickname from Damon Runyon for his unique ability to pitch one game of a double header and catch the other. In 1935, the Columbus Elite Giants played in the Negro National League.

In the five seasons from 1932 to 1936, Red Bird Nick Cullop established a well-deserved reputation as one of the greatest players ever to wear a Columbus uniform by hitting over .300 every season while averaging 26 homers and 123 RBI. In 1937, paced by Enos Slaughter's .382 average and the leadership of manager Burt Shotton, the Red Birds won the Association pennant again. The Red Birds then won the first three games of the Junior World Series against the International League's Newark Bears, but dropped four in a row to suffer a disappointing loss of the series.

After a couple of seventh place finishes in 1938 and 1939, Columbus rebounded to second in 1940 and won the pennant and the league playoffs in 1941. Murray Dickson led the league in wins that year with 21. The Red Birds finished third in the regular season standings in 1942 and 1943, but both years won the playoffs. Columbus also won the Junior World Series three straight years, from 1941 to 1943. In 1950, under Rollie Hemsley, Columbus would once again come from third place in the regular season standings to win the playoffs and the Junior World Series.

Historian Marshall Wright sums up the success of the Red Birds as follows: "In all, between 1934 and 1950, Columbus finished in the playoffs nine times. Of those nine, seven times the team reached the Junior World Series. Of these, the Red Birds won six, making them the undisputed ruler of the American Association's post-season kingdom."

Columbus' James Thurber wrote a baseball-themed short story for the *Saturday Evening Post* in 1941 that holds a special place in the lore of the game. "You Could Look It Up" begins in the bar of the Chittenden Hotel, at Spring and High Streets, where fictional baseball manager Squawks Magrew meets the midget Pearl DuMonville. Magrew takes the midget along with the team as a mascot to St. Louis, where he surprises everyone by using him as a pinch hitter in a major league game for the purpose of getting a walk. Ten years later, St. Louis Browns' owner Bill Veeck borrowed Thurber's plot line by sending 3-foot 7-inch Eddie Gaedel up to bat in an official game between the Browns and the Detroit Tigers. Gaedel walked on four pitches. *The Sporting News* placed Veeck's Thurber-inspired maneuver at the top of the list of baseball's "Most Unusual and Unforgettable Moments" of the 20th century.

Columbus fell all the way to last place in 1951, followed by two seventh place finishes. Attendance tumbled to an average of fewer than 89,000 a year from 1951 to 1953. The end of the relationship between the Cardinal organization and Columbus came in 1954 when St. Louis announced plans to move the franchise to Omaha. When the Red Birds played their last game of the 1954 season, fans had to face the very real possibility that there might be no baseball in Columbus in 1955.

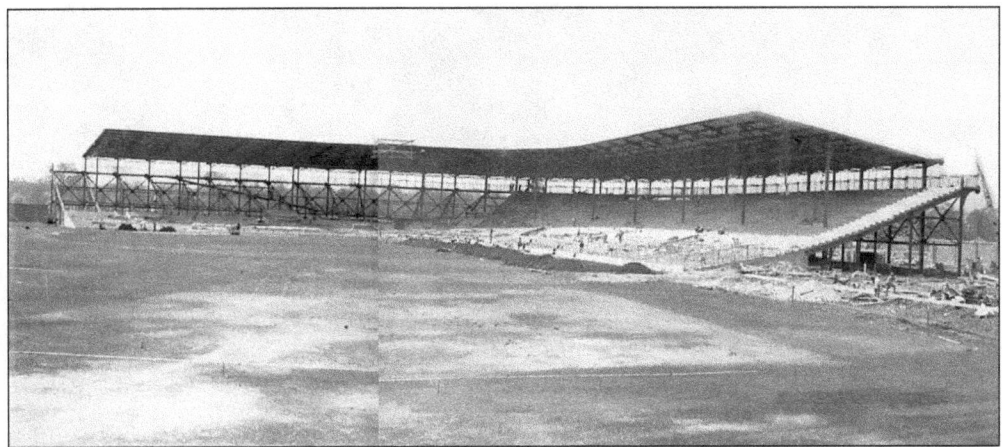

NEW STADIUM. When the St. Louis Cardinal organization added Columbus to its farm system in 1931, Larry McPhail was named president of the Red Birds. To improve the franchise, one of the first steps taken by McPhail and the Cardinals was to begin building a new ballpark on Mound Street on Columbus' west side. This photo from the off-season of 1931-32 shows the new stadium under construction. (Columbus *Citizen*, Scripps-Howard Newspapers/Grandview Heights Public Library/Photohio.org.)

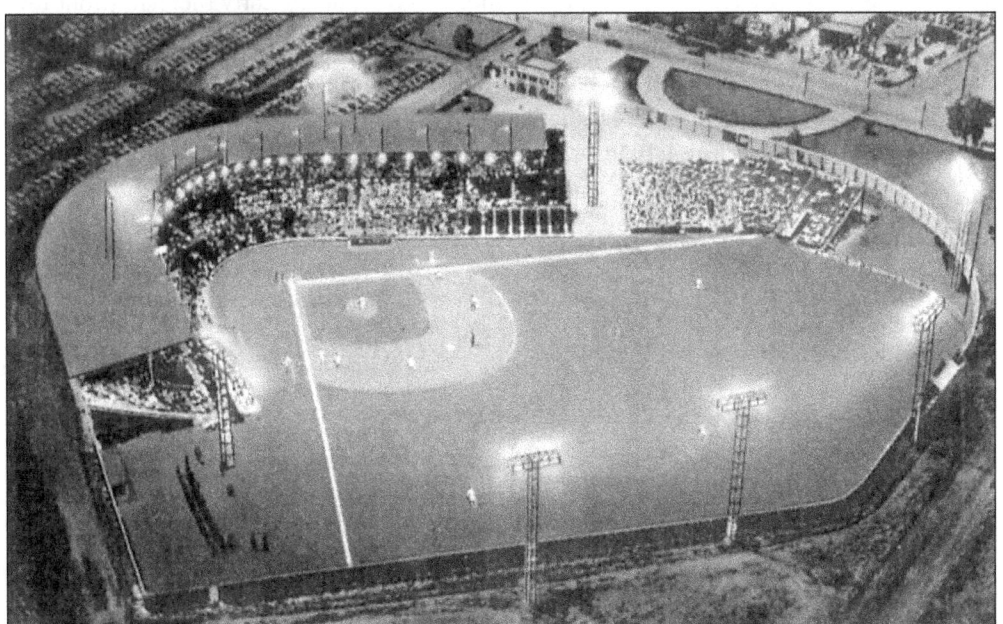

NIGHT BASEBALL AT RED BIRD STADIUM. New president Larry McPhail was an innovative executive with a keen interest in promotions and increasing attendance during the depression era. "Night baseball needed a champion and it turned out to be Larry McPhail," writes historian Michael Gershman. McPhail went from Columbus to Cincinnati, where he introduced night baseball to the majors in 1935 at Crosley Field. (Author's collection.)

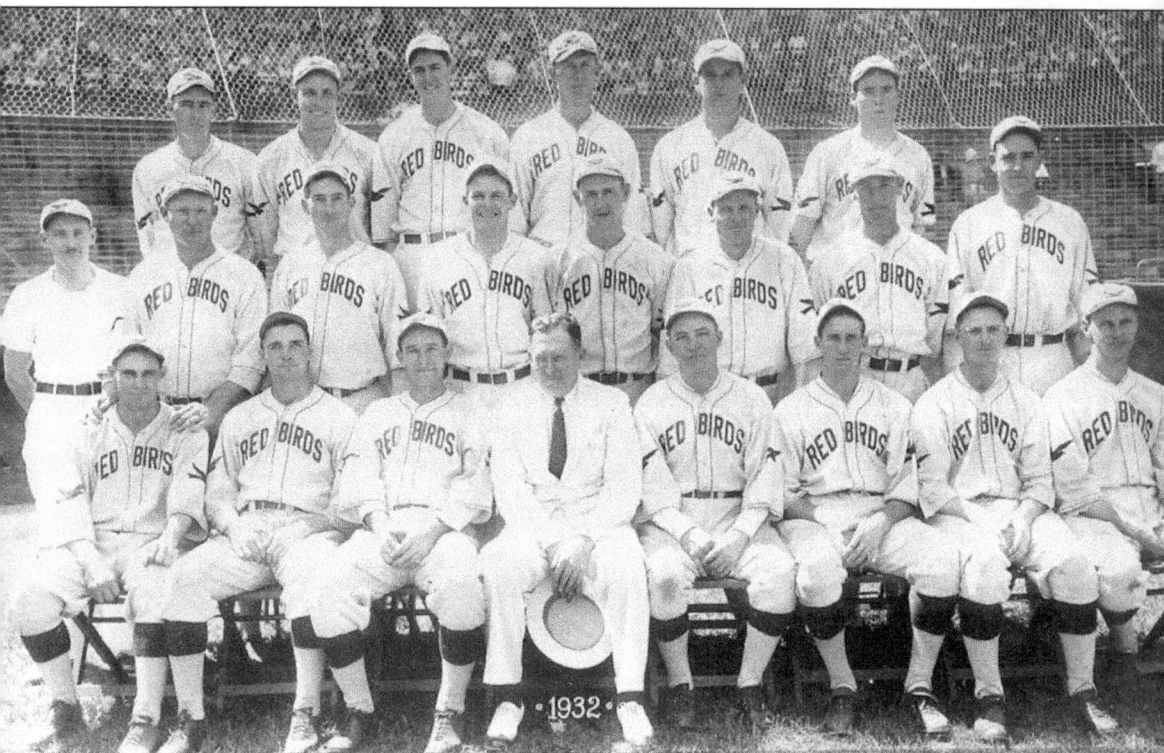

**The 1932 Red Birds.** This 1932 team photo shows club President Larry McPhail (front row, white suit), who revitalized baseball in Columbus, and Manager Billy Southworth (right of McPhail). A true baseball family, McPhail's son Lee was president of the American League from 1974 to 1983. Grandson Andy became president and CEO of the Chicago Cubs in 1994. Both Larry and Lee McPhail are members of the Baseball Hall of Fame.

Commissioner Kenesaw Mountain Landis came to Columbus for the opening of the new Red Bird Stadium that year. He called it "the finest park in all of baseball." The team won the opener in the new stadium and finished second, drawing 309,869, a huge improvement over the 1931 attendance of 174,511.

Top performers on the '32 club were speedy outfielder Evar Swanson, who hit .375 and had 131 RBI; first baseman Pat Crawford, who hit .369 with 140 RBI; and Nick Cullop, who hit .348 with 99 RBI. Bill Lee's 20–9 record and LeRoy Parmelee's 14–1 mark led the pitching staff. (Courtesy Joe Santry.)

**RED BIRD ROOTERS.** The new ballpark and the success of the team on the field in the early 1930s sparked an increase in fan interest. This support for the Columbus team in the depression era included a spirited song backing the club, "Come On, Let's Root for The Red Birds" (music by Jack Rich, words by Art Longbrake). (Courtesy Richard E. Barrett.)

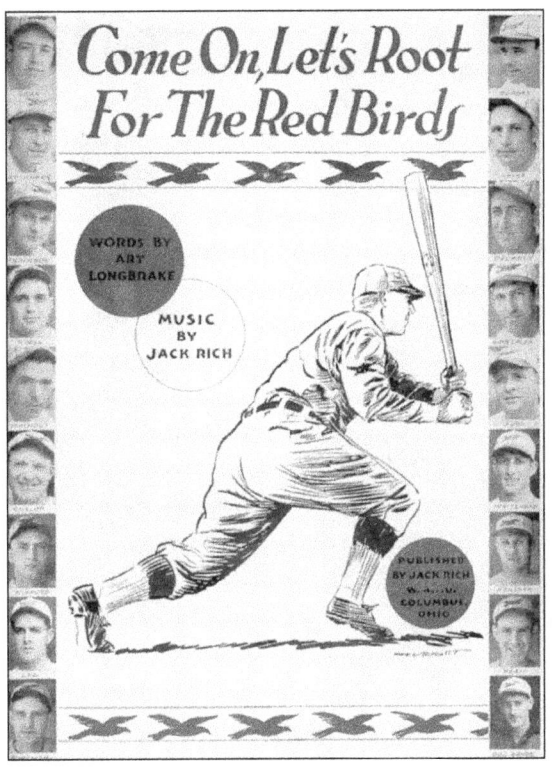

**A TALENTED TEXAN.** Frederick "Pat" Ankenman was an infielder for the Red Birds in the mid-1930s, coming here from the University of Texas. Although small in stature, the 5-foot 4-inch Ankenman hit .312 in 1935, .288 in 1936, and .296 for the great championship club of 1937. Ankenman made it to the majors for brief stints with the Cards in 1936 and the wartime Dodgers of 1943-44. (Courtesy Richard E. Barrett.)

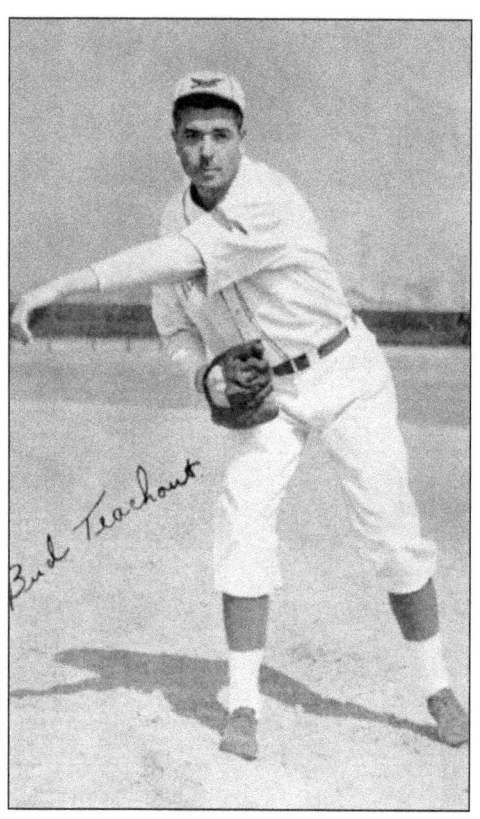

BUD TEACHOUT. Before coming to Columbus, Art "Bud" Teachout had pitched in the majors, his best year being an 11–4 record for the Cubs in 1930. In 1933, Teachout won 15 games for the Red Birds as they won the American Association championship in a post-season playoff against Minneapolis. In 1934, Teachout won 17 for Columbus as they again defeated Minneapolis for the championship. (Courtesy Richard E. Barrett.)

KEN O'DEA. Pictured in 1930s-style catching gear in this photo from his days as a Red Bird, Ken O'Dea was the regular backstop for the 1934 Columbus club that won the American Association championship. Highlights of his 12-year career in the majors include playing on the Cardinals' World Series championship teams of 1942 and 1944 and being named to the National League All-Star team in 1945. (Courtesy Richard E. Barrett.)

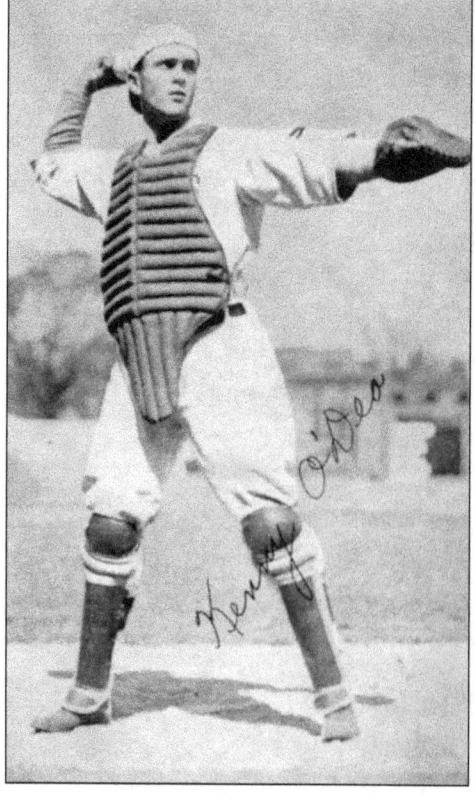

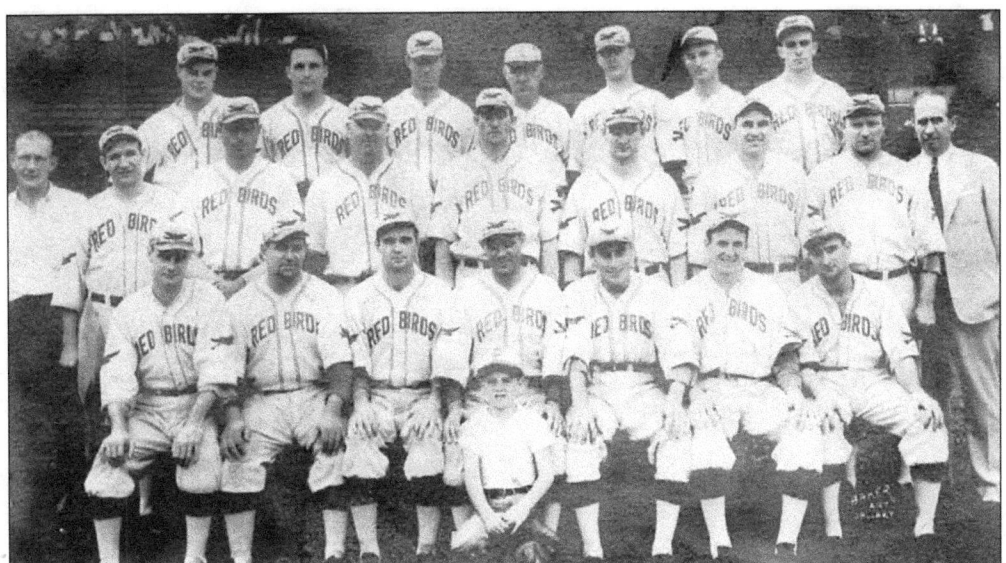

THE 1934 PENNANT WINNERS. The recent affiliation with the Cardinals enabled both Columbus and St. Louis to prosper. In 1934, the "Gas House Gang" won the World Series and the Red Birds won their second straight American Association championship. The back-to-back victories in 1933 and 1934 gave Manager Ray Blades, a former Cardinal catcher and future manager, two titles in his first two years in Columbus. (Courtesy Richard E. Barrett.)

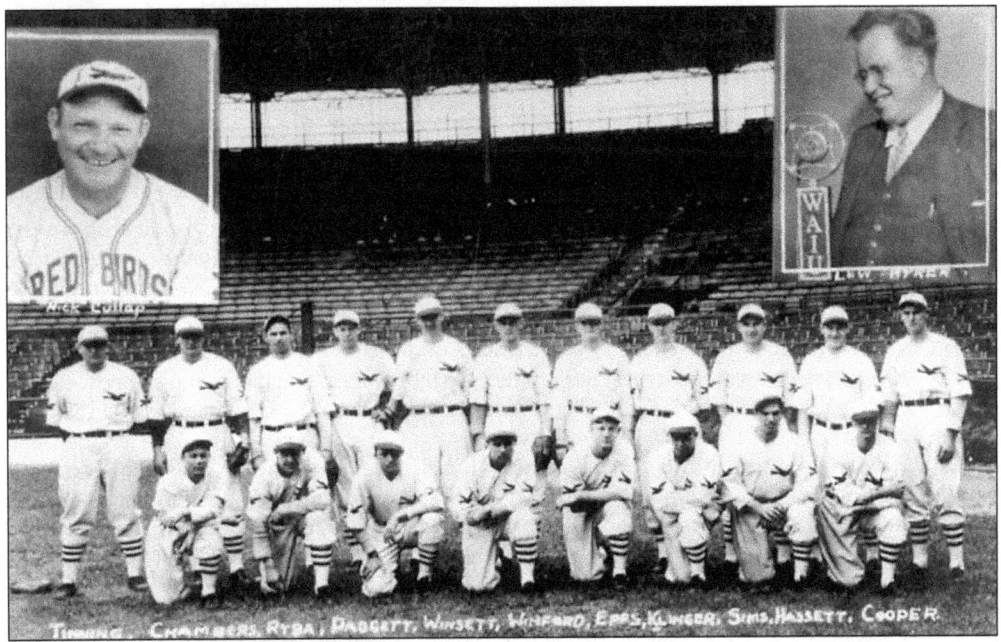

THE 1935 RED BIRDS. From left to right: (front row) Ankenman, Ogrodowski, Mooney, Blades, Copeland, Fullis, Gutteridge, and Anderson; (back row) Tinning, Chambers, Ryba, Padgett, Winsett, Winford, Epps, Klinger, Sims, Hasset, and Cooper. Left inset: Nick Cullop. Right inset: sportswriter Lew Byrer. The defending champs finished third, but slugger Cullop hit .340, with 24 homers and 128 RBI. John Winsett batted .348 and won the AA Triple Crown in 1936 (.354, 50 HR, 154 RBI). (Courtesy Richard E. Barrett.)

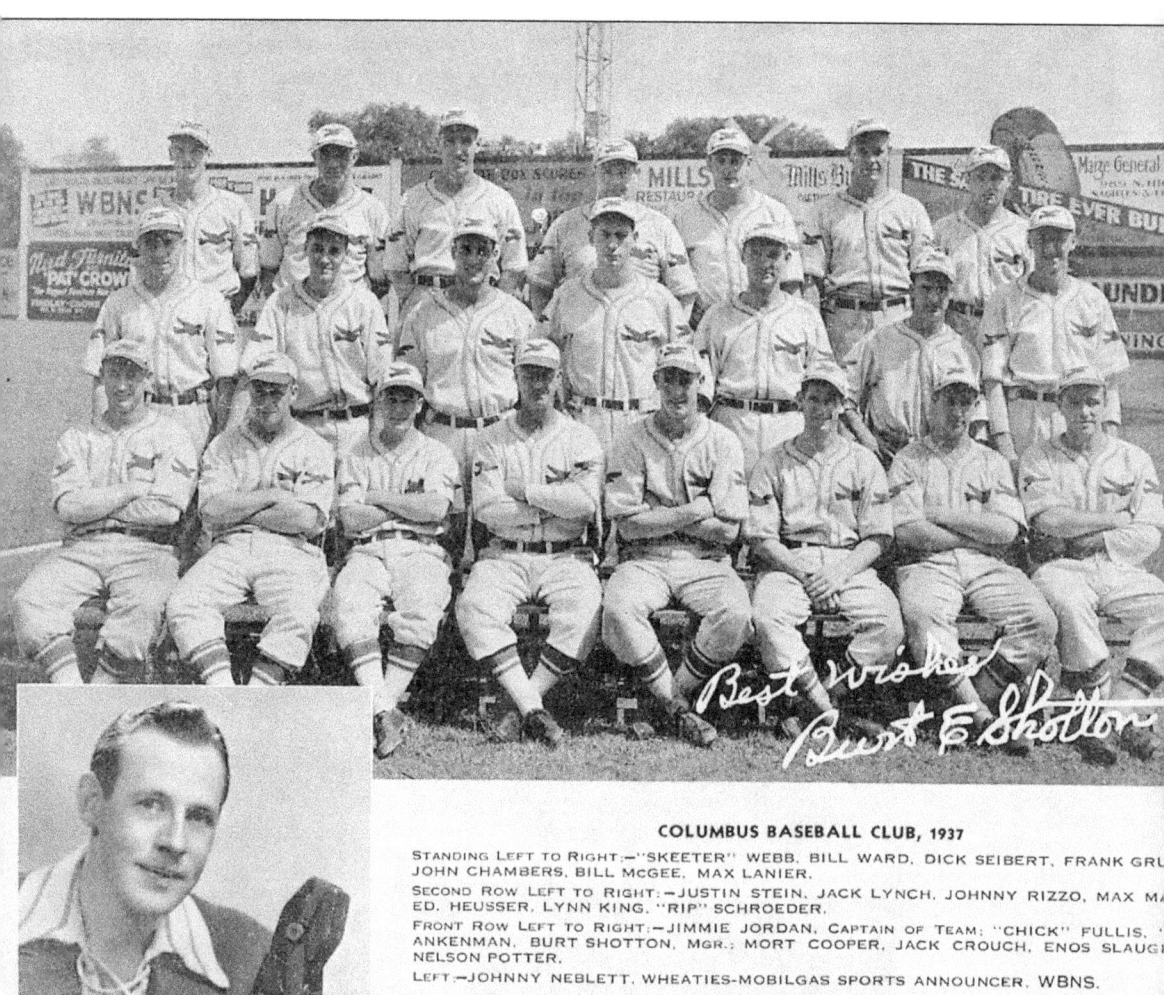

**COLUMBUS BASEBALL CLUB, 1937**

STANDING LEFT TO RIGHT:—"SKEETER" WEBB, BILL WARD, DICK SEIBERT, FRANK GR[U]
JOHN CHAMBERS, BILL McGEE, MAX LANIER.
SECOND ROW LEFT TO RIGHT:—JUSTIN STEIN, JACK LYNCH, JOHNNY RIZZO, MAX M[A]
ED. HEUSSER, LYNN KING, "RIP" SCHROEDER.
FRONT ROW LEFT TO RIGHT:—JIMMIE JORDAN, CAPTAIN OF TEAM; "CHICK" FULLIS,
ANKENMAN, BURT SHOTTON, MGR.; MORT COOPER, JACK CROUCH, ENOS SLAUG[HTER]
NELSON POTTER.
LEFT.—JOHNNY NEBLETT, WHEATIES-MOBILGAS SPORTS ANNOUNCER, WBNS.

**RADIO APPRECIATION DAY—RED BIRD STADIUM—COLUMBUS, 1937**

**SHOTTEN'S 1937 CHAMPIONS.** This legendary team won the pennant by one game over Toledo. In the second year of playoffs involving the league's top four teams, Columbus won the post-season championship. Hustling outfielder Enos Slaughter led the league with a .382 average, 245 hits, and 147 runs scored.

Manager Burt Shotton of Brownhelm, Ohio, an outfielder with the Browns, Senators, and Cardinals in his major league playing days (1909-1923), was often among the league leaders in hits, runs, on-base percentage, and steals. He managed the Phillies for six years (1928-33) before coming to Columbus where he managed from 1936 to 41. When Dodger manager Leo Durocher was suspended just before the start of the 1947 season, Branch Rickey persuaded the experienced Shotton, then 62, to take over the Dodgers at that critical juncture when Jackie Robinson broke the color barrier in the major leagues. Shotton guided the Dodgers for four seasons, winning National League pennants in 1947 and 1949 and losing by two games to the Philadelphia Phillies' "Whiz Kids" in 1950. (Courtesy Joe Santry.)

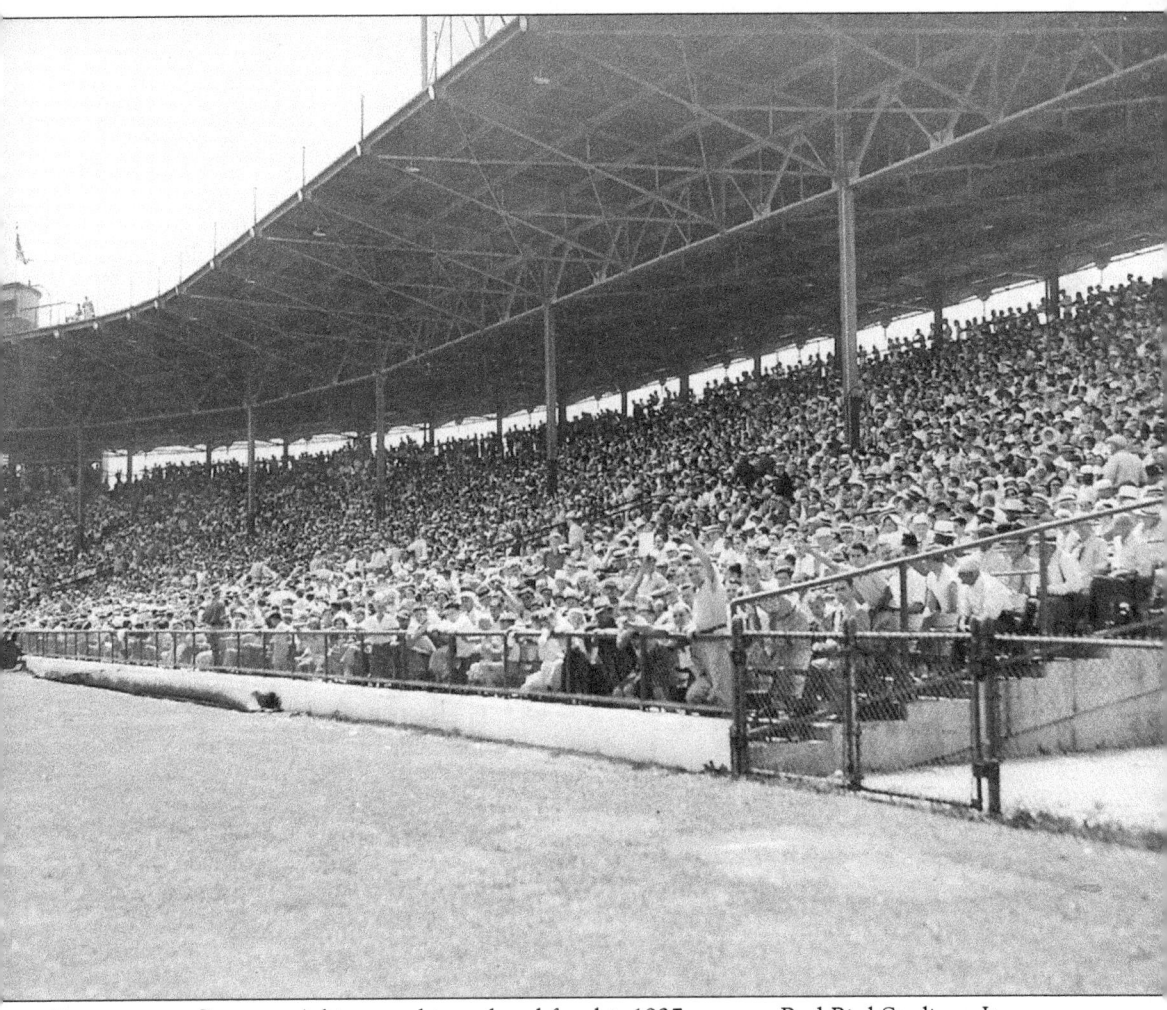

FANS IN THE STANDS. A big crowd is on hand for this 1937 game at Red Bird Stadium. It was an exciting year as Columbus drew more than 218,000 fans, a significant increase over the 1936 attendance of 121,680. During the Great Depression, attendance was an ongoing concern for major and minor league clubs across the country.

In addition to future Hall-of-Famer Enos Slaughter's banner season for the pennant-winning Red Birds, Columbus fans came out to see outfielder Johnny Rizzo, who had a 36-game hitting streak and batted .358 for the year. Columbus' Max Macon led the league in wins with 21, and fellow Red Bird hurler Bill McGee was the ERA leader. (Columbus *Citizen*, Scripps-Howard Newspapers/Grandview Heights Public Library/Photohio.org.)

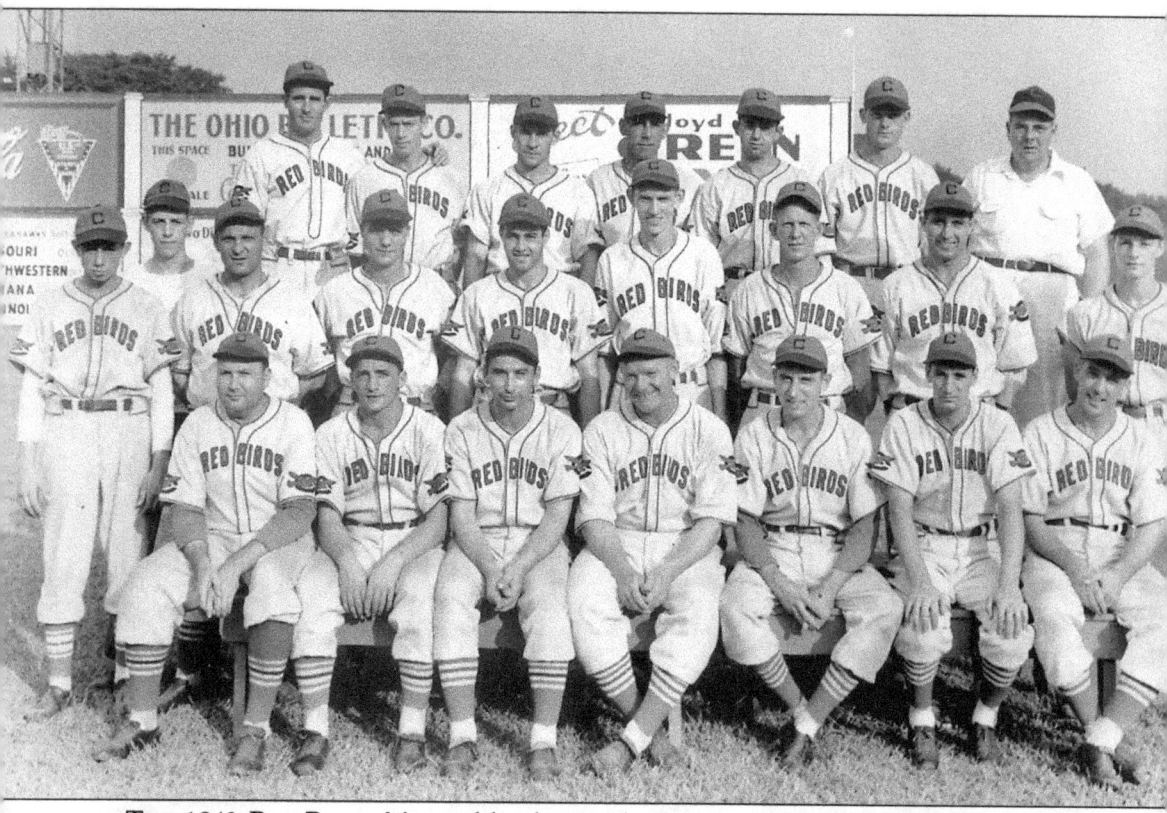

**THE 1943 RED BIRDS.** Managed by the popular former star player Nick Cullop (front row, center), Columbus won the playoffs and the Junior World Series in 1943. Cullop was named Minor League Manager of the Year in 1943 and again in 1947 when he piloted the Milwaukee Brewers. Cullop played a total of 173 games in the majors with five different teams between 1926 and 1931, but is best remembered for his great career in the minors. He stands first on the all-time minor league RBI list with 1857, fourth in home runs with 420, and is tied for first in 20-home run seasons with 12.

Over Cullop's right shoulder (second row, fourth from left) stands catcher Joe Garagiola, who broke in with St. Louis in 1946 and helped them win the World Series that year. Garagiola enjoyed a nine-year career in the majors with the Cardinals, Pirates, Cubs, and Giants. After his playing days he built a successful career in television as a baseball broadcaster and host of NBC's *Today* show.

The thin young fellow on the left end of the second row is the Red Birds' batting practice pitcher, 17-year-old high school student Harvey Haddix from nearby Clark County. Haddix would go on to enjoy a memorable professional career pitching first for the Red Birds from 1948 to 1950 and then in the majors from 1952 to 1965, mostly with the Cardinals and Pirates. (Courtesy Joe Santry.)

**FUTURE UMPIRE.** Ken Burkhart pitched for Columbus from 1942 through 1944, leading the team with 15 wins and 231 innings pitched in 1944. He won 18 for the Cardinals in his rookie year of 1945, the best of his five seasons in the majors. A National League umpire for 17 seasons (1957-1973), Burkhart umpired no-hitters on consecutive days by Gaylord Perry and Ray Washburn in 1968. (Columbus *Citizen*, Scripps-Howard Newspapers/Grandview Heights Public Library/Photohio.org.)

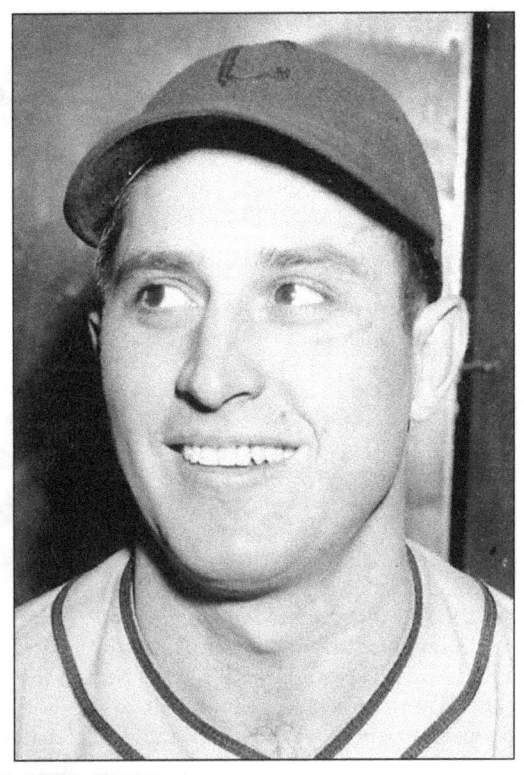

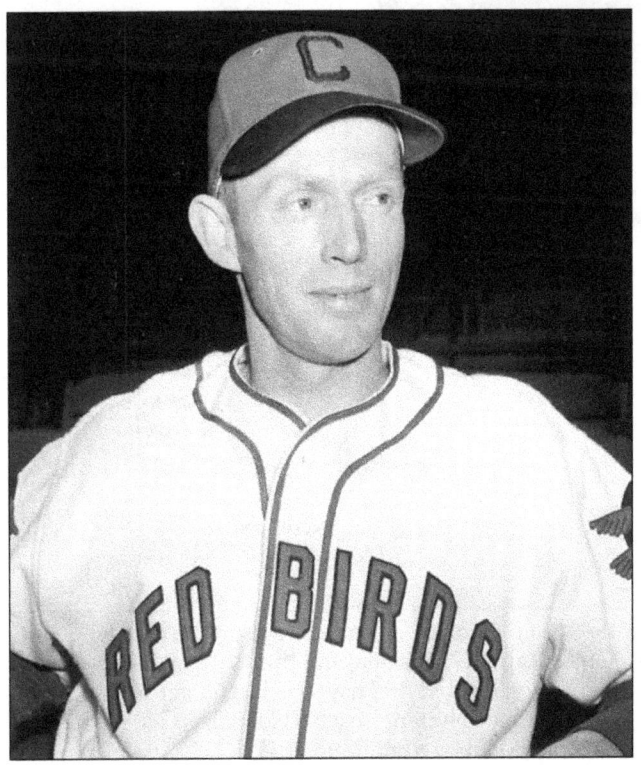

**PEP YOUNG.** Floyd "Pep" Young enjoyed a productive nine-year career in the major leagues, mostly with the Pirates, before he came to Columbus in 1942. In his three seasons with the Red Birds, the veteran earned considerable playing time at shortstop, second, and third. At age 37, Young made it back to the majors with the Cardinals for 27 games in 1945. (Columbus *Citizen*, Scripps-Howard Newspapers/Grandview Heights Public Library/Photohio.org.)

SPRING TRAINING 1947. Manager Hal Anderson, club president Al Bannister, and pitching coach Ira Hutchinson go over plans as spring training opens at the Red Birds' camp. Anderson, a Red Bird player in the 1930s, was just beginning a three-year stint as skipper of the Columbus club. Bannister served as president of the Red Birds from 1939 to 1952. (Columbus *Citizen*, Scripps-Howard Newspapers/Grandview Heights Public Library/Photohio.org.)

THE CLUB HOUSE. Members of the 1949 team enjoying a game of cards in the club house are, from left to right, John Remke, Ellis "Cot" Deal, Mel McGaha, and Kurt Krieger. Deal was both a starting pitcher and a regular outfielder during his Red Bird days. He had a long and successful career as a minor league manager and major league pitching coach. (Columbus *Citizen*, Scripps-Howard Newspapers/Grandview Heights Public Library/Photohio.org.)

**HOME PLATE CLUB.** This 1950 photo was taken at a meeting of the Home Plate Club at the team's office at Red Bird Stadium. Pictures of past Columbus teams line the paneled walls. Team president Al Bannister stands at the far left. The Home Plate Club still convenes once a month to talk about baseball, and members raise funds to support little league teams. (Columbus *Citizen*, Scripps-Howard Newspapers/Grandview Heights Public Library/Photohio.org.)

**LEFTY.** Before there were varsity sports for women, Alice "Lefty" Hohlmayer represented Ohio State (1943-49) in the club sports of softball, field hockey, basketball, soccer, badminton, archery, and tennis. From 1946 to 1951, Lefty played for the Kenosha Comets in the All-American Girls Professional Baseball League, the subject of the popular movie, *A League of Their Own*. Hohlmayer is a member of The Ohio State University Athletic Hall of Fame. (Author's collection.)

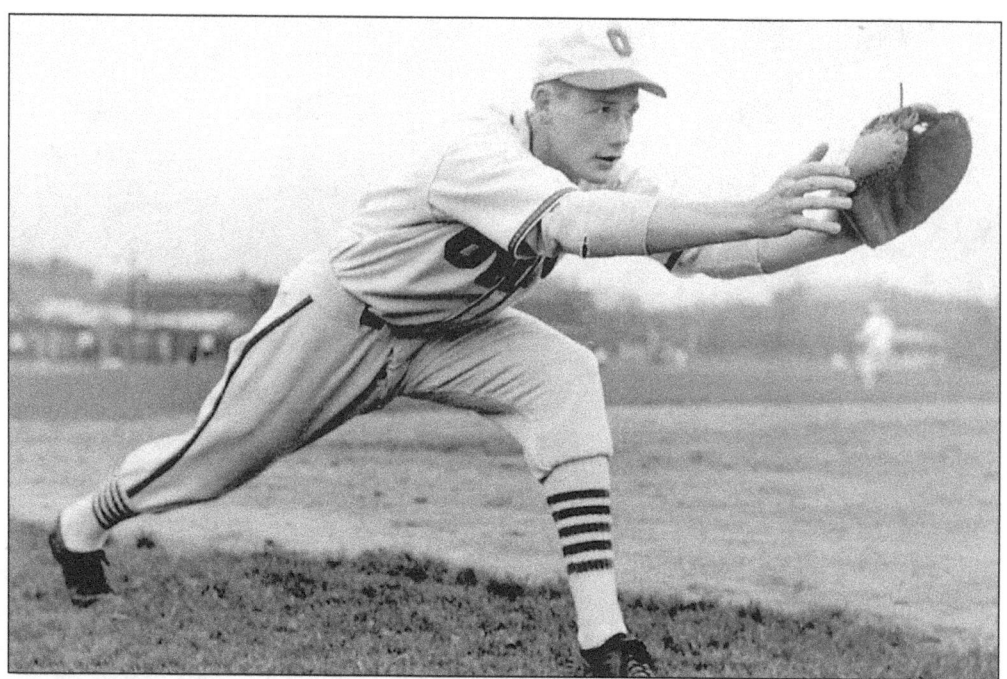

**FUTURE COACH.** Fred Taylor played basketball and baseball for Ohio State. The hard-hitting first baseman earned All-American honors in his senior year, 1950, and made it to the majors with the Washington Senators for 22 games from 1950 to 1952. He returned to his alma mater as freshman baseball and basketball coach in 1953 and was head basketball coach from 1958 to 1976. (The Ohio State University Archives, 19182.)

**BASEBALL MOSAIC.** As part of Ohio's public art policy, the Schottenstein Center on the Ohio State campus features mosaics in the terrazzo floors of each of the four rotundas. Artist Alexis Smith chose the 1950 photo of Fred Taylor as the inspiration for one of her large mosaics. Taylor is the only person to play major league baseball and coach a team to a national championship in basketball. (The Ohio State University Athletics Department.)

**CHECKING THE STANDINGS.** First baseman Steve Bilko and infielder Joe Aliperto appear to be looking at the sports page of the Columbus *Citizen* in May 1951. Bilko became a regular with the Cardinals in 1953 and hit 21 home runs while driving in 84. He later played with the Cubs, Reds, Dodgers, Tigers, and Angels, staying in the majors through the 1962 season. (Columbus *Citizen*, Scripps-Howard Newspapers, Grandview Heights Public Library/Photohio.org.)

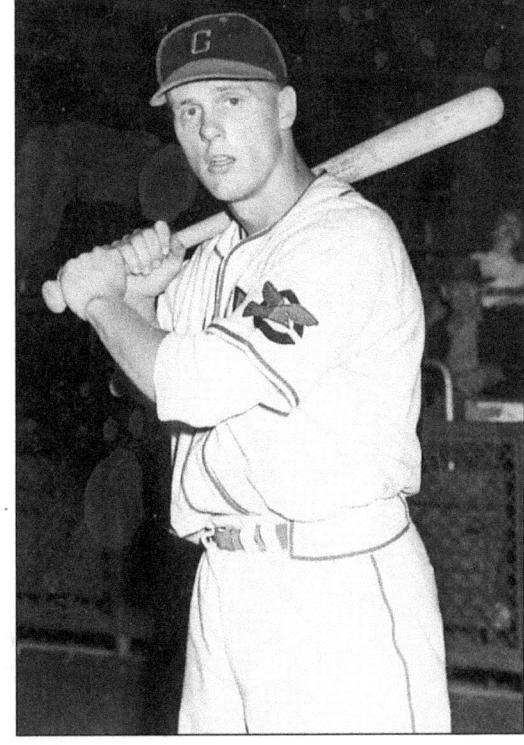

**RED BIRD BATTER.** Eldon John "Rip" Repulski is pictured at Red Bird Stadium in 1951. Repulski moved up to St Louis as a regular outfielder for four seasons beginning in 1953, making the All-Star team in 1956. He later played for the Phillies, Dodgers, and Red Sox during his nine-year major league career. (Columbus *Citizen*, Scripps-Howard Newspapers/ Grandview Heights Public Library/ Photohio.org.)

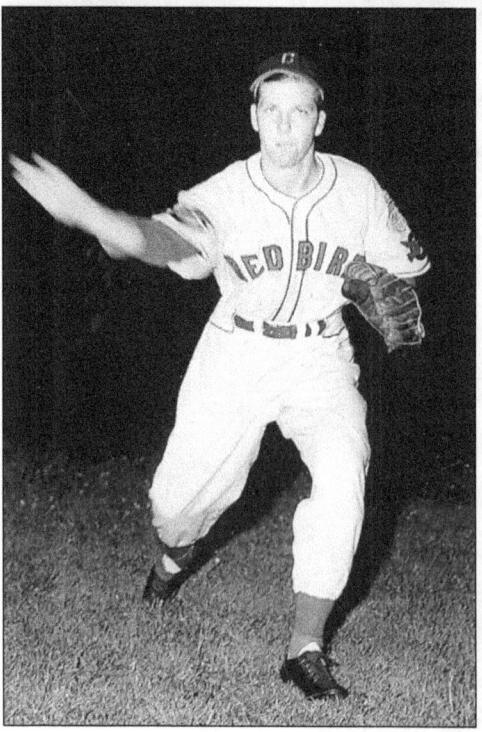

**SPRING TRAINING 1950.** Les Fusselman (left) receives instruction on his catching technique from a qualified teacher, Red Bird manager Rollie Hemsley. During his 19-year playing career (1928-1947), Hemsley made the All-Star team five times. In 1940, Hemsley caught Bob Feller's Opening Day no-hitter. Fusselman made it to the majors with the Cardinals in 1952 and 1953. (Columbus *Citizen*, Scripps-Howard Newspapers/Grandview Heights Public Library/Photohio.org.)

**BOYER BROTHER.** Cloyd Boyer is shown pitching for Columbus in 1951. He played five seasons in the majors. Brother Ken was an All-Star third baseman for the Cardinals, winning the NL MVP Award in 1964. Brother Clete, known for his spectacular fielding at the hot corner, played on five Yankee AL pennant winning teams, and then coached and managed many years in the Yankee organization. (Columbus *Citizen*, Scripps-Howard Newspapers/Grandview Heights Public Library/Photohio.org.)

**HADDIX AS A RED BIRD.** Harvey Haddix was an American Association All-Star in 1948, 1949, and 1950, and then pitched 14 years in the majors. He is best remembered for pitching a perfect game for 12 innings in 1959 for Pittsburgh, only to lose in the 13th. Haddix had a successful career as a major league pitching coach for the Mets, Reds, Red Sox, Indians, and Pirates. (Columbus *Citizen*, Scripps-Howard Newspapers/Grandview Heights Public Library/Photohio.org.)

**CATCHING TIPS.** Red Bird manager Rollie Hemsley (left), a former big-league receiver, and Bill Sarni, the starting catcher in 1950, give some pointers to batboy Charles Wareham, son of team official Chuck Wareham. The hard-hitting Sarni was named to the All-Star team in 1950 and 1953. In 1954 he hit .300 and drove in 70 runs for the Cardinals. (Columbus *Citizen*, Scripps-Howard Newspapers/Grandview Heights Public Library/Photohio.org.)

RED BIRD FAVORITE. Shortstop Solly Hemus, nicknamed "Mighty Mouse," was a popular player for Columbus. He replaced the great Marty Marion at shortstop for the Cardinals when called up in 1951. Hemus was named player-manager of the Cardinals for the 1959 season. He was succeeded as Cardinal manager in mid-season 1961 by Johnny Keane, who had managed the Columbus Red Birds from 1952 to 1954. (Columbus *Citizen*, Scripps-Howard newspapers/Grandview Heights Public Library/Photohio.org.)

BILL HOWERTON. Outfielder Bill Howerton was an exceptionally productive player for the Red Birds in the late 1940s. In 1949, he hit .329, with 21 homers and 111 RBI and was named to the American Association All-Star team. He was a member of *The Sporting News* All-Rookie team in 1950 and played in the majors with the Cardinals, Pirates, and Giants. (Columbus *Citizen*, Scripps-Howard Newspapers/Grandview Heights Public Library/Photohio.org.)

**HEADING FOR COLUMBUS.** Having completed spring training, Cot Deal, Mo Mozzali, and Roy Broome ride the train home from Florida in April 1951. Deal switched from pitching to the outfield in 1951 and hit 18 home runs. Mozzali, a line-drive hitter who was excellent defensively at first base, was an All-Star in 1953 and 1954. Broome, a speedy outfielder, had five solid years with Columbus (1947-1951). (Columbus *Citizen*, Scripps-Howard Newspapers/Grandview Heights Public Library/Photohio.org.)

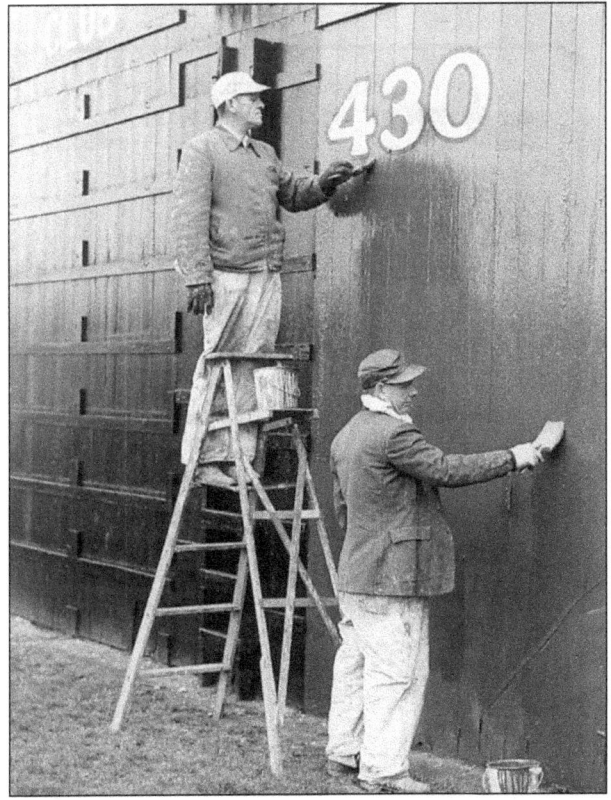

**GETTING READY.** Painters Ernie Lantz and William Shields apply a fresh coat to the scoreboard and outfield fence in preparation for the 1951 season. Player-manager Harry "The Hat" Walker, a major league veteran, hit .393 and made the American Association All-Star team, but the Red Birds compiled a record of 53–101 and finished in the cellar. (Columbus *Citizen*, Scripps-Howard Newspapers/Grandview Heights Public Library/Photohio.org.)

**RED BIRD ARRIVALS.** Pitcher Luis Arroyo, pitcher Herb Moford, and shortstop Fred McAlister arrive at Union Station from spring training in Florida in April 1951. Arroyo made the NL All-Star team as a 28-year-old rookie in 1955 and was the Yankees' relief ace in 1961. Appearing in 65 games, he won 15 and led the league with 29 saves. (Columbus *Citizen*, Scripps-Howard Newspapers/Grandview Heights Public Library/Photohio.org.)

**THE KNOT HOLE GANG.** Young Red Birds fans who belonged to the Knot Hole Gang had access to home games at a reduced rate. The name comes from the ancient practice of kids looking through a hole in the outfield fence to see the game. The chairman of the program, State Auditor James A. Rhodes, was a former mayor of Columbus who later served as Ohio's Governor for 16 years. (Courtesy Mike Nightwine.)

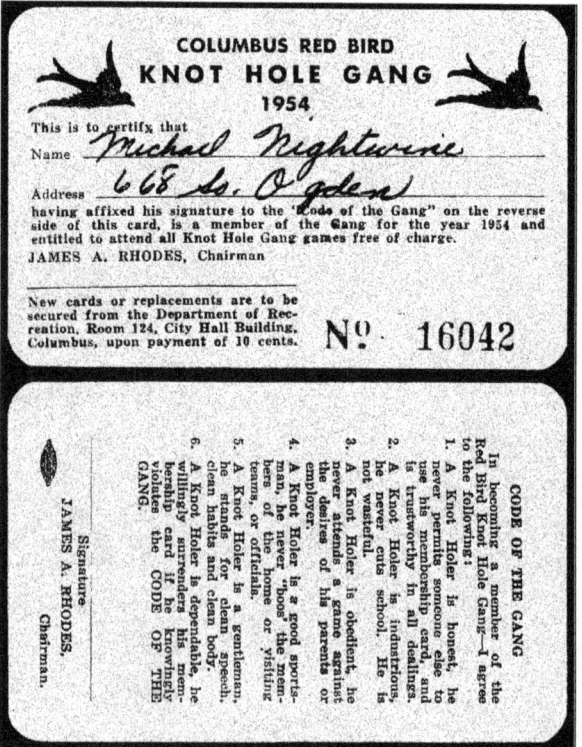

*Five*

# THE JETS TAKE OFF

When the Red Birds played their last game at the end of the 1954 season, some feared professional baseball in Columbus was gone. Fortunately, a group of business and community leaders stepped forward to try to keep baseball alive in the capital city. These investors succeeded in acquiring the Ottawa franchise in the International League, the Triple-A affiliate of the Athletics, who were in the process of moving from Philadelphia to Kansas City during the 1954-55 off-season. The new team was named the Jets. The group also bought Red Bird Stadium from the Cardinals, renaming it Jet Stadium. Columbus, the eastern-most city of the original members of the American Association, became the western-most city of the International League.

In becoming part of the Athletics' organization, the Jets were wading into the shallow end of the talent pool. In 1954, their final year in Philadelphia, the A's had finished dead last in the American League with a record of 51-103, an incredible 60 games behind the first-place Cleveland Indians. The 1954 Ottawa A's were also a cellar team at 58-96, 39 games off the pace. Both Philadelphia and Ottawa had experienced abysmal attendance in 1954, finishing last in their leagues at the gate as well as in the standings. The major league A's drew only 304,666 for the entire season, while just 93,982 watched their Triple-A club play.

While the prospect of putting a winning team on the field was not good, the people of Columbus were glad to have a club coming in for the new season. The community rallied to support the new team in part because of its organizational philosophy, as explained in this statement in the 1955 program:

> *The operation of the Columbus Jets is unique in baseball history. Never before has a group of the outstanding, civic-minded citizens of a community banded together to assure the continuance of professional baseball by putting up a certain amount of money without a chance of even a nickel in return—then turning all profits over to the youth of their community.*

*Yes, that is just what has happened in Columbus this season. As soon as legal barriers can be hurdled, the Youth Foundation of Columbus will actually own the Columbus Baseball Club. The same 11 directors of the Baseball Club are the trustees of the Youth Foundation.*

Insurance executive Fred Jones, a member of the investor group, served as club president. Harold Cooper, who had worked in the Red Bird organization and led the effort to bring a new team to Columbus in 1955, was named general manager. Cooper would later become a Franklin County Commissioner and president of the International League. Columbus baseball icon Nick Cullop, the slugging outfielder of the 1930s and championship-winning manager of the 1940s, was hired as field manager.

On the playing field, the 1955 Jets featured Spook Jacobs at second base, the club's lone representative on the IL All-Star team. Russ Sullivan was a power-hitting outfielder in the early years of the Jets, eventually earning a place in the Columbus Baseball Hall of Fame. The Club finished seventh in 1955, but drew more than 204,000 fans, a total that doubled what the Red Birds had averaged in recent years.

In 1956, the Jets had the distinction of playing before the largest crowd in minor league history when 57,713 jammed the Orange Bowl in Miami to see ageless Satchel Paige pitch the Marlins to a victory over Columbus. Another highlight of 1956 was second baseman Curt Roberts' feat of hitting four home runs in a seven-inning game against Havana.

After two seasons in the Kansas City organization, the Jets became Pittsburgh's top farm club, a natural association since the principal owner of the Pirates was John Galbreath of Columbus. After Columbus became part of Pittsburgh's farm system, both the Jets and the Pirates began to move up in the standings.

Many Jets, including the great Willie Stargell, went on to play important roles on the Pirates. Some made their mark with other teams. Tom Cheney, pitching for Washington in 1962, set a major league record by striking out 21 batters in a 16-inning game. Julian Javier became a NL All-Star for the Cardinals. Wilbur Wood won 20 games four straight years for the White Sox. Fred Patek starred at shortstop for Kansas City. Al Jackson pitched well for the expansion Mets.

People could see future big league stars not only on Triple-A teams but also in intercollegiate action at Ohio State. As the 1955 defending Big Ten champions, the 1956 team was invited go on an extensive tour of the Far East from late June to early August. This team included the familiar names of Frank Howard, Galen Cisco, and Hopalong Cassady. All were two-sport stars for the Buckeyes, and all were still affiliated with professional baseball nearly 50 years after serving as good will ambassadors on that trip to Japan. In 1966, Coach Marty Karow's Ohio State team, led by future San Diego Padres' pitcher Steve Arlin, won the College World Series.

The two best seasons for the Jets came in 1961 and 1965, when they won the International League pennant under manager Larry Shepard. In addition to the pennant wining seasons, the Jets also participated in the Governor's Cup playoffs in 1958, 1959, and 1966-70.

For all the good intentions of the civic leaders who saved baseball by acquiring the Ottawa franchise in 1955, the Club's altruistic relationship with the Columbus Youth Foundation proved its undoing. By the late 1960s, Jet Stadium was in need of repairs, but a judge ruled that since all profits of the club were to be paid to the Foundation, funds could not be spent on the ballpark. As the condition of the park declined, the Pirates had no alternative but to move the franchise to Charleston, West Virginia after the 1970 season, again jeopardizing Columbus' baseball future.

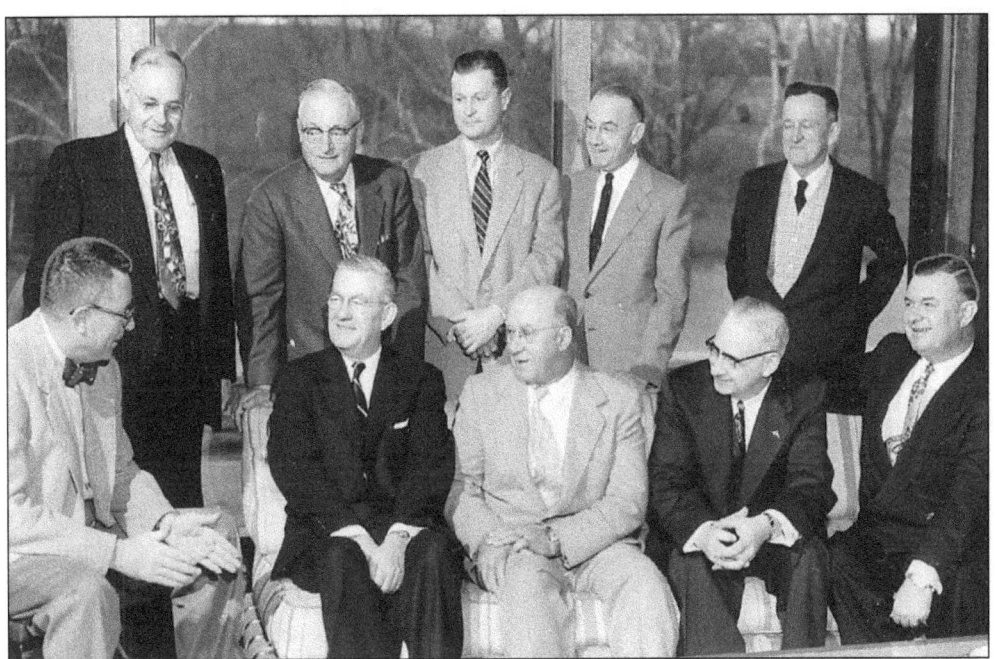

BASEBALL SAVED IN COLUMBUS. When the St. Louis Cardinals moved the Red Birds to Omaha after the 1954 season, a group of community and business leaders acquired the Ottawa franchise of the International League. From left to right: (front row) Fred Jones, Thomas Carroll, J.J. Visintine, George Byers, and Robert Barton (representing Wayne Brown); (back row) F.E. Gooding, H.W. Jameson, Don Casto, Jr., Robert Lazarus, and John Galbreath. (Columbus *Citizen*, Scripps-Howard Newspapers/ Grandview Heights Public Library/Photohio/org.)

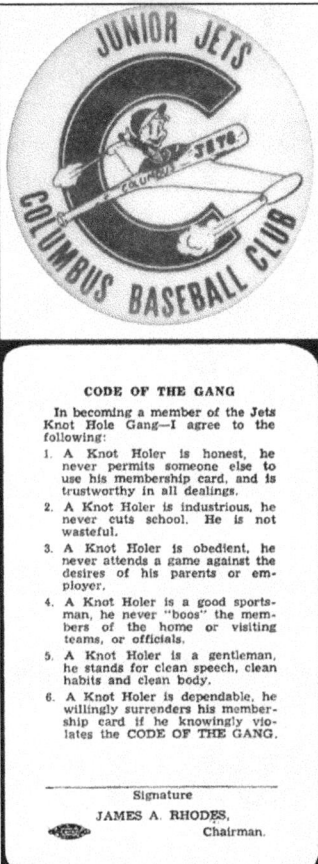

JET BADGE. Although the name of the Columbus team had been changed from the Red Birds to the Jets, the Knot Hole Gang idea was continued by the new ownership. Having members wear metal badges with the team emblem gave the program more visibility. Young fans with a Jet Badge could buy a ticket for fifty cents. The code of conduct for members was also continued. (Courtesy Mike Nightwine.)

77

**A TIME OF TRANSITION.** In the winter of 1955, Mayor Maynard Sensenbrenner (left) uses a crowbar to remove the letters spelling out "Red Bird Stadium" from the Columbus ballpark's brick façade. As Columbus moved from the Cardinal organization and the American Association to the Kansas City organization and the International League, the park would be renamed Jet Stadium. (Columbus *Citizen*, Scripps-Howard Newspapers/Grandview Public Library/Photohio.org.)

**END OF AN ERA.** Columbus Jets' General Manager Harold Cooper (right) lights a match under the recently removed letters that had spelled out "Red Bird Stadium" on the front of the ballpark. Jim Visintine and Mayor Maynard Sensenbrenner (center) get ready to warm their hands over the fire. (Columbus *Citizen*, Scripps-Howard Newspapers/Grandview Heights Public Library/Photohio.org.)

**1955 SCOREBOOK.** Club officers are Fred Jones, president; Harold Cooper, general manager; Chuck Wareham, business manager; and Don Labbruzzo, assistant general manager. Columbus baseball legend Hank Gowdy is listed as Coordinator of Youth Activities. A feature on Manager Nick Cullop reports that the "the old Hipper Dipper," who starred for the Red Birds from 1932 to 1936, is glad to be back in Columbus. (Courtesy Mike Nightwine.)

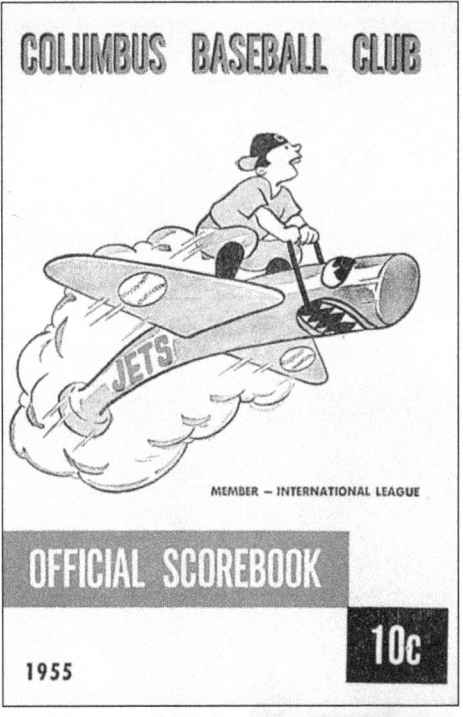

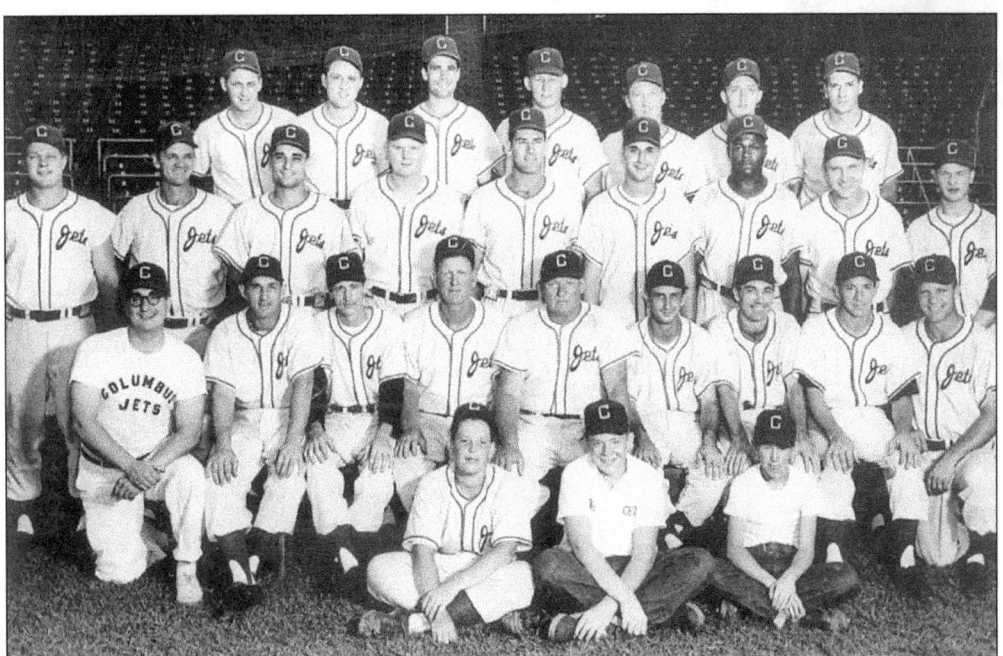

**THE 1955 JETS.** From left to right: (up front) batboys Rodger Corbin, Harry Sykes, and Howdy Lewis; (front row) Trainer Randy Alfano, Charlie Haak, Jim Miller, Coach Red Barrett, Manager Nick Cullop, Spook Jacobs, Joe Erautt, and Russ Sullivan; (middle row) Eric Roden, Al Lakeman, Ted Del Guercio, Leroy Wheat, John Gray, Constantine Keriazakos, Al Pinkston, Dick Kryhoski, Carl Duser; (back row) Jake Theis, Frank Verdi, Cal Van Brabant, Bill Stewart, Lou Sleater, Dutch Romberger, and Hal Bevans. (Courtesy Joe Santry.)

**FAN FAVORITE OF THE NEW JETS.** Forrest "Spook" Jacobs, who had played with the Athletics in 1954, quickly gained popularity in Columbus for his hitting, hustle, and defense in 1955, the Jets' first year. Jacobs hit .316 and was named to the International League All-Star team at second base. He played again in the majors with the A's and Pirates. (Columbus *Citizen*, Scripps-Howard Newspapers/Grandview Heights Public Library/Photohio.org.)

**BASEBALL ON THE RADIO.** Joe Hill became the first broadcaster of the Jets, as this ad from the scorebook indicates. His familiar voice would continue to describe the action at the ballpark through the 1964 season and again in 1970. In 1992, announcers Joe Hill and Jack Buck (1950-1952) were elected to the Columbus Baseball Hall of Fame. (Courtesy Mike Nightwine.)

**ORIGINAL JETS.** Pitching coach Red Barrett and catcher Mike Roarke were members of the first Columbus Jets club of 1955. Barrett was a former big league hurler. Roarke made it to the majors as a player with Detroit (1961-64), and then enjoyed a long career (1965-94) as a major league coach with the Tigers, Angels, Cubs, Cardinals, Padres, and Red Sox. (Columbus *Citizen*, Scripps-Howard Newspapers/Grandview Heights Public Library/Photohio.org.)

**JOE GIBBON.** Lefty Joe Gibbon of the Jets led the International League in strikeouts in 1959. Called up to the Pirates in 1960, he pitched in two World Series games. Used as both a starter and reliever, Gibbon had a solid a 13-year career in the National League with the Pirates, Giants, Reds, and Astros. (Columbus *Citizen*, Scripps-Howard Newspapers/Grandview Heights Public Library/Photohio.org.)

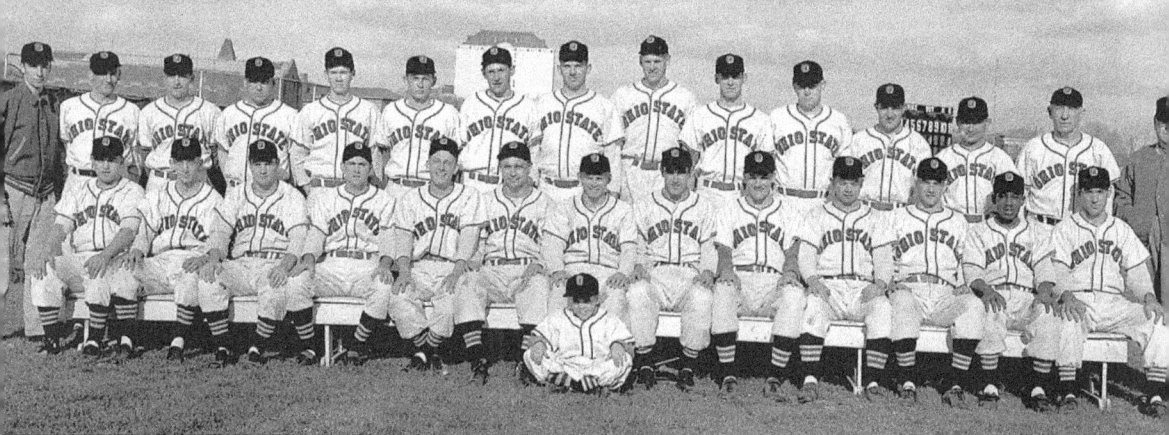

THE 1956 BUCKEYES. From left to right: (front row) Dzingeleski, Shay, Cassady, Sadler, Burns, Schnabel, Ellis, Kelley, Hartley, Purvis, Steagall, Barkstall, and Cardinia; (back row) McClure, Rose, Burkley, Cisco, Holland, Oltmanns, Lindop, Burger, Howard, Rutecki, Meade, Soter, Mizutani, Karow, and Busenburg.

In spring 1956, it was announced that Coach Marty Karow's Ohio State baseball team would be leaving in June on an extensive trip to Japan for a series of games against Japanese university teams and American and Japanese military teams. The Buckeye baseball team included two future major leaguers—junior pitcher Galen Cisco, later a football co-captain, and slugging sophomore outfielder Frank Howard, who would attain All-American honors in basketball. The team also included the 1955 Heisman Trophy winner, center fielder Howard "Hopalong" Cassady.

The first game was played before a crowd of 55,000 in Tokyo on June 20. Plans called for the team to return August 9, having played about 30 games. In a July 5 column about the trip, *Columbus Dispatch* sportswriter Paul Hornung reported that big Frank Howard's long home runs had made him "a slugging sensation in the Far East." After commenting on the team's winning record on the tour, Hornung observed, "On the good will side, the Buckeyes appear to be accomplishing their purposes too. The Japanese press commended Karow's men...for 'strong competitive spirit and admirable sportsmanship.' It comes as no surprise, of course, that the Buckeyes are representing their university and their nation so nobly." (The Ohio State University Archives, x27746.)

FRANK HOWARD. A graduate of Columbus South High School, Frank Howard is pictured here as a slugging outfielder for the Ohio State Buckeyes in the spring 1956. The 6-foot 7-inch Howard was a two-sport standout for the Buckeyes, earning All-American honors in basketball. He was named NL Rookie-of-Year 1960 and was one of the game's most feared hitters during his 16 years in the majors. (The Ohio State University Archives x27754.)

GALEN CISCO. Buckeye fullback Galen Cisco was also the leading pitcher on the baseball team. Cisco pitched for the Red Sox, Mets, and Royals as both a starter and reliever during his seven years in the majors. After his playing days, he had a long and successful career as a pitching coach for the Royals, Expos, Padres, Blue Jays, and Phillies. (The Ohio State University Archives, x27754.)

A LOYAL FAN. Manager Frank Oceak chats with a Columbus fan, identified as Mrs. C.W. Jarvis of Grandview, seated in the front row at Jet Stadium. She was one of 180,072 fans who came to watch the seventh-place Jets in 1957, Oceak's only year in Columbus. Pitcher Don Kildoo, who was 7–11 in 36 games, signs her scorecard. (Columbus *Citizen-Journal*, Scripps-Howard Newspapers/Grandview Heights Public Library/Photohio.org.)

CHAMPIONSHIP YEAR. The Jets won the International League pennant in 1961 and again 1965. This scorebook is from 1961, Larry Shepard's first of six seasons as manager. Shepard later managed the Pirates and was the pitching coach on the Cincinnati teams of the 1970s. Jets Donn Clendenon, Roman Mejias, Bob Oldis, Bob Veale, and Diomedes Olivo were All-Stars in '61. Shepard was the All-Star manager. (Courtesy Mike Nightwine.)

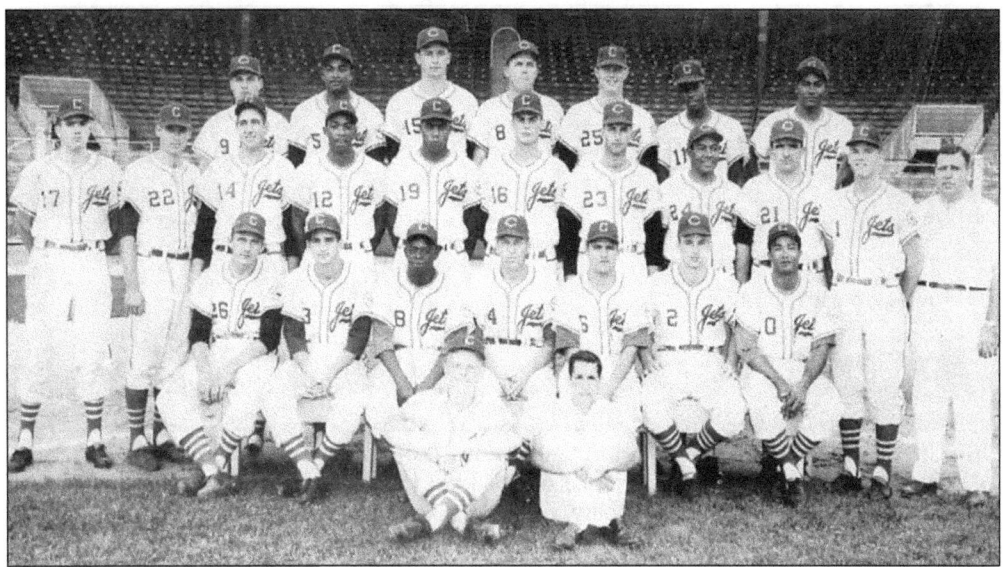

THE 1961 JETS. From left to right: (up front) batboy Jim Tice and club house boy Johnny Nicholson; (front row) Bob Oldis, Jim Mahoney, Al Jackson, Manager Larry Shepard, player-coach Dick Gray, Buddy Pritchard, and Duncan Campbell; (middle row) Jim Saul, Larry Elliot, Jim Umbricht, Donn Clendenon, Bobby Veale, Tom Parsons, Fred Green, Diomedes Olivo, Jack Lamabe, Ed Sada, and Trainer Tiny Tunis; (back row) Johnny Schaive, Roman Mejias, Tommie Sisk, Johnny Powers, Don Rowe, Elmo Plaskett, and Nino Escalera. (Courtesy Joe Santry.)

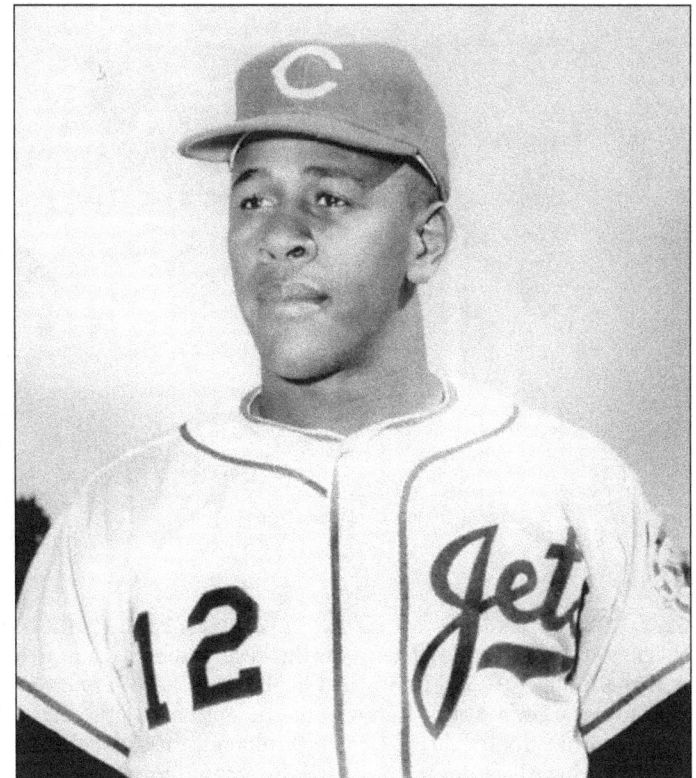

WILLIE STARGELL. Playing in 138 games for the Jets in 1962, Stargell hit 27 homers and knocked in 82 runs. His promotion to the Pirates in September marked the beginning of an extraordinary career. A seven-time All-Star, he led the Pirates to World Series championships in 1971 and 1979. Stargell was named co-winner of the MVP award in 1979 and was elected to the Hall of Fame in 1988. (Columbus Clippers.)

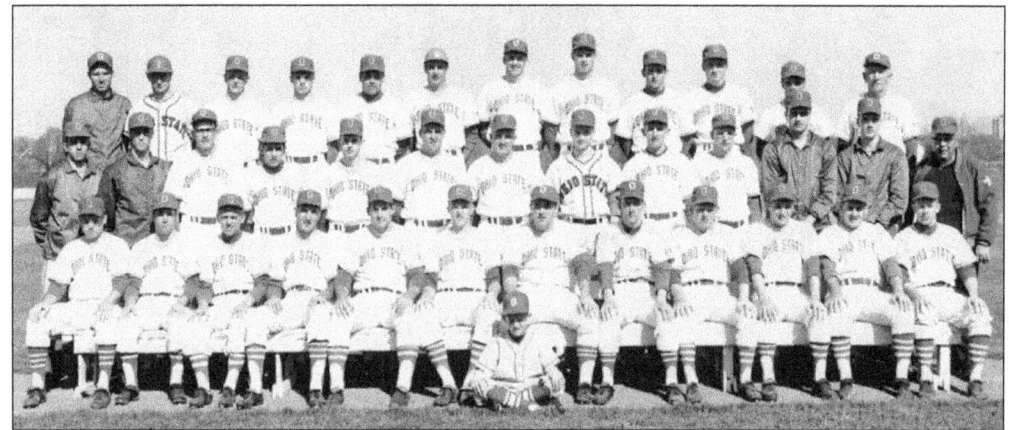

OHIO STATE BASEBALL CHAMPS. Ohio State went 27–6–1 and won the College World Series in 1966. From left to right: (up front) batboy Sickles; (front row) Reed, Morehead, Budding, Rein, Nagelson, Brinkman, Dusenbury, Winning, Graham, Copp, Heinfeld, and Heine; (middle row) Dawson, Marcucci, Zayac, Solomon, Monroe, Anderson, Cozze, Iannarino, Morgan, Elshire, Sepic, Hearst, and Trainer Busenberg; (back row) Dillon, Buckler, Stillwell, Shoup, Sexton, LeBay, Arlin, Swain, Baker, Boggs, Machado, and Coach Karow. (The Ohio State University Archives, 144.)

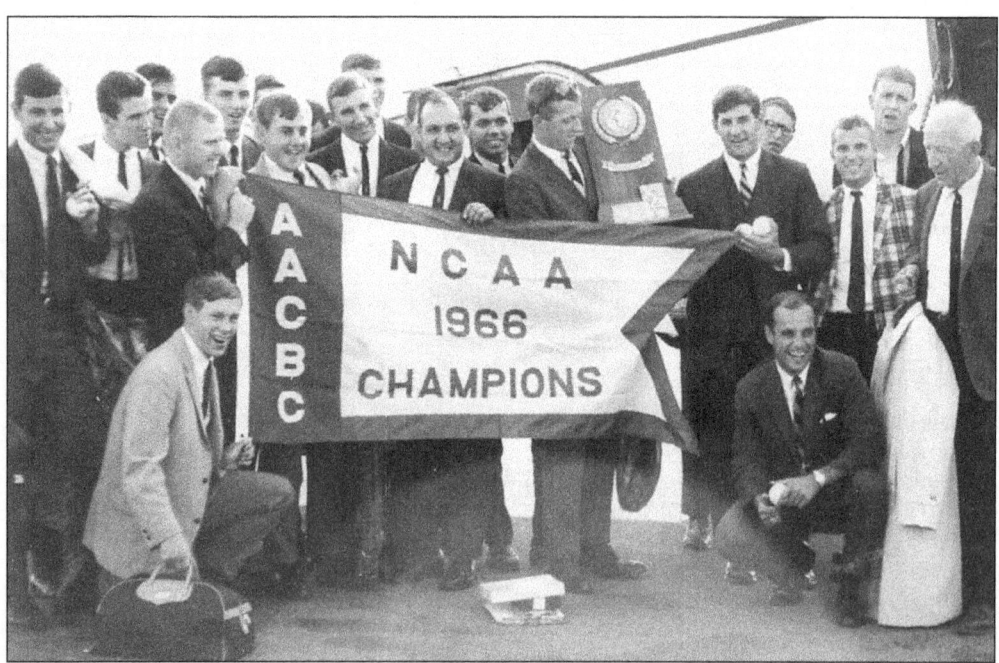

NATIONAL CHAMPIONS. The 1966 Buckeye baseball team arrives back in Columbus having won the College World Series in Omaha with an 8–2 victory over Oklahoma State in the final game. Coach Marty Karow is at the extreme right. Series MVP Steve Arlin holds the championship trophy. Arlin, Chuck Brinkman, Russ Nagelson, Bo Rein, and Ray Shoup were named to the All-Series team. (The Ohio State University Archives, 144.)

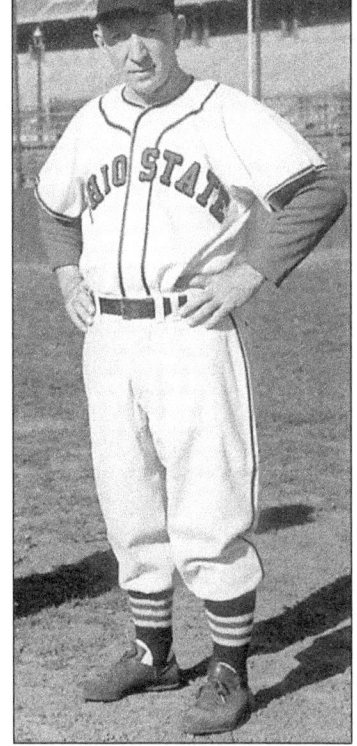

STEVE ARLIN. Two-time All-American Steve Arlin led Ohio State to the College World Series runner-up spot in 1965 and to the national championship in 1966. Arlin pitched for the San Diego Padres from 1969 to 1974. Buckeye teammates Russ Nagelson and Chuck Brinkman also played in the majors. Arlin's grandfather, Harold Arlin, announced the first major league baseball radio broadcast from Pittsburgh in 1921. (The Ohio State University Athletics Department.)

LEGENDARY COACH. Marty Karow was an All-American football player at Ohio State in 1926 and played baseball with the Red Sox in 1927. Head baseball coach at Ohio State from 1951 through 1975, his teams won 478 games, five Big Ten championships, and made three straight trips to the College World Series. Karow was named National Coach of the Year in 1967. (The Ohio State University Athletics Department.)

*Opposite*: THE 1968 JETS. From left to right: (up front) batboy Doug Geckler, club house attendant Bob Evans, and batboy Mitch Malloy; (front row) Chuck Hiller, Elvio Jimenez, Jack Damaska, Manager John Pesky, Bernie Smith, John Kennedy, and Gene Garber; (middle row) Trainer Rudy Owen, Ed Hobaugh, Dave Wickersham, Dan Schneider, Al Oliver, Andre Rodgers, Jim Shellenback, and Richie Hebner; (back row) Chris Cannizzaro, Manny Sanguillen, Pete Ramos, Dave Roberts, Ken Larsen, Jerry Wild, and George Spriggs. Not pictured is John Gelnar. (Courtesy Joe Santry.)

BASEBALL AT THE OHIO PEN. The baseball field at the old Ohio Penitentiary, shown in this photo from 1969, was named in honor of the institution's most distinguished former inmate, O. Henry. Although significant controversy exists regarding his guilt, William Sidney Porter was convicted of embezzlement and incarcerated in Columbus from 1898 to 1901. He began his writing career and published his first short story in a national magazine while in prison.

Upon his release, he moved to New York and took the name O. Henry. He then began turning out notable works such as "The Gift of the Magi" and "The Ransom of Red Chief" which established his reputation as one of America's most popular short story writers.

The site of the old Ohio Pen has been developed as part of an entertainment and sport complex that includes Nationwide Arena, home of the NHL Columbus Blue Jackets. (Columbus *Citizen-Journal*, Scripps-Howard Newspapers/Grandview Heights Public Library/Photohio.org.)

**THE LAST JETS TEAM.** From left to right: (up front) batboy Jeff Hall, club house attendant Rick Schirtzinger, and batboy Mark Kerns; (front row) Trainer Rudy Owen, Will Hammond, Buddy Booker, Chuck Goggin, Manager Joe Morgan, Rimp Lanier, Gene Garber, Angel Manguel, and Jose Martinez; (middle row) Dan Rivas, Pablo Cruz, Ron Davis, Frank Brosseau, George Kopacz, Dick Colpaert, Gary Kolb, and General Manager Charles Wareham; (back row) Fred Cambria, Milt May, Ron Campbell, Denny Ribant, Denny Riddleberger, Tom Frondorf, and Ed Acosta. Inset left: Larry Killingsworth. Inset right: Jim Nelson. (Courtesy Richard E. Barrett.)

**LASTING BENEFITS.** Willie Stargell, Pirate owner John Galbreath, and Commissioner Bowie Kuhn are pictured at an off-season celebration of Pittsburgh's 1979 World Series championship. Although the Jets departed Columbus after the 1970 season, former Jets continued to pay dividends for the Pirates over the next decade.

In addition to Stargell—the 1979 MVP—Al Oliver, Steve Blass, Dock Ellis, Manny Sanguillen, Richie Hebner, Bob Robertson, and a number of other former Columbus players were important contributors the success of Pittsburgh's great "Lumber Company" teams of the 1970s. The Pirates were frequently in the post-season playoffs, winning the National League Eastern Division championship in 1970, 1971, 1972, 1974, 1975, and 1979.

Columbus' John Galbreath, a noted horse breeder, sportsman, and real estate executive, joined a syndicate that bought the Pirates in 1946 and became club president in 1950. In the words of biographer John Hanners, "Galbreath's honesty and even-handedness made him among America's most respected elder sportsmen." His son Dan was named president of the Pirates in 1970. In 1985, the family sold its interests in the team. (Columbus *Citizen-Journal*, Scripps-Howard Newspapers/Grandview Public Library/Photohio.org.)

## Six

# COLUMBUS WINS WITH THE CLIPPERS

With departure of the Jets, Columbus was without professional baseball in 1971. For six summers, Jet Stadium—still owned by the Youth Foundation—sat vacant and fell into a state of deterioration. Sections of the roof caved in and the playing field was overgrown with weeds. While a group of community activists worked to bring baseball back to Columbus, County Commissioner Harold Cooper, along with Youth Foundation Trustees Robert Lazarus and Dan Galbreath, came up with a plan for Franklin County to purchase the stadium and fund a massive renovation.

In 1977, with the money in place and stadium restoration underway, George Sisler, Jr. was hired as general manager. An experienced and respected baseball executive, he had served as president of the International League for the past eleven years. The Charleston franchise was moved back to Columbus by the Pirates.

By the spring of 1977, the newly remodeled and renamed Franklin County Stadium was ready for baseball again. On April 22, the Columbus Clippers took the home field for the first time before an enthusiastic crowd of 15,721 on "Baseball Returns to Columbus Night."

The Clippers finished seventh in that first year, but established an IL record by drawing over 457,000 fans. Sisler was named International League and Triple-A Executive of the Year. Columbus had another seventh-place finish in 1978, but again led the league in attendance. Columbus' Harold Cooper, who worked so skillfully to bring baseball back in 1977, was elected president of the International League, a post he would hold until 1990. In recognition of his contributions to baseball in Columbus, Franklin County Stadium was named Cooper Stadium in 1984.

After two years with the Pittsburgh organization, Sisler signed an agreement for Columbus to become the Triple-A affiliate of the New York Yankees in 1979. The Clippers proceeded to become the first club in International League history to win three straight pennants and Governor's Cup championships (1979-81). This unprecedented feat was accomplished under three different managers: Gene Michael, Joe Altobelli, and Frank Verdi, one of the original Jets of 1955. In the middle of this extraordinary run of success on the field, an all-time attendance record was set on July 17, 1980, when 20,131 packed the stadium for the Rochester-Columbus

game featuring an appearance by The Famous Chicken.

After finishing a close second in 1982, the Clippers won IL pennants in 1983 under Johnny Oates and in 1984 under Stump Merrill. During the Clippers' first ten years, five members of the team won the league's MVP award: Bobby Brown (1979), Marshall Brant (1980), Tucker Ashford (1982), Scott Bradley (1984), and Dan Pasqua (1985). In 1987 under Bucky Dent, they were once again Governor's Cup champions.

After thirteen successful seasons, George Sisler, Jr. stepped down as the head of the Clippers, and his long-time assistant Ken Schnacke became general manager in late 1989. The Clippers began the decade of the 1990s by winning three consecutive pennants. Rick Down and Stump Merrill split the managerial duties in 1990, when Hensley Meulens was named league MVP. In 1991 and 1992 under Down, the Clippers won the Governor's Cup. J.T. Snow took 1992 MVP honors on a Clipper team that included future Yankee great Bernie Williams

While the Clippers were doing well in attendance and the standings, college baseball in Columbus continued to grow and prosper. New programs at Ohio Dominican and Columbus State complemented the established programs at Capital, Otterbein, and Ohio State, which could trace their roots back to the 19th century. With the opening of Ohio State's Bill Davis Stadium in March 1997, the university now had the facilities to bring NCAA post-season tournaments to Columbus. The stadium helped Ohio State become one of the few northern schools to be listed regularly among the top 25 college teams in the national rankings.

The Columbus area continues to produce major league talent. Reynoldsburg's Mike Matheny, a catcher for Milwaukee, Toronto, and St. Louis, won a Gold Glove with the Cardinals in 2000. Kent Mercker of Dublin began his long major league career in 1989 with Atlanta. He pitched a no-hitter for the Braves in 1994. Ohio State product Dave Burba has been a dependable pitcher in the big leagues for over ten years, including stints with both Cincinnati and Cleveland.

The Clippers' excellence has continued. Stump Merrill returned as Clipper manager in 1996 and won both the pennant and the Governor's Cup, the club's seventh Cup championship since 1979. In that span, no other club has won more than three. The 1999 edition of the Clippers, under Trey Hillman, won the IL pennant—the club's 11th since becoming the Yankees' Triple-A affiliate in 1979.

The Clippers' achievements have contributed to the enormous success of the parent Yankees. It is an ancient but accurate baseball adage that teams win championships through strength up the middle of the diamond. As the Yankees move into the 21st century with an impressive run of championship seasons, their strength up the middle is being provided by former Clippers. Catcher Jorge Posada, shortstop Derek Jeter, second baseman Alfonso Soriano, center fielder Bernie Williams, and star pitchers Andy Pettitte, Mariano Rivera, and Ramiro Mendoza all wore the Clipper pinstripes before moving up to New York. Shane Spencer, Nick Johnson and other Clipper alumni have also made important contributions.

In addition to rooting for the home team, part of the enjoyment of watching minor league baseball in Columbus has always been to look ahead and predict who will go on to success in the majors. The enjoyment of today's game is also enriched by knowledge of baseball's heritage, remembering the people and ballparks that belong to its storied past.

The connection to the early days of baseball in Columbus is symbolized by the location of the Mound Street stadium and Mt. Calvary Cemetery just beyond the ballpark's outfield fence. While watching the latest edition of the Clippers on a warm summer night, it is good to know that the ambient light from the ballpark is casting a glow over the grave of Ed Dundon, the young man who grew up in Columbus and played on the city's first major league team more than a century ago.

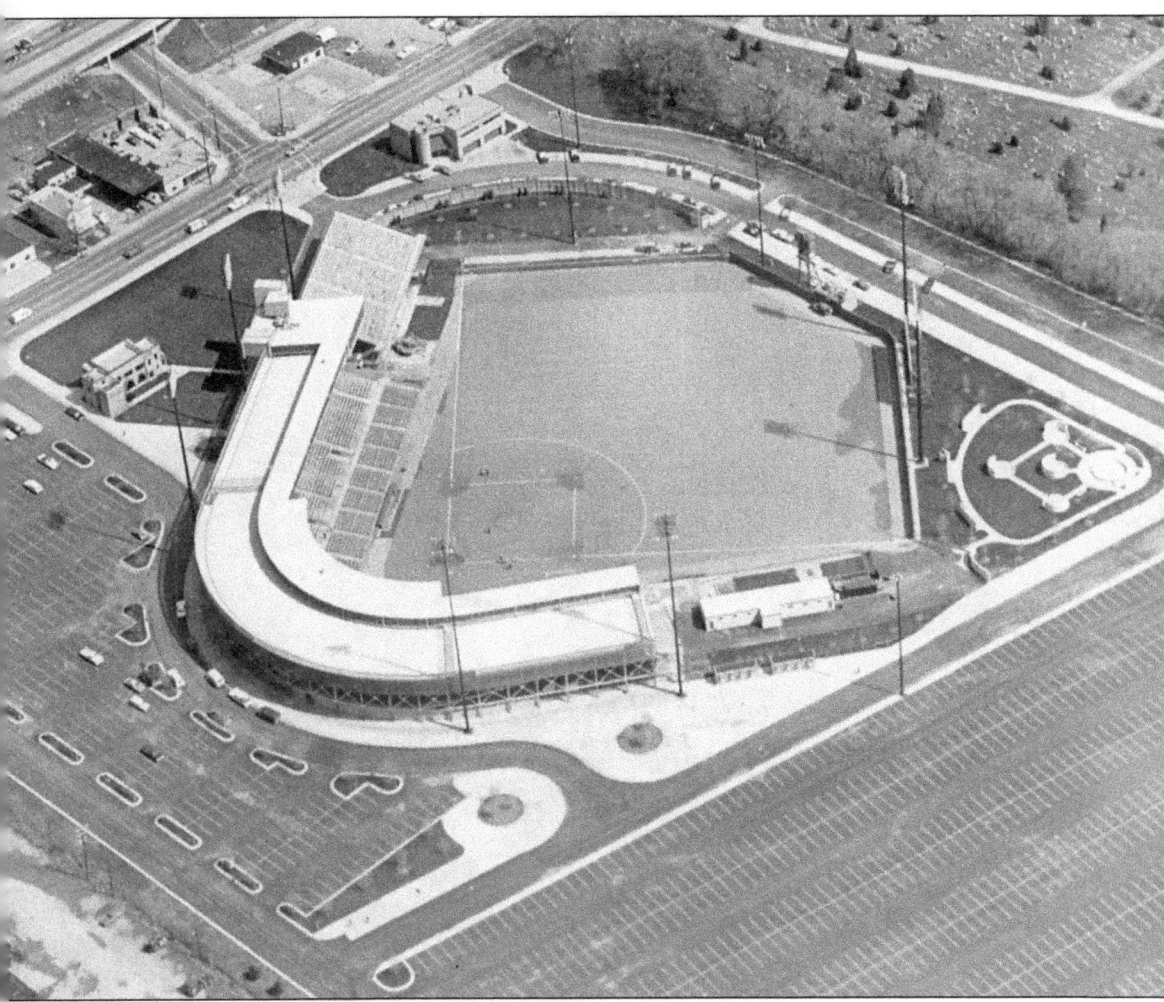

BASEBALL RETURNS. Commenting on the resurgence of the minors in the mid to late 1970s, baseball historians Lloyd Johnson and Miles Wolff cited Columbus as a prime example in their important book, *The Encyclopedia of Minor League Baseball*: "In 1977, Columbus, Ohio, without baseball for six years, saw its county government pump more than five million dollars into its old park, refurbishing the stadium and bringing back a team. It was a remarkable sum for a government to spend on a minor league park, but the results were immediate. Seventh place Columbus drew 457,251 fans, a total unheard of since the boom days of the late 1940s."

This aerial photograph shows the newly remodeled Franklin County Stadium in the fall of 1977, at the conclusion of its first season of use as the home of the Columbus Clippers. (Columbus *Citizen-Journal*, Scripps Howard Newspapers/Grandview Public Library/ Photohio.org.)

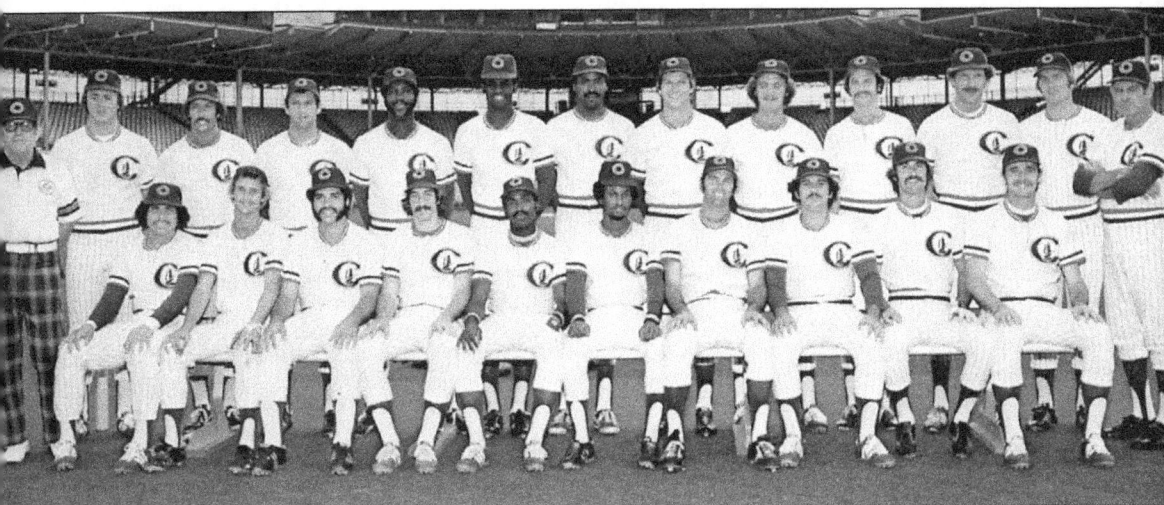

**THE FIRST CLIPPER TEAM.** From left to right: (front row) Ellie Rodriguez, Garry Hargis, Al Holland, Dale Berra, Alberto Louis, Mike Edwards, Jim Nettles, Steve Nicosia, Dave Augustine, and Jim Sadowski; (Back row) Trainer Red Hartman, Tim Jones, Lowell Palmer, Fred Scherman, Bob Oliver, Ron Mitchell, Randy Hopkins, Greg Terlecky, Ed Whitson, Rich Standart, Bob Johnson, Ken Macha, and Manager John Lipon.

The Clippers were the Triple-A affiliate of the Pirates when Columbus returned to the International League in 1977. Fans were thrilled to have a team in Columbus again. A crowd of 15,721 turned out on April 22 for "Baseball Returns to Columbus Night"; 15,907 came to a promotion on May 19; and 13,343 were on hand for a Pirates-Clippers exhibition game on May 26. The team got off to a slow start (11–24) but finished strong (54–51) after a managerial change brought in veteran major league infielder Johnny Lipon to run the team. The club finished seventh, but baseball was definitely back. Columbus led the IL in attendance with 457,251, more than 300,000 above the Jets' attendance of 140,700 in their final season (1970).

On the playing field, Mike Easler led the club in batting average (.302) and home runs (18); his homer total was matched by Dale Berra (son of the Hall of Fame catcher). Manager Lipon was named Clipper of the Year. (Author's collection.)

*Opposite:* **GEORGE SISLER, JR.** The general manager of the new 1977 Columbus Clippers was the experienced and knowledgeable baseball executive, George Sisler, Jr. Sisler had been the general manager of the Columbus team in 1953 and 1954, the last two years the Red Birds were in the Cardinal organization. In 1964 with Rochester, Sisler was named International League Executive of the Year. Upon returning to Columbus, his outstanding leadership would make him the recipient of this prestigious award after the Clippers' inaugural season and again in 1979 and 1980. Sisler was also named Triple-A Executive of the Year by *The Sporting News* for 1977 and 1979. In 1989, the Clippers were named Triple-A "Organization of the Decade."

As a member of one of baseball's most distinguished families, Sisler's leadership of the new franchise in Columbus gave the Clippers instant respect and credibility. Son of the great St. Louis Browns first baseman George Sisler, Sr., whose lifetime batting average of .340 made him an early selection to the Hall of Fame, the new Columbus general manager connected with baseball's historic past while building a future winner at the gate and on the field.

Columbus led the International League in attendance every season during Sisler's 13 years at the helm (1977-1989). After becoming part of the New York Yankee organization in 1979, Columbus won three straight IL pennants. A second place finish the next year was followed by two more pennants in 1983 and 1984. The Clippers also won the Governor's Cup three consecutive years (1979-1981) and again in 1987 during Sisler's highly successful tenure as general manager. He was succeeded by Ken Schnacke after the 1989 season. (Columbus Clippers.)

**THE OFF-SEASON.** This January 1978 photo of the Columbus ballpark buried under a fresh snowfall brings to mind a comment attributed to the great Rogers Hornsby: "People ask me what I do in winter when there is no baseball. I'll tell you what I do. I stare out the window and wait for spring." (Columbus *Citizen-Journal*, Scripps-Howard Newspapers/Grandview Heights Public Library/Photohio.org.)

**THE HIT MAN.** Columbus Clippers' outfielder Mike Easler (left) is pictured in June 1978 with teammate Billy Baldwin receiving Player of the Month awards. Easler led the International League with a .330 average in 1978 and was named to the IL All-Star team. Known as "The Hit Man," Easler achieved a .293 average during his fourteen-year career in the majors. (Columbus *Citizen-Journal*, Scripps Howard Newspapers/Grandview Heights Public Library/Photohio.org.)

**FAMILIAR NAMES.** The 1979 team included Chris Welsh (top row, third from left), better known today as the popular TV broadcaster for the Cincinnati Reds. Welsh compiled a 22–31 record over five seasons in the majors. Gene "Stick" Michael (middle row, center), who managed the Clippers to the IL pennant and Governor's Cup championship in 1979, later served as the Yankees' manager and general manager. (Courtesy Mike Nightwine.)

**CLASS OF '79.** Danny Schmitz (top row, left in the 1979 Clipper team photo) played on three IL pennant winners as an infielder for Columbus from 1979 to 1982. Since 1991, Schmitz has been head baseball coach at Bowling Green State University where he has built a winning program and compiled over 300 coaching victories. Under Schmitz, the Falcons have made two appearances in the NCAA Tournament. (BGSU Photo Services.)

BUCKEYE COACH. Dick Finn was a four-year letter winner at Ohio State as a player from 1952 to 1955 under Marty Karow. In 1976, he succeeded his mentor as head coach of the Buckeyes and continued Karow's winning tradition. Coach Finn won more than 300 games in his 12 seasons as head of the Ohio State program. (The Ohio State University Athletics Department.)

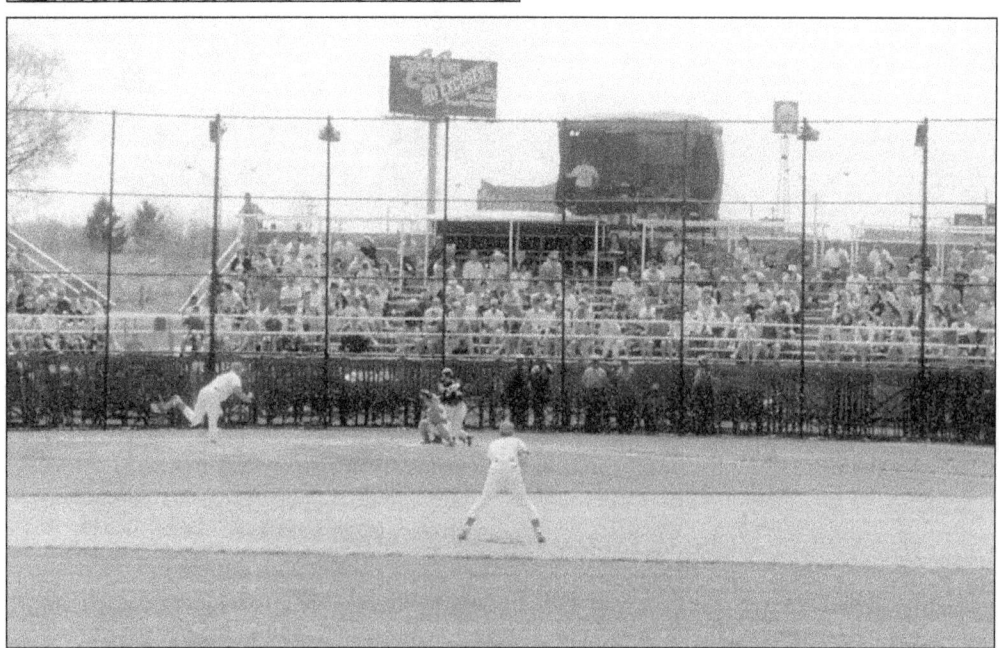

TRAUTMAN FIELD. From 1967 to 1996, the Ohio State baseball team played its home games at Trautman Field. The ballpark was named for George M. Trautman, former varsity athlete and coach at Ohio State. For many years Trautman was head of the National Association of Professional Baseball Leagues (the minors), headquartered in Columbus. The Trautman Field site is now occupied by the Jesse Owens Memorial Stadium. (The Ohio State University Athletics Department.)

**STARTER AND RELIEVER.** Dave Righetti joined the Clippers in 1979 and led the team in strikeouts in 1980. Promoted to the Yankees as a starting pitcher, Righetti was named American League Rookie of the Year in 1981. On July 4, 1983, he pitched a no-hitter against the Red Sox. Converted suddenly to a reliever for the 1984 season to replace Goose Gossage as the Yankees' closer, "Rags" attained instant bullpen success with 31 saves.

The Yankees' relief ace for seven seasons during which he saved 223 and won 41, he captured the Rolaids Relief Award twice. His best of several excellent years as one of baseball's top relievers of his era was 1986, when he led both leagues with 47 saves (a major league record at the time) and finished 4th in the voting for the Cy Young Award and 10th for MVP. Righetti is now enjoying a successful career as pitching coach for the San Francisco Giants. (Columbus *Citizen-Journal*, Scripps-Howard Newspapers/Grandview Heights Public Library/Photohio.org.)

**MARSHALL BRANT.** Clipper first baseman Marshall Brant led the International League in home runs and RBI in 1980, when he was named International League MVP, Topps Triple-A Player of the Year, and Clipper of the Year. The following year Brant had another great season, but came in second in the league in home runs and RBI to teammate Steve Balboni. In 1981, Brant and Balboni combined for 58 homers and 193 RBI as they led the Clippers to their third straight pennant and Governor's Cup championship.

Brant is the all-time Clipper franchise leader in RBI (302) and is second in home runs and total bases. Elected to the Columbus Baseball Hall of Fame in 1989, Brant is the only Clipper to have his uniform number (#33) retired. (Columbus *Citizen-Journal*, Scripps-Howard Newspapers/Grandview Heights Public Library/Photohio.org.)

**STEVE BALBONI.** A power hitting first baseman and DH, Balboni led the IL in RBI and home runs in the 1981 championship season. He repeated as league home run champ in 1982. He is the all-time Clipper franchise leader in home runs with 92. Balboni had a successful 11-year major league career with the Yankees and Royals. (Columbus Clippers.)

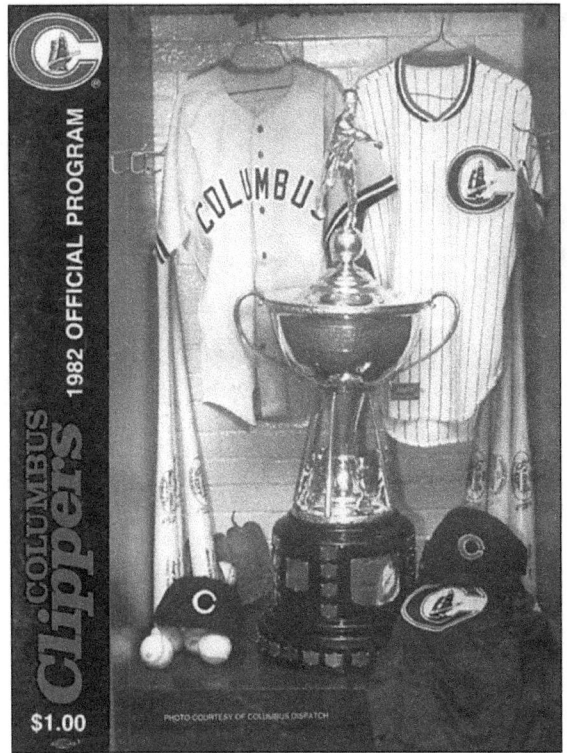

**1982 PROGRAM.** The Governor's Cup featured on this 1982 program was a fixture in the Clippers' trophy case. Managed by former Jet player Frank Verdi, they won their third straight championship in 1981. The Clippers finished second in 1982 and won two more IL pennants—in 1983 under Johnny Oates and 1984 under Stump Merrill. Tucker Ashford, who hit .331 with 101 RBI, was the 1982 Clipper of the Year. (Courtesy Mike Nightwine.)

**DON MATTINGLY.** Playing the outfield and first base, Don Mattingly batted .321 for the Clippers during his two seasons in Columbus (1982 and the first part of 1983). Along with Clipper teammates third baseman Tucker Ashford, designated hitter Marshall Brant, and pitcher Curt Kaufman, Mattingly was named to the International League All-Star team as an outfielder in 1982.

An outstanding hitter while playing for Columbus, Mattingly was even more productive after his promotion to New York, where he became one of the great players in the history of the franchise. In his first year as a regular in 1984, he won the American League batting championship with an average of .343, and proceeded to hit over .300 for six straight years. In 1985, Mattingly won the MVP award with an average of .324, 35 home runs, and a league-leading 145 RBI. An excellent defensive first baseman, he won nine Gold Glove awards. Mattingly was named to the AL All-Star team his first six years in the majors (1984-89). The onset of back problems cut into his offensive production beginning in 1990, but he remained a dangerous clutch hitter and respected team leader through his retirement after the 1995 season. Mattingly's number 23 has been retired by the Yankees. (Columbus Clippers.)

AUTOGRAPH REQUESTS. Jim Deshaies heads for the dugout as young fans ask him to sign. In 1984, Deshaies led the IL in ERA and shutouts, and Columbus in complete games, strikeouts, and innings pitched. In 1985, he was the staff leader in starts and strikeouts. During his 12 years in the majors, mostly with the Houston Astros, Deshaies won 84 games. He later became a broadcaster with the Astros. (Columbus *Citizen-Journal*, Scripps-Howard Newspapers/Grandview Heights Public Library/Photohio.org.)

LEAGUE LEADER. Columbus lefthander Dennis Rasmussen led the International League in wins, starts, and strikeouts in 1983. In his 12-year major league career, he won 91 games pitching for the Yankees, Padres, Reds, and Royals. His best year was 1986, when he was 18–6 for New York. (Columbus *Citizen-Journal*, Scripps-Howard Newspapers/Grandview Heights Public Library/Photohio.org.)

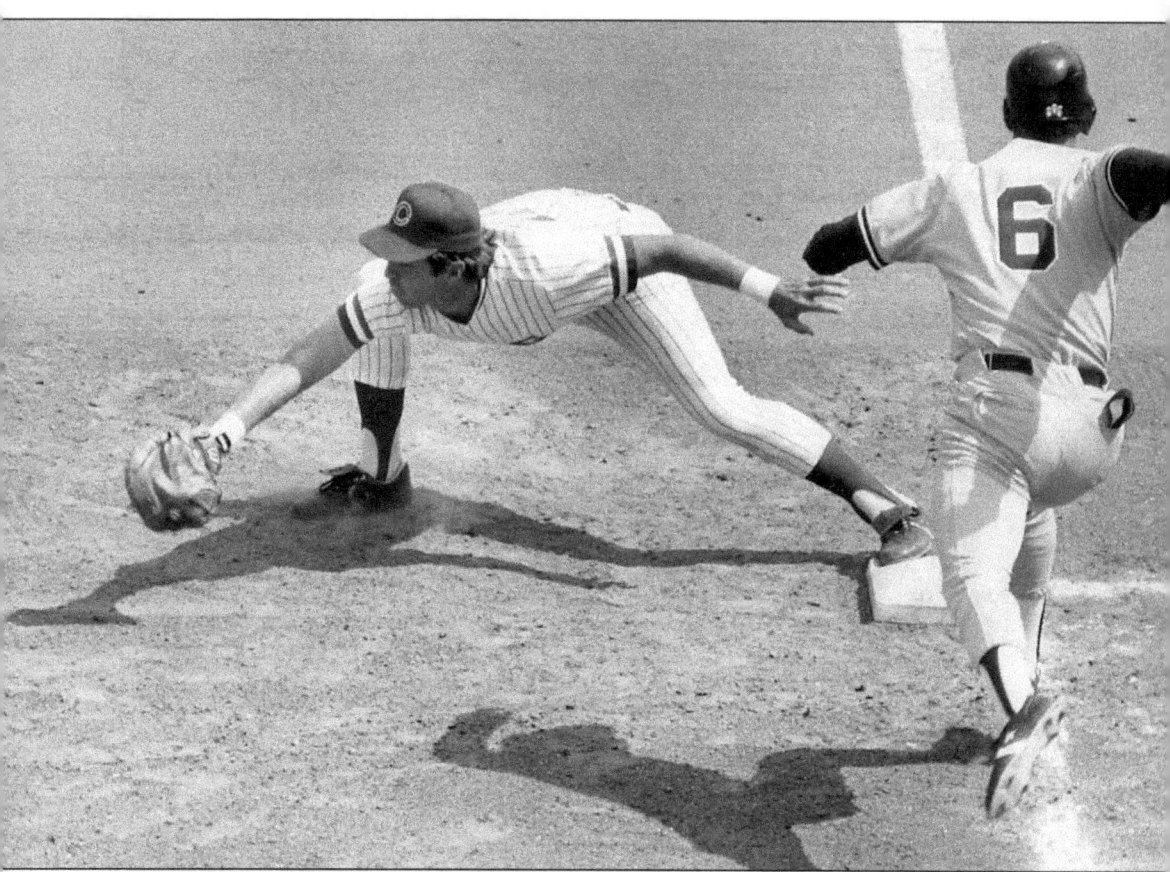

**EXHIBITION GAME.** On April 12, 1985, the Yankees visited Columbus for an exhibition game with the Clippers. Yankee third baseman Mike Pagliarulo (#6), who played for Columbus in 1984, is pictured trying to beat a throw to first baseman Dan Briggs. The hard-hitting Briggs spent 7 seasons in the big leagues. A crowd of 8,750 saw the Clippers win 14–5. "Pags" played 11 years in the majors with the Yankees, Padres, Twins, Orioles, and Rangers. He had his best year for the Yankees in 1987 when he hit 32 homers with 87 RBI.

In addition to the 1985 game, the Yankees have visited Columbus for games against their top minor league affiliate on six other occasions. The Clippers have managed three wins in the seven contests. The most recent game in 1997 was won by New York 11–9 before a Cooper Stadium crowd of 13, 834. (Columbus *Citizen-Journal*, Scripps-Howard Newspapers/Grandview Heights Public Library/Photohio.org.)

**PLAY AT FIRST.** Clipper first baseman Pete Delena tries to tag Mike Sharperson of Syracuse in this game action from 1985. Delena played in 486 games for Columbus from 1984 to 1988, second only to Bubba Carpenter's 574 on the all-time Clipper list. Delena, an IL All-Star in 1986, is also second in franchise history in doubles (89), and fourth in hits (438). (Columbus *Citizen-Journal*, Scripps-Howard Newspapers/ Grandview Heights Public Library/ Photohio.org.)

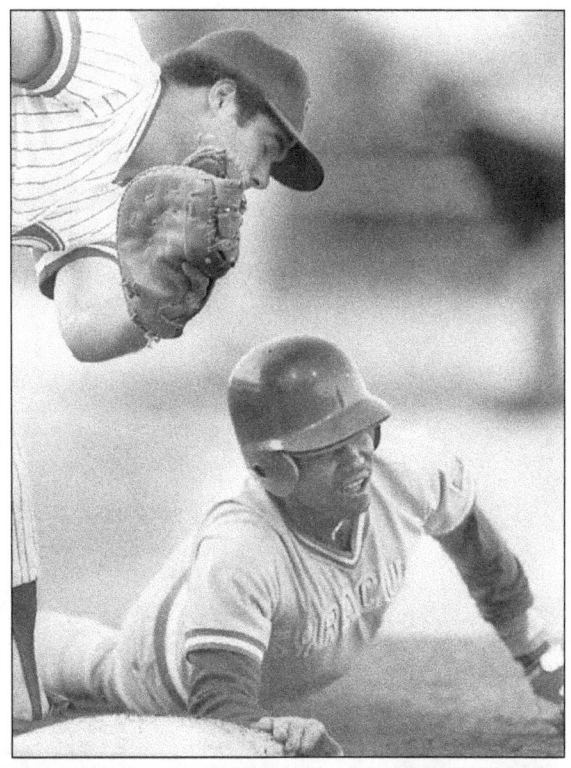

**PLAY AT THE PLATE.** Columbus catcher Bill Lindsey puts the tag on the sliding Mitch Webster of Syracuse in this June 1985 game. Lindsey made it to the majors with the White Sox in 1987. Webster had a 13-year career in the majors with six teams. Columbus was the runner-up for the Governor's Cup in 1985. (Columbus *Citizen-Journal*, Scripps-Howard Newspapers/ Grandview Heights Public Library/ Photohio.org.)

*Opposite, Above*: **SNAPSHOT**. Clipper coach Jerry McNertney takes a photo from the dugout before a 1985 game at Cooper Stadium. McNertney broke in with the White Sox in 1964 and had a nine-year career as a major league catcher with five teams. After his time in Columbus, he coached in the majors and at his alma mater, Iowa State. (Columbus *Citizen-Journal*, Scripps-Howard Newspapers/Grandview Heights Public Library/Photohio.org.)

*Opposite, Below*: **CLIPPERS WIN!** Columbus celebrates a victory in 1985. Tom Barrett (batting helmet) played in the majors with the Red Sox and Phillies. The versatile Rex Hudler (hand raised) played every position except pitcher and catcher during a 13-year major league career and is now a broadcaster for the Anaheim Angels. Longtime major and minor league pitching coach Sammy Ellis (right) won 22 games for the Reds in 1965. (Columbus *Citizen-Journal*, Scripps-Howard Newspapers/Grandview Heights Public Library/Photohio.org.)

**VETERAN MANAGER**. Carl "Stump" Merrill first managed the Clippers in 1984, when he led them to an International League pennant, and has returned to Columbus on several other occasions when his leadership abilities were needed. In 1996, Merrill came back to Columbus and the Clippers won both the regular season championship and the Governor's Cup. In 1997 under Merrill, they followed up with another pennant and a runner-up finish for the Cup.

Over his long career in the Yankee organization, Merrill has managed at every level, willing to serve where he is most needed to help with the teaching and development of young players. In addition to his various minor league assignments, he has coached and managed the major league club. When the Clippers got off to a poor start in 2002, Merrill was summoned from his post as manager of the Double-A Norwich Navigators to become the Columbus manager for the sixth time. (Columbus *Citizen-Journal*, Scripps-Howard Newspapers/Grandview Heights Public Library/Photohio.org.)

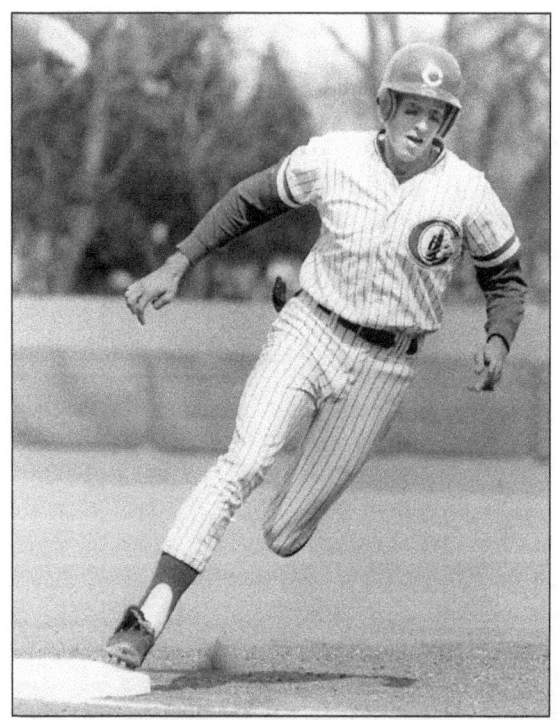

**CLIPPER STALWART.** Outfielder Matt Winters, hustling around third base in this photo, was a Clipper from 1983 to 1986. He played on two pennant winning teams (1983, 1984) and led the International League champs of '83 in batting with a .292 average. Winters made it to the majors with the Kansas City Royals in 1989. (Columbus *Citizen-Journal*, Scripps-Howard Newspapers/Grandview Heights Public Library/Photohio.org.)

**FUTURE STARS.** Triple-A games give Columbus fans a daily opportunity to see players on the brink of major league success. In this game action from 1985, Clipper Tom Barrett slides in safely under Tidewater third baseman Kevin Mitchell. With the Giants in 1989, Mitchell was NL MVP with 47 homers and 125 RBI. (Columbus *Citizen-Journal*, Scripps-Howard Newspapers/Grandview Heights Public Library/Photohio.org.)

MEMORABLE HOMER. In 1987, Bucky Dent managed Columbus to the Governor's Cup championship. A major league shortstop for 13 years, Dent is remembered for his dramatic 3-run homer that gave New York a 5–4 victory over Boston in the one-game playoff for the AL pennant in 1978. Dent was named World Series MVP that year when he hit .417 in the Yankees' series win over the Dodgers. (Columbus Circulating Visuals Collection Columbus Metropolitan Library.)

ALL-STAR GAME. Columbus hosted the Triple-A All-Star game in 1989. A crowd of 14,131 saw players from National League affiliates defeat their American League counterparts 8–3. Clipper All-Star catcher Brian Dorsett hit a home run for the AL team. Dorsett shared the team home run championship in 1989 with fellow All-Star Hal Morris. Dorsett and Morris also shared the Clipper of the Year award for 1989. (Courtesy Mike Nightwine.)

**HAL MORRIS.** First baseman Hal Morris played for Columbus in 1988 and 1989. He was the IL batting champion in 1989, but was traded by the Yankees to the Reds. With Cincinnati in 1990, he hit .340 during the season and .417 in the World Series sweep of Oakland. Morris hit .304 over 13 years in the majors. (Columbus Clippers.)

**CLIPPER OLYMPIAN.** Dave Silvestri played shortstop in Columbus from 1992 to 1994 and had an eight-year career as a major league infielder with the Yankees and four other teams. He was a member of the USA's Gold Medal team in the 1988 Olympics. An IL All-Star in 1992, Silvestri is among the top ten on the Clippers' all-time list in home runs, RBI, runs scored, and total bases. (Columbus Clippers.)

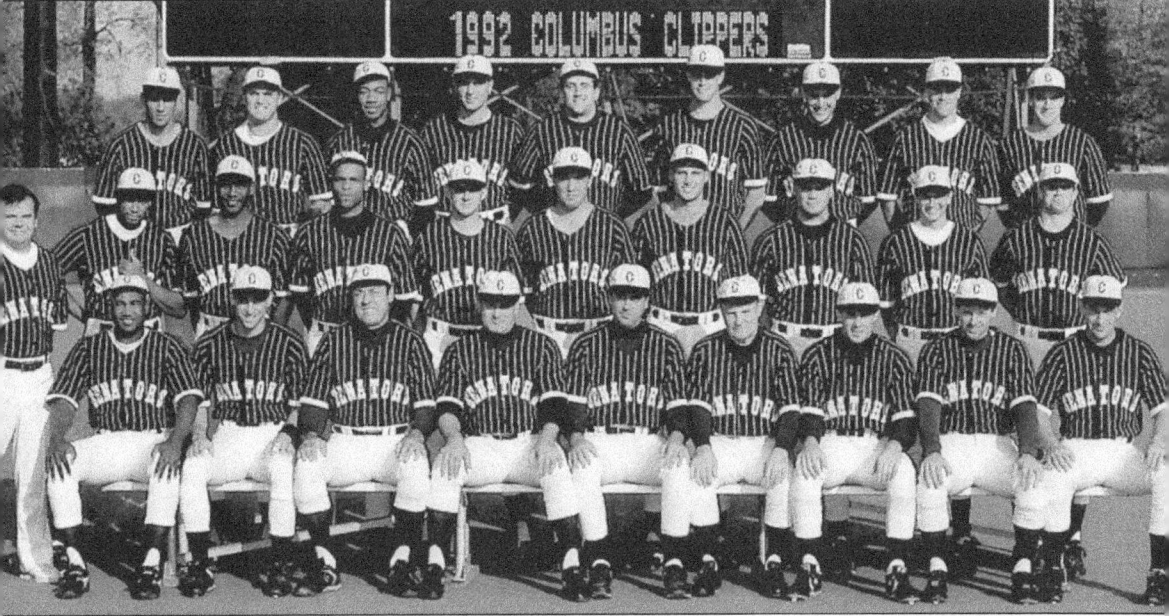

ANNIVERSARY. In 1992, the Clippers observed one hundred years of professional baseball in Columbus by wearing Columbus Senator uniforms in this team picture. From left to right: (front row) Francisco de la Rosa, Torey Lovullo, Coach Ted Uhlaender, Manager Rick Down, Coach Mike Brown, Coach Hop Cassady, Jay Knoblauh, Dave Sax, and Jeff Livesey; (middle row) Trainer Mike Heifferon, Bernie Williams, Hensley Meulens, Royal Clayton, Mike Draper, Don Stanford, Andy Cook, Bob Wickman, Bobby DeJardin, and Brad Ausmus; (back row) Dave Rosario, Billy Masse, Gerald Williams, Shawn Hillegas, Larry Stanford, Russ Springer, Sam Militello, J.T. Snow, and Ed Martel.

Under Manger Rick Down, Columbus had the best regular season record and won the Governor's Cup. First baseman Snow won the league batting championship, Rookie of the Year, and MVP awards. Meulens led the league in homers and RBI. Gerald Williams led the league in hits, Lovullo in doubles, and Bernie Williams in triples. Militello was Pitcher of the Year. (Author's collection.)

**CLIPPER GREAT.** Don Sparks was Clipper of the Year in 1994 and an IL All-Star in 1995, when he led the league in RBI. In 472 games in two stints in Columbus (1990-91 and 1993-95), Sparks collected 490 hits, good for first place on the all-time Clipper list. He is also among the club's all-time top five in doubles, triples, RBI, and total bases. (Author's collection.)

**SCRAPPY INFIELDER.** Andy Stankiewicz played with Columbus four separate times over 13 seasons (1988, 1990-91, 1993, 1999-2000). During that span he also played seven seasons in the majors (1992-98) with the Yankees, Astros, Expos, and Diamondbacks. A Cooper Stadium favorite for his hustling play, Stankiewicz is among the Clipper all-time top ten in games played, hits, triples, and runs scored. (Author's collection.)

**600 AND COUNTING.** Since becoming head coach of Ohio State in 1988, Bob Todd has won more than 600 games and was named Big Ten Coach of the Year four times. Under Todd, the Buckeyes have won the Big Ten regular season championship seven times, the Big ten tournament four times, and have made eight appearances in the NCAA Tournament. (The Ohio State University Athletics Department.)

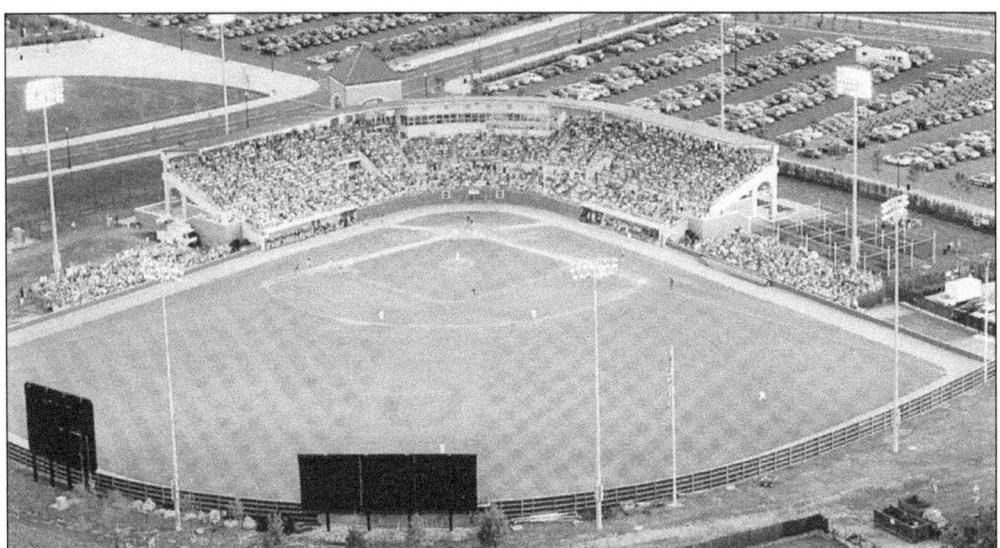

**BILL DAVIS STADIUM.** Located on the Ohio State campus in Columbus, it is one of the finest collegiate ballparks in the country. The Buckeyes played the first game in the facility in March 1997. Lights were installed the following year. The 4,450-seat stadium was chosen as the site for the NCAA Regional Tournament in 1999 and 2001 and the NCAA Super Regional in 1999. (The Ohio State University Athletics Department.)

ALL-AMERICAN. Left-hander Matt Beaumont was selected as a first-team All-American in 1994, the first Ohio State player to attain that recognition since Ray Shoup in 1967. Beaumont's career record was 25–7 (.781), as he helped lead the Buckeyes to three straight Big Ten regular season championships (1992-94) before signing with the California Angels' organization. (The Ohio State University Athletics Department.)

WINNING PITCHER. Justin Fry, a four-year letterman, holds the Ohio State record for most career wins with 36. Also the Buckeye career leader in innings pitched and strikeouts, Fry was 11–2 his senior year and received All-American recognition as Ohio State won the 1999 Big Ten Championship and the NCAA Regional at Columbus. (The Ohio State University Athletics Department.)

BUCKEYE VICTORY. Players celebrate as Ohio State (50–14) wins the 1999 NCAA Regional by defeating perennial power Mississippi State in the championship game at Bill Davis Stadium. Senior First baseman Jason Trott set a Buckeye record in 1999 with a career average of .399. Trott won three consecutive Big Ten batting championships (1997-99) with averages of .429, .428, and .367, respectively. (The Ohio State University Athletics Department.)

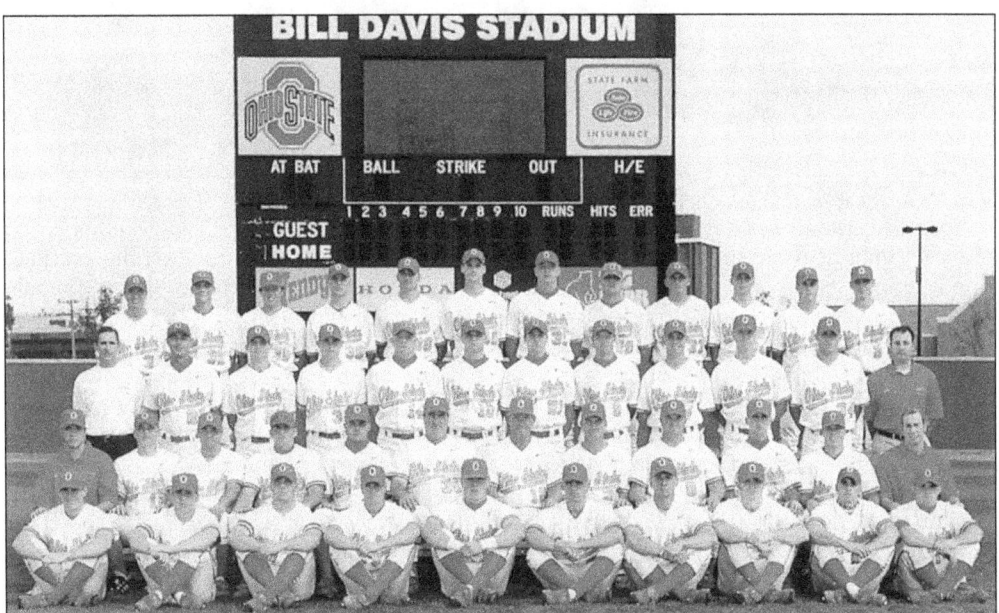

CONSISTENT WINNERS. The 2001 Ohio State team had a 43–18 overall record and won the Big Ten Championship with a league record of 20–7. The consistent success of the program in recent years and the excellent facilities of Bill Davis Stadium resulted in Columbus being selected once again to host an NCAA Regional. (The Ohio State University Athletics Department.)

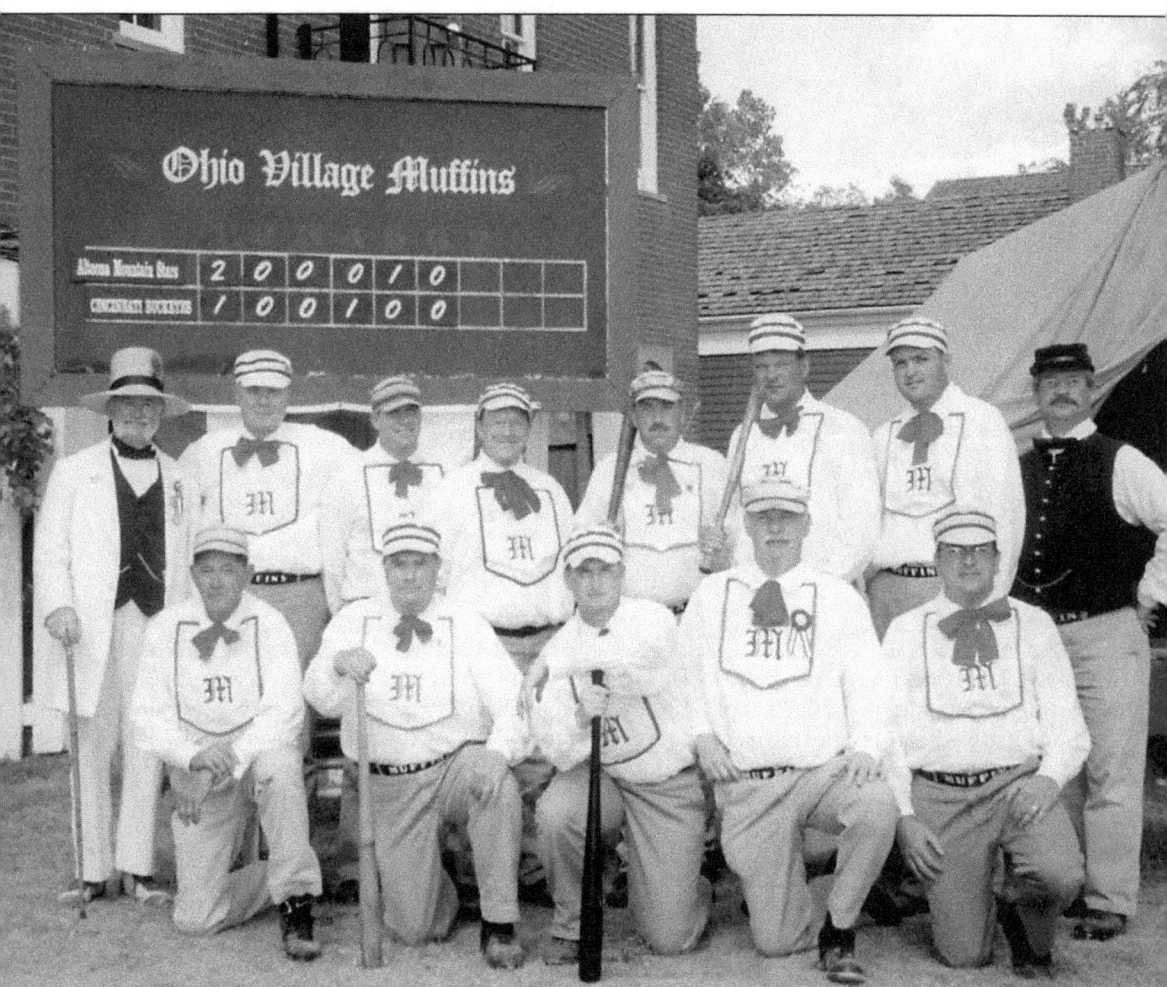

VINTAGE BASE BALL. Columbus is a hub of vintage base ball, the sport of playing the game using 19th-century rules, uniforms, and equipment. In 1981, the Ohio Village Muffins began playing games at the Ohio Historical Society's Ohio Village according to the rules of 1860. The Muffins are part of the Education Division of the Historical Society and play a schedule of about 50 games a year. In addition to home games at Ohio Village, the Muffins travel to community festivals and the home fields of the other vintage teams in Ohio and across the country. There are about 15 vintage teams in Ohio and more than 100 nationwide. Many of these other teams got their start through contact with the Muffins.

In addition to authentically re-creating the game of base ball as it was played in the 1860s, the Muffin program also emphasizes the manners, language, and customs of the times. While vintage teams play to win, matches are conducted according the highest standards of gentlemanly behavior and good sportsmanship so characteristic of the game's early days. (Author's collection.)

THE OLD FASHIONED GAME. Each year on Labor Day weekend, Columbus becomes the center of vintage base ball (two words in the 19th century). Two dozen colorfully-uniformed teams from Ohio and other states converge for two days of playing the game by the rules of 1860. This vintage base ball festival is hosted by the Ohio Village Muffins at the Ohio Historical Center. (Author's collection.)

BAT FACTORY. Phoenix Bat Company founder Charlie Trudeau of Columbus started making a few wooden bats for vintage base ball teammates in 1996. When players on other teams started ordering the 19th century-style bats, a hobby became a booming business. The company is now a licensed supplier to Major League Baseball, and sells approximately 10,000 vintage and modern bats a year to amateur and professional players nationwide. (Author's collection.)

**BASEBALL AT OTTERBEIN.** A legendary figure in the athletic history of Otterbein College, Coach Dick Fishbaugh led the Cardinal baseball program for 34 years until his sudden passing in 1999. A native of Pickerington, Coach Fishbaugh won 624 games at Otterbein and took his teams to the NCAA Division III Tournament six times, advancing to the national championship game in 1983. (Otterbein College.)

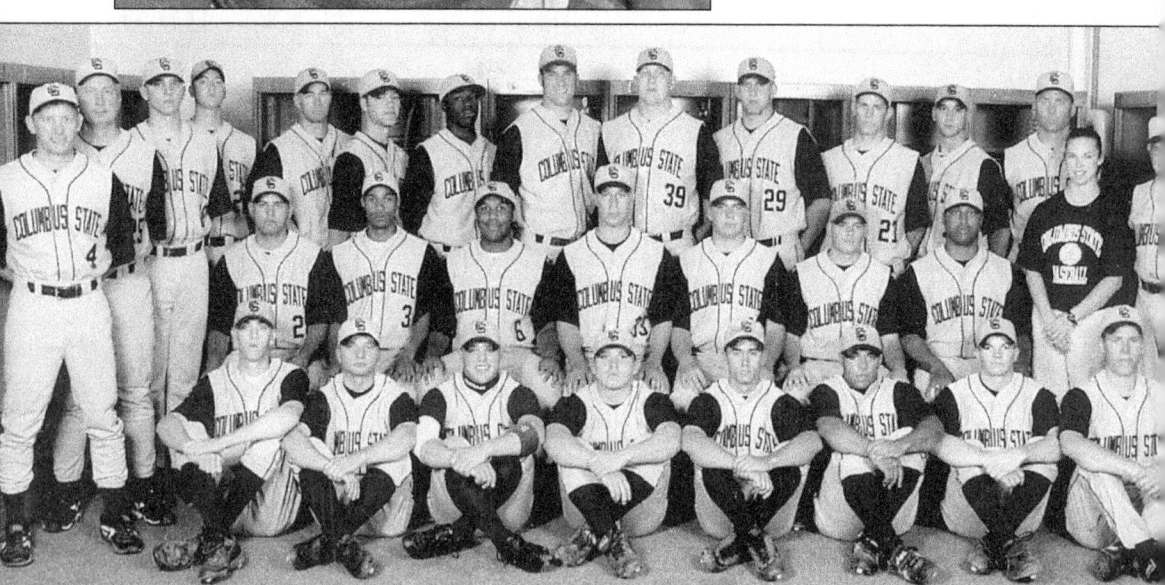

**COUGAR BASEBALL.** Columbus State Community College began its baseball program in 1988. Since 1992, the Cougars have made five appearances in the National Junior College Athletic Association Division III World Series. In 2001, Coach Greg Weyrich's Cougars won 51 games and finished the year as the national runner-up. The CSCC campus includes the former Aquinas High School property where George Steinbrenner coached in the 1950s. (Columbus State Community College.)

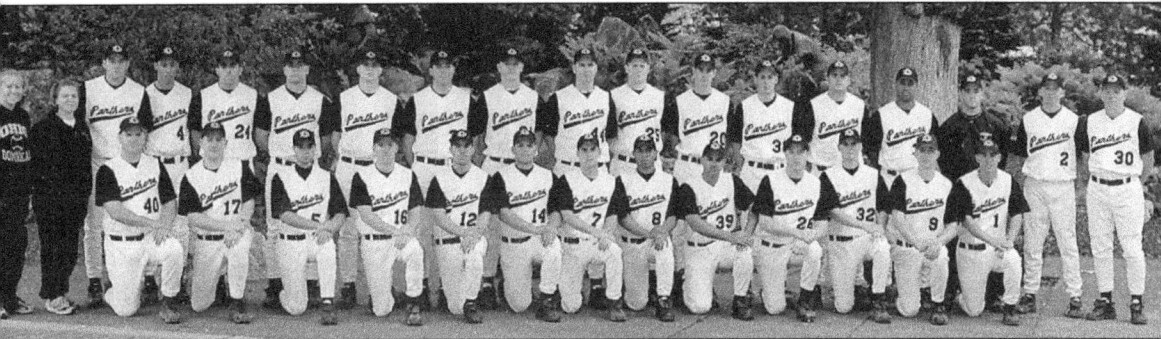

OHIO DOMINICAN UNIVERSITY. Panther Valley, tucked away on a scenic part of the campus, is the home of the ODU baseball program. Since becoming Head Baseball Coach and Athletic Director in 1987, Paul Page has led the Panthers to a winning season every year, and his winning percentage ranks in the top ten of all active NAIA coaches. Ohio Dominican made back-to-back NAIA World Series appearances in 2001 and 2002. (Ohio Dominican University.)

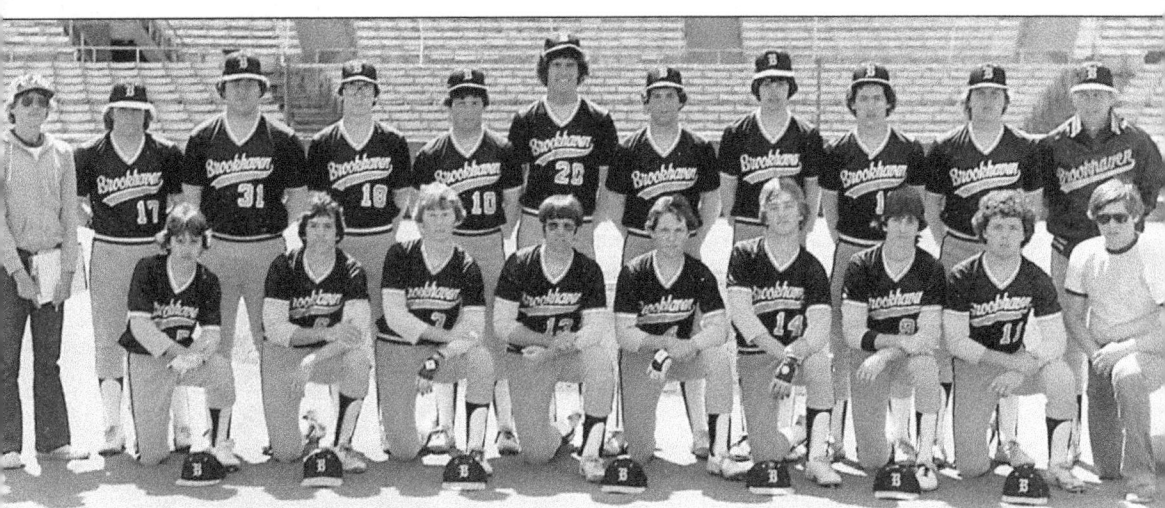

PAUL O'NEILL. In 1981, Coach Fred Michalski's Brookhaven High School Bearcat team was led by senior Paul O'Neill (#20, middle of back row), who earned all-city and all-state honors. In his distinguished major league career, O'Neill was a key player on five World Series championship teams: the Reds in 1990 and the Yankees in 1996, 1998, 1999, and 2000. In 1994, O'Neill was the AL batting champ. (Courtesy Fred Michalski.)

**BERNIE WILLIAMS.** The regular center fielder for the New York Yankees since 1993, Bernie Williams played for the Clippers in 1989 and 1991-92. Winner of four Gold Gloves and the American League batting championship in 1998, Williams has been a key contributor to the recent string of Yankee pennant-winning teams and World Series champions (four rings in five years, 1996-2000). (Columbus Clippers.)

**LEFTHANDER.** Andy Pettitte led the Clippers' staff in complete games in 1994 before moving up to the Yankees' starting rotation in 1995. The Yankees have been in post-season play every year since Pettitte joined the staff. In these pressure games, he has contributed eight wins in the American League playoffs and two more victories in the World Series. (Columbus Clippers.)

**EL DUQUE.** Orlando Hernandez, the Cuban pitching legend who was at least 32 when signed by the Yankees following his escape to Florida, played for the Clippers in 1998. An unflappable veteran, "El Duque" has been a dependable starter for the Yankees. Pitching his best in clutch situations, Hernandez has been especially effective in post-season games including the World Series. (Columbus Clippers.)

**MAJOR LEAGUE UMPIRE.** Tim Timmons grew up in Columbus, graduating in 1986 from Bishop Watterson High School, where he was a catcher on the baseball team. He began his professional umpiring career while a student at Ohio State and perfected his craft during the 1990s while working his way up through the minors. Timmons became a full-time major league umpire in 2001. (Courtesy Tom Watson.)

**CLIPPER CATCHER.** Clipper Jorge Posada was selected as the catcher on the International League All-Star team in 1995 and 1996. Since becoming the Yankees' regular catcher in 1998, the switch-hitting defensive standout has been the backstop on three World Series championship teams (1998-2000) and is a three-time American League All-Star. (Columbus Clippers.)

**DRAWING CARD.** When Japanese star Hideki Irabu was signed by the Yankees, Columbus fans turned out in record numbers in 1997 to see the new sensation pitch at Cooper Stadium. On July 5, Irabu helped draw 15,873 through the turnstiles, and on August 1, the gate was 16,952. Irabu pitched for the Yankees through 1999, and was traded to the Expos. (Columbus Clippers.)

**HEAVY HITTER.** In 1998, third baseman Mike Lowell led Columbus in doubles, runs, and RBI, and tied (with catcher Mike Figga) for the club lead in homers. Lowell was the IL MVP in the 1998 Triple-A All-Star Game and Clipper of the Year. Traded to Florida in 1999, he drove in 100 runs for the Marlins in 2001 and was named to the National League All-Star team in 2002. (Columbus Clippers.)

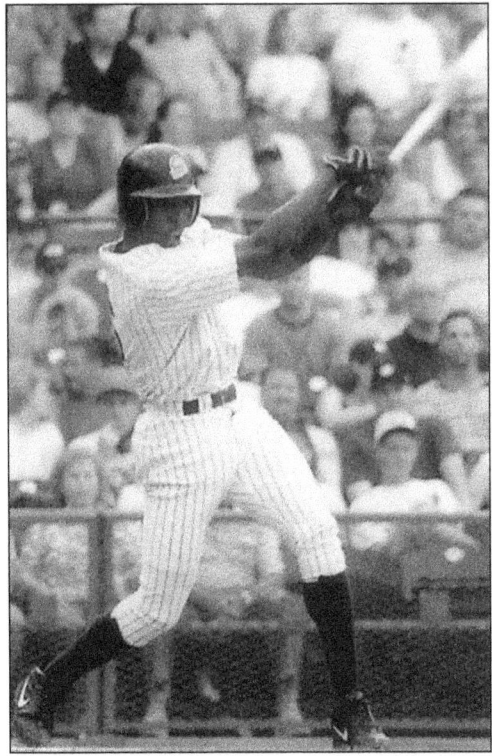

**EMERGING SUPERSTAR.** The Yankees received many offers for Alfonso Soriano when he led the Clippers in doubles and runs scored in 2000. Declining those bids for his services proves the old saying that "the best trades are the ones you don't make." Taking over at second base for the Yankees in 2001, he has become one of the most productive offensive players in the America League. (Columbus Clippers.)

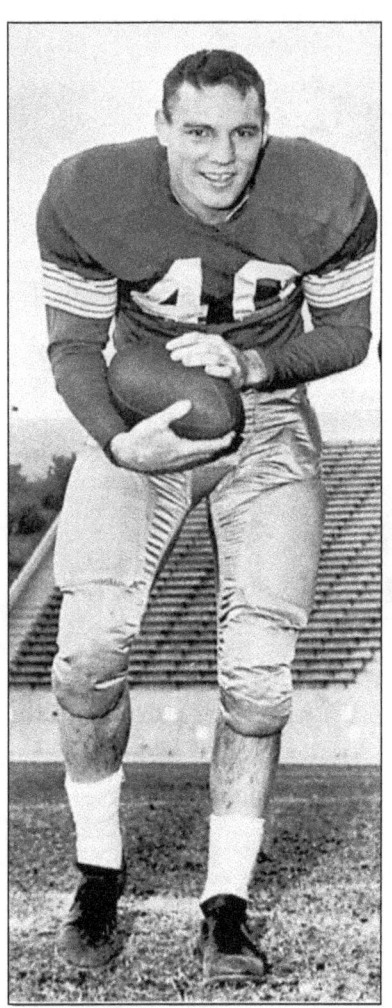

THE FAMILIAR NUMBER 40. Howard "Hopalong" Cassady, a graduate of Columbus Central High School, was the 1955 Heisman Trophy winner at Ohio State. In addition to his monumental gridiron achievements for Woody Hayes' football team, the legendary "Hop" was an excellent hitter and played shortstop and center field on the Buckeye baseball team. (The Ohio State University Athletics Department.)

NUMBER 40 FOR THE CLIPPERS. Hopalong Cassady has served in various coaching and scouting capacities in the Yankee organization since 1973 and has been the Clippers' first base coach since 1992. His football number 40 was retired by The Ohio State University in 2000, but Columbus fans enjoy seeing it still being worn by its owner in the Cooper Stadium coach's box. (Author's collection.)

**TOMORROW'S YANKEES.** The athletically talented Drew Henson led the Clippers in home runs in 2002. Like Derek Jeter, Alfonso Soriano, Shane Spencer, and others before him, the former college quarterback has spent productive time in Columbus refining his game while providing local fans another opportunity to watch a future major leaguer develop. *Baseball America* recently named Henson the most outstanding high school baseball player of the last 20 years. (Courtesy Mark Carrow.)

**BOYER AT THIRD.** Clete Boyer, former great third baseman and current minor league instructor for the Yankees, is seen here coaching third base for the Clippers during the 2002 season. Boyer's presence at Cooper Stadium is a link to the old Red Bird days. His older brother Cloyd played on the same field for Columbus as a Cardinal farmhand over 50 years ago. (Author's collection.)

HISTORY AND TRADITION. The leadership team of the Clippers has done a thoughtful and informed job of connecting with the long tradition of baseball in Columbus. This awareness of the club's historic past is evidenced by commemorating milestone anniversary seasons, wearing "turn-back-the-clock" uniforms, and holding annual Hall of Fame inductions. Preserving the club's architectural heritage, club offices today occupy the original entrance to old Red Bird Stadium. (Author's collection.)

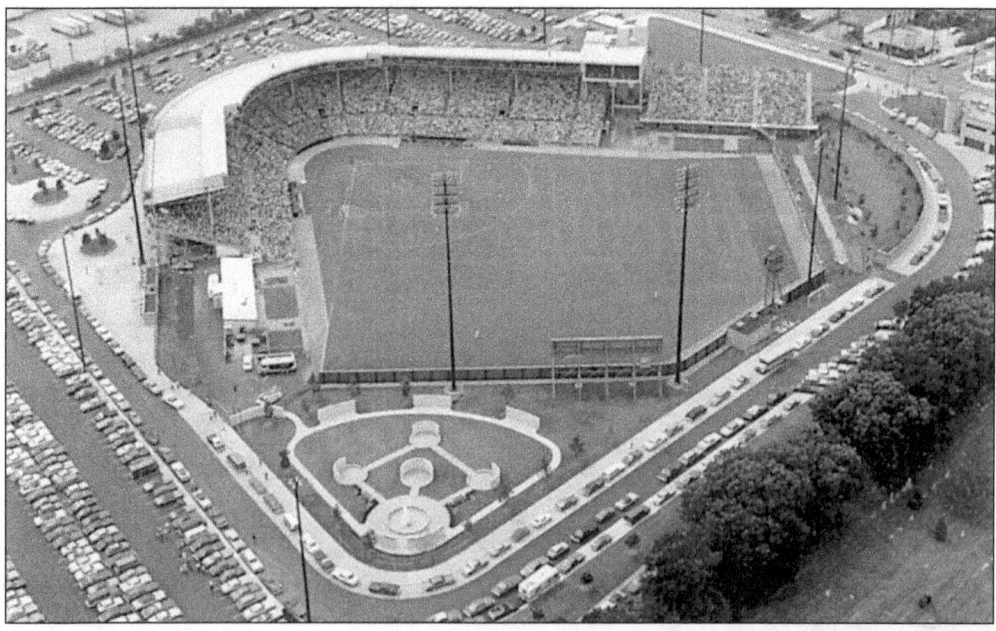

COLUMBUS LANDMARK. A full-house crowd packs Cooper Stadium. Professional baseball has been played on this location in Columbus since 1932. Those who have made outstanding contributions to the city's rich baseball heritage are enshrined in the Columbus Baseball Hall of Fame located in Dysart Park, the baseball diamond-shaped area just beyond the right field fence. (Columbus Clippers.)

CAP AND GOWN. Yankee owner George Steinbrenner is pictured receiving the honorary degree Doctor of Business Administration from Ohio State President Brit Kirwan at the June 2002 commencement. Steinbrenner's ties to Columbus go back to the early 1950s when, after graduating from Williams College, he was stationed at Lockbourne AFB and coached at Aquinas High School. Columbus has been the Yankees' Triple-A affiliate since 1979. (Kevin Fitzsimons, The Ohio State University.)

NATIONAL RECOGNITION. Under Ken Schnacke, general manager since 1989 and an IL Executive of the Year winner, the Clippers have enjoyed consistent success in the standings and in attendance. In recognition of the achievements of Schnacke and his predecessor, George Sisler, the Columbus Clippers received a prestigious award from *Baseball America* in 2002 as the outstanding Triple-A organization of the past 20 years. (Columbus Clippers.)

**CLIPPER OF THE YEAR AND MORE.** While playing for Columbus in 1995, shortstop Derek Jeter led the team in hitting with a .317 average, led the league in runs scored with 96, and was named Clipper of the Year. Superb on defense, Jeter represented Columbus in the Triple-A All-Star game and, along with teammates Don Sparks and Jorge Posada, was named to the post-season International League All-Star team.

Selected as the American League's Rookie of the Year in 1996, his first season as a regular with the Yankees, Jeter has been a principal player in the team's recent dynasty. A five-time All-Star selection, Jeter led the American League in runs scored in 1998 and hits in 1999 while batting .349. In 2000, he became the only player ever to be named MVP of the All-Star Game and the World Series in the same year. In Jeter's first six years as the Yankee shortstop, New York advanced to the World Series five times, winning the Fall Classic on four occasions (1996, 1998, 1999, and 2000).

The success of Jeter and his Clipper teammates at the Triple-A level and in the major leagues is representative of the high quality of Columbus baseball. Hundreds of thousands of fans have cheered a winning organization at the local ballpark and have followed many of the club's former players as they go on to big league success. (Courtesy Joe Santry.)

Visit us at
arcadiapublishing.com